Philip Hook is a director and senior paintings specialist at Sotheby's. He has worked in the art world for thirty-five years, during which time he has also been a director of Christie's and an international art dealer. He is the author of five novels and two works of art history, including *The Ultimate Trophy*, a history of the Impressionist Painting. Hook has appeared regularly on television, from 1978–2003 on the BBC's *Antiques Roadshow*.

PHILIP HOOK

Breakfast at Sotheby's

An **A-Z** *of the Art World*

PENGUIN BOOKS

PENGUIN BOOKS

Published by the Penguin Group
Penguin Books Ltd, 80 Strand, London WC2R ORL, England
Penguin Group (USA), Inc., 375 Hudson Street, New York, New York 10014, USA
Penguin Group (Canada), 90 Eglinton Avenue East, Suite 700, Toronto, Ontario, Canada M4P 2Y3
(a division of Pearson Penguin Canada Inc.)
Penguin Ireland, 25 St Stephen's Green, Dublin 2, Ireland (a division of Penguin Books Ltd)
Penguin Group (Australia), 707 Collins Street, Melbourne, Victoria 3008, Australia
(a division of Pearson Australia Group Pty Ltd)
Penguin Books India Pvt Ltd, 11 Community Centre, Panchsheel Park, New Delhi – 110 017, India
Penguin Group (NZ), 67 Apollo Drive, Rosedale, Auckland 0632, New Zealand
(a division of Pearson New Zealand Ltd)
Penguin Books (South Africa) (Pty) Ltd, Block D, Rosebank Office Park,
181 Jan Smuts Avenue, Parktown North, Gauteng 2193, South Africa

Penguin Books Ltd, Registered Offices: 80 Strand, London WC2R ORL, England

www.penguin.com

First published by Allen Lane 2013
Published in Penguin Books 2014
001

Copyright © Philip Hook, 2013

The moral right of the author has been asserted

All images courtesy of Sotheby's other than: p. 9 © Lucio Fontana/SIA E/DACS,
London 2013; p. 41 © Succession Marcel Duchamp/ADAGP, Paris and DACS, London 2013;
p. 43 © The Munch Museum/ The Munch-Ellingsen Group, BONO, Oslo/DACS,
London 2013; p. 71 © Salvador Dali, Fundació Gala-Salvador Dalí, DACS, 2013;
p. 105 © DACS 2013; p. 116 © The Estate of Francis Bacon. All rights reserved.
DACS 2013; p. 139 © The Estate of Alberto Giacometti (Fondation Giacometti, Paris and
ADAGP, Paris), licensed in the UK by DACS and DACS, London 2013; p. 181 © DACS 2013;
p. 193 © ADAGP, Paris and DACS, London 2013; p. 319 © Man Ray Trust/ADAGP,
Paris and DACS, London 2013; p. 342 © The Andy Warhol Foundation for the
Visual Arts, Inc./Artists Rights Society (ARS), New York

Typeset by Jouve (UK), Milton Keynes
Printed in Great Britain by Clays Ltd, St Ives plc

A CIP catalogue record for this book is available from the British Library

ISBN: 978-0-718-19245-7

www.greenpenguin.co.uk

Contents

Introduction

When you stand in front of a work of art in a museum or exhibition, the first two questions you ask yourself are normally 1. Do I like it? and 2. Who's it by? When you stand in front of a work of art in an auction room or dealer's gallery, you also ask yourself the same two questions first; but they are followed by others, rather less noble-minded, such as: how much is it worth? How much will it be worth in five or ten years' time? And, what will people think of me if they see it hanging on my wall?

This dictionary is a guide to how people reach answers to those questions, and how in the process art is given a financial value. I have spent more than thirty-five years working in the art market, first at Christie's, then as a dealer, and latterly at Sotheby's. That is my excuse for writing a book about the art world that investigates in prurient detail the guilty but ever-fascinating relationship between art and money. It is divided into five parts, each one of which analyses a different factor in what determines the amount a buyer ends up paying for a work of art. In the process I have undertaken a highly subjective and shamelessly self-indulgent tour of those aspects of art and the art world that have struck me over the years as comic, revealing, piquant, splendid or absurd.

The first part examines the artist and his hinterland. Who's

it by? The identity of the artist and his perceived importance in the scheme of art history is a factor that has an understandable influence on buyers and the price they pay for a painting; but there is also a back story to artists' lives that affects our appreciation of them and the works they produce, a romance made up of the glamour and myth of artistic creation. Quite apart from the art historical importance of – say – Van Gogh and his significance as the originator of Expressionism, there is a tragic romance to his life that enhances his value to the collector both emotionally and financially.

The second section looks at what subjects and styles are in demand. The answer to the question 'Do I like it?' is influenced by one's own personal predilections, but also by a broader artistic taste that is constantly evolving. At different times in history people want different things from art, so that what artists paint and how they paint it can to succeeding generations vary in desirability and financial value. But within that evolution, certain subjects and styles emerge as selling better than others with a reasonable consistency. This part of the dictionary attempts to analyse the factors in play, and to look at artistic taste as manifested now, in the early years of the twenty-first century. A warning in advance: the determinants of what sells and what doesn't are occasionally subtle ones, but more often alarmingly simplistic.

The third part, 'Wall-Power', looks in more detail at what makes us like a painting. What gives it the impact that makes us want to own it (and attracts a crowd of other admirers too so that it sells for appreciably more than we can afford)? Of course, surpassing artistic quality is the element always reflected positively in the price a work of art realizes. And, at the very top of the quality tree, the price differential between something that is very good and something that is superlative is astonishingly

large. That gap is something I find oddly vindicating about the market: in this respect it has its values right. It recognizes the very best and sets it very emphatically apart.

But how does it do it? Artistic quality is notoriously difficult to pin down. Certain contributory factors are examined here: a work's colouring, its composition, its finish, its emotional impact, its relationship to nature, and to other works of art. Conversely, on what grounds do we have reservations about a painting that will negatively affect its price? Is it unfinished, or too dark, or heavily restored, or depicting something unpleasant? Could it be, horror of horrors, a fake?

In the same way that an artist's back story affects our perception of him and his work, so does the back story of the physical work of art: whose collection it has been in, where it's been exhibited, which dealers have handled it. So the fourth part looks at provenance. If the work you are buying comes from a distinguished private collection, it will raise the price because previous ownership by a very eminent collector is an imprimatur of the work's quality. A Cézanne from the Mellon Collection will be worth more than the same picture from an unnamed private collection. Similarly, to those in the know, certain names appearing in a picture's provenance can trigger alarm signals. These are the dealers that research has identified as having trafficked in looted art during the Second World War, for instance. Unless it can be proved that the painting was not stolen from a Jewish collector, its value may be seriously reduced by its handling by one of these dealers. It may not be saleable at all. And the name of Field Marshal Göring in the list of previous owners of your picture – even if he came by it legally – isn't necessarily a bonus.

What's it worth? Art is assessed and changes hands in a constantly evolving market environment. That environment

is the product of a vast range of elements: economic, political, cultural, emotional and psychological. It is influenced by the marketing of dealers and auction houses, by the whims of collectors and the caprice of critics, by what people see in museums and on television, by their own individual aspirations. The final section of the dictionary, 'Market Weather', examines some of the varied factors that contribute to the storms and sunshine of the art-world climate.

Attaching financial value to works of art is not an entirely uncontroversial activity. But on the whole I think the art trade performs a necessary function and does it no worse than a number of other respectable commercial institutions. It has certainly provided me with an interesting life. I have had close encounters with a large number of great works of art (and a large number of less good ones, too, which is also salutary). I have met some extraordinary (and extraordinarily rich) people. This dictionary is an anthology of what I have learned from them. And, having spent two happy decades working for Sotheby's, I should of course point out that the conclusions I draw are my own and not necessarily the views of my long-suffering employers.

The Artist and His Hinterland

Bohemianism

Branding

Brueghel

Creative Block

Degas

Diarists (Artists as)

Female Artists

Fictional Artists

Géricault

Images (Famous)

-Isms

Jail (Artists in)

Madness

Middlebrow Artists

Models and Muses

Quarters and Colonies

Spoofs

Suicides

Bohemianism

Iris Barry, having given birth to the child of the Vorticist painter Wyndham Lewis, returned from hospital to his studio with the new baby but had to wait outside until he had finished having sex with Nancy Cunard. When Vlaminck sold a painting unexpectedly, he took the cash and went on a three-day drinking bout with Modigliani; what money they didn't drink they folded into paper aeroplanes and sent gliding into the trees along Boulevard Raspail. To paint *The Raft of the Medusa*, Théodore Géricault shaved his head, cut himself off from his friends, put a bed in his studio and worked there unremittingly for ten months. After the completion of the picture he suffered a total nervous collapse.

Artists live differently from ordinary people. This was recognized early on: in one of Franco Sacchetti's *novelle*, written in Italy in the late fourteenth century, a painter's wife exclaims: 'You painters are all whimsical and of ever-changing mood; you are constantly drunk and not even ashamed of yourselves!' Five hundred years later Edvard Munch's father, in classic bourgeois horror at his son's choice of profession, said that to be an artist was like living in a brothel. The alienation of artists is grimly described by the British painter Keith Vaughan in 1943: 'We see them at odds with themselves and others, perpetually lonely and ailing, carved out with wretchedness, their manhood falling to pieces about them and only the bright jewel of their creative rage burning in the centre of the wreckage.'

Bohemianism is an expression of the artist's otherness. In its modern form, it flowered in the nineteenth century as a growth

of the Romantic Movement. The artist was cast as tortured hero, a bohemian in the sense of being a gypsy, one who led a vagabond or irregular and unconventional life; not necessarily by choice, but because he had to, being driven by an irresistible creative impulse. Heavy drinking, sexual promiscuity, drug-taking, flirtations with madness, and eccentricities of appearance and dress were deemed the symptoms of creativity; there were even those who believed that indulgence in such things was creativity's precondition, and steeled themselves to drink more or to grow their hair long (or cut it short if they were girls) in order to become great artists.

Henry Murger, who wrote *La Vie de Bohème* in 1843, is generally credited with having invented bohemia. He fixed it as immutably centred in the Latin Quarter, declaring that 'it only exists and is only possible in Paris'. Arriving there from Germany in 1900, Paula Modersohn-Becker observed that the painters all wore 'long hair, brown velvet suits, or strange togas on the street, with enormous fluttering bow ties – altogether a rather remarkable bunch'. By then the uniform of the anti-uniform was established.

Other bohemias sprang up later to rival Paris – Berlin before the First World War, perhaps, and New York in the 1960s. The British competed gamely, and produced a few fully fledged bohemians of their own such as Augustus John and Wyndham Lewis. But in the ranks beneath them, there was a lack of com-mitment, and a sanitized, romanticized, peculiarly British bohe-mia came into being. George du Maurier's *Trilby*, a successful late-nineteenth-century novel, features three impossibly hearty British art students in Paris, and portrays the Latin Quarter as a place where drink flowed, but no one got drunk, no one drank absinthe, and no man or woman ever had sex. Rather than Paris, British artists of the time were actually more likely

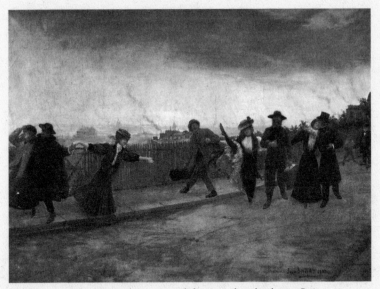

Bohemians at play: artists misbehaving as dawn breaks over Paris
(Jean Béraud, *Le Petit Matin, après la fête à Montmartre*, oil on
canvas, 1907)

to gravitate to summer colonies in places like St Ives and New-
lyn in Cornwall to paint and live unconventionally [see **Quarters
and Colonies** below]; but despite valiant attempts at bohemian-
ism the British ended up playing rather a lot of golf and cricket.
In 1942 Osbert Sitwell told George Orwell that in the event of
a Nazi invasion the Home Guard had orders to shoot all artists.
Orwell observed that in Cornwall that might be no bad thing.

According to Murger, bohemia is 'a stage in artistic life; it is
the Preface to the Academy, the Hotel Dieu, or the Morgue'.
Part of your duty as an artist was to shock the bourgeoisie, to
position yourself remorselessly against convention. This was all
very well up to a point, until you found that the bourgeoisie
were actually also your buyers. Then you sold out and joined the
Academy. Or you didn't sell out, and either went mad or died.

Another exit from bohemia was via the domesticity of marriage, or more specifically of parenthood. That was often a dispiriting cul-de-sac. Nothing, in Cyril Connolly's words, is more inimical to artistic endeavour than 'the pram in the hall'.

The ultimate bohemian, in his pursuit of a primitive life, uncontaminated by industrial and bourgeois values, was Gauguin, who escaped to the South Seas [see Part II, **E**xoticism]. Then there was Augustus John, who literally became a gypsy and learned the Romany language, wandering the country in an itinerant, rootless existence trailing mistresses and children, which was a good way of dealing with the pram-in-the-hall problem. Modigliani may have stayed mostly in Paris but set standards of excess that have remained a benchmark ever since. Munch, perhaps finally heeding his father's strictures, in later life vowed to reform. He would confine himself, he said, to 'tobacco-free cigars, alcohol-free drinks and poison-free women'.

Flaubert was an advocate of restraint: 'Be regular and ordinary in your life, like a bourgeois, so that you can be violent and original in your works,' he advised. There is an interesting subsection of artists for whom the bohemian way of life has held no attraction, who have rebelled against the paradoxical uniformity of its eccentricity. These artists make no connection between the production of good work and unconventional behaviour, and deliberately adopt a conservative, bourgeois lifestyle. Pierre Bonnard, for instance, lived a private life of quiet domesticity apparently punctuated (to judge from his subject matter) only by the regularity with which his wife took baths. Magritte maintained a deeply conventional appearance and favoured a bowler hat. Sir Alfred Munnings – whose subjects were mostly horses – dressed and lived like an English country squire, and once memorably suggested that if he ever met Picasso he'd give him a good kicking.

Today there is a group of successful portraitists in London

known as the Pinstripe School, because they are rarely seen wearing anything but suits. It is entirely possible that these men – who are talented if somewhat representational painters – take off their jackets to work, and perhaps even loosen their ties. But their supreme conventionality and the dapperness of their appearance are reassuring to a certain sort of public. They drink, no doubt, and may even chase women, but no more so than the merchant bankers, hedge-fund managers and high-earning barristers who constitute the majority of their clientele. On the other hand, the suits worn by Gilbert and George, at the cutting edge of contemporary art, are part of a different agenda. Their apparent conventionality of dress is actually the ultimate non-conformity, a post-bohemian bohemianism.

The artist as bohemian is an important part of the myth of art. Art is something magical, transcendent, and worth paying large amounts of money for precisely because it is priceless and unquantifiable. Artists, as the producers of this supremely desirable spiritual commodity, need to dress and behave differently in order to demarcate themselves from ordinary people. Their bohemianism is a badge of their anointed state, a reminder that art is special. And financially valuable.

Branding

The most overworked word today in the vocabularies of dealers, critics and auction-house experts is 'iconic' [see Part V, **G**lossary]. But to praise a work of art as 'iconic', besides acknowledging its artistic quality, also betrays an underlying assumption

that works of art are good in so far as they are typical or recognizable. An art market that values the highly recognizable qualities of the works that it sells is essentially purveying brands. This is a development that you can trace back to the beginning of modernist art. The challenge for the great Impressionist art dealer Paul Durand-Ruel in Paris in the late nineteenth century was to market a new way of painting, to sell a new and unfamiliar commodity to the art-buying public. One of his successful innovations was to popularize exhibitions of the work of a single artist. This focusing of attention on the individual talent and achievement of a Monet, a Renoir or a Pissarro had an important effect: for the first time it defined an artist's brand. Noting the saleability of a strongly branded product, art dealers have been doing the same thing ever since.

Damien Hirst is a present-day triumph of branding. The paint-maker's colour charts that his spot paintings resemble now strike the eye as imitation Hirsts rather than vice versa. But Hirst is exceptional. Art as a strongly branded product can have two problematic results: with living artists, the danger is that branding encourages sameness and discourages radical experiment, unless you are clever enough to be branded as an unpredictable experimenter, which is a difficult act to carry off. Constrained by their dealers, today's artists paint and sculpt in fear of disintegrating their brand. And with the art of the past the effect is that the work of an artist like Monet grows expensive in direct proportion to the degree that it is recognizable, to the degree that people will come into a room where it is hanging and exclaim to the gratified owner, 'Ah! You have a Monet!' An easily identifiable style – or indeed subject matter – reassures the buyer, makes him feel good about himself and his own knowledge of art. Thus there is a premium on very typical ('iconic') works. But beware the untypical: a still life, say, or a portrait by

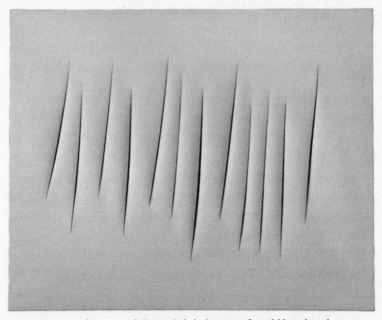

Easily recognized: Fontana's slashed canvas, a formidable trademark
(Lucio Fontana, *Concetto spaziale*, waterpaint on canvas, 1965)

Monet, will make considerably less than a view of his water-lily
pond [see Part II, **I**ndividual Artists].

In addition to Monet, there are a number of other dead art-
ists who are particularly strongly branded in the public percep-
tion, which doesn't do them any harm commercially. These
include:

Tamara **DE LEMPICKA**: the visual poetess of Art
Deco, whose elegant, faintly Sapphic women, either nude or
encased in vaguely Cubistic body-hugging white silk dresses,
evoke the stylish world of Hollywood in the 1930s and have
proved alluring to Hollywood collectors two or three genera-
tions later.

Lucio **FONTANA**: the blank canvas elegantly lacerated by a slash of the Stanley knife was an inspired move. 'I pierce the canvas,' said the artist himself, 'and I have created an infinite dimension.' Plus an infinitely recognizable and repeatable motif.

Alberto **GIACOMETTI**: the thin, craggy, elongated limbs of his later figural sculptures are immediately identifiable, powerful expressions of the existentialist crisis of twentieth-century man.

Atkinson **GRIMSHAW**: this Victorian landscape painter's lamp-lit street scenes at night create a frisson of pleasurable nostalgia. He is the entry portal of many nervous new collectors to the art market: the cosiness of his images coupled with the high recognizability of his style is a hugely reassuring combination.

L. S. **LOWRY**: the distinctive stick men and the gaunt northern cityscapes, gloomily evocative of mid-twentieth-century urban life, are patented trademarks whose appeal endures into the twenty-first.

Amedeo **MODIGLIANI**: his sinuous women with elongated necks and faces are among the most readily recognizable in modern art. Modigliani knew what he liked and stuck with it: almost three-quarters of his entire artistic output is constituted by these female portraits.

Piet **MONDRIAN**: grids, composed of vertical and horizontal lines, with the spaces created here and there blocked in with rectangles of colour. The simple ideas are the best.

Giorgio **MORANDI**: bottles and jars, jars and jugs, jugs and bottles, in rows, on shelves, on tabletops. He could have

made a fortune if he'd started his own brand of kitchen utensils.
Imagine how well they would sell now in museum shops.

John Singer **SARGENT**: a distinctive, slick and glor-
iously free brushstroke creates a look that endows his sitters
with elegance and opulence. The most successful conventional
portraitists today are still the ones who most effectively replicate
the Sargent effect.

B*rueghel*

The first artist I was ever aware of was Pieter Brueghel the Elder.
To be more accurate, I wasn't so much aware of him as of his
paintings. I was six or seven when my mother showed me a
book of colour reproductions of the sixteenth-century Flemish
artist's works. I have the actual book in front of me as I write,
and opening it again brings back extraordinarily vivid memories
of how captivating I found the images from the first moment
I saw them. They conjured an absorbing world of fantasy, of
fairy tale, of the grotesque, of men who looked like fishes and of
fishes who looked like men, of villages under snow and toothless
peasants enjoying simple rural pleasures, of violent death and
fallen angels. I certainly didn't think, 'Ah! These are all painted
by the same man.' Nor did I think, 'How extraordinary that
these were painted four hundred years ago.' But I did think that
they depicted a totally convincing and coherent other world
into which it was a delight to enter.

Once I discovered these images, I returned to them again and

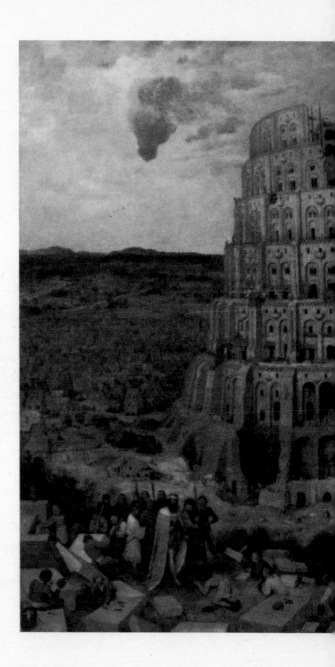

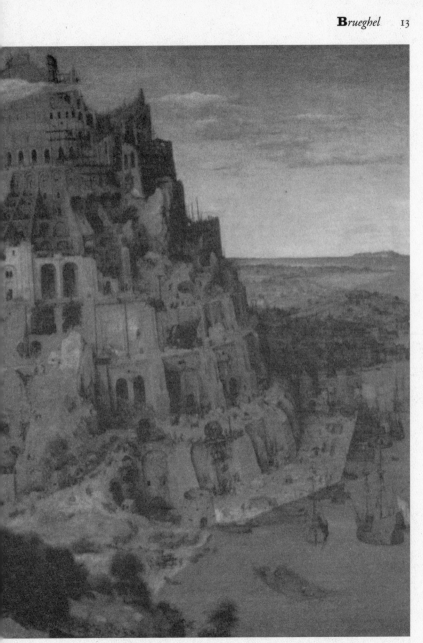

The Tower of Babel, as built by Pieter Brueghel, oil on panel, 1563

again. There was the comically macabre procession of *The Blind Leading the Blind*, six sightless figures lurching after each other into a ditch. And the apocalyptic *Triumph of Death*, a scene of desolation and destruction eerily predictive of twentieth-century warfare, a melee of civilian carnage in the foreground, with a sort of Mediaeval evacuation of Dunkirk going on in the distance. *The Adoration of the Magi*, relocated in a Flemish village with the snow falling, is one of the great evocations of winter, best enjoyed from a drawing-room fireside. In *Fool's Paradise* three men sleep off the effects of overindulgence, their bodies swelling out of their clothes with that comfortable bulbousness characteristic of Brueghel's peasant figures. *The Tower of Babel*, that vast architectural *folie de grandeur* stretching up into the clouds, is full of the sort of entrancing technical building detail that you could drive yourself mad with frustration attempting to recreate in Lego or Minibrix. And there was *The Fall of Icarus*: the young man who flew too close to the sun, melting his wings and crashing to earth, is depicted at the moment he hits the sea, pale legs flailing; but he is a minor detail in a much larger coastal landscape which encompasses a ploughman tilling his fields, a shepherd tending his flock, a fisherman, and various sailing vessels bobbing over the ocean.

Today the number of people who collect old master paintings is small by comparison with those who buy contemporary art. The problem is that some old masters are too far removed from us; they are mired in obscure biblical or classical iconography. But Brueghel is one of those old master painters to whom the modern spectator responds more easily. The world Brueghel illustrates is quirky and strange, but its essential humanity survives. It is no coincidence that paintings by Brueghel have inspired two fine twentieth-century poems: John Burnside's 'Pieter Brueghel: Winter Landscape with Skaters and Bird Trap,

1565' and W. H. Auden's meditation on *The Fall of Icarus*, 'Musée des Beaux Arts'. The people in Brueghel's paintings still communicate with us across the centuries. That communication is a key prerequisite in what draws collectors to the art of the past.

Creative Block

A state of inertia, the inability to create, from time to time afflicts all creative people. It is part of the romantic baggage of being an artist, and the public like to hear accounts of it partly because the suffering validates the work of art that does ultimately get produced. Some painters and writers make a career of creative block. 'I'm writing a novel,' says the anguished-looking literary man in the *Private Eye* cartoon. 'Neither am I,' says his companion. Real creative block is no joke, of course: it leads to a questioning of one's talent, and therefore of one's right to practise as an artist. Under these circumstances, for a painter, the blank canvas or the clean sheet of drawing paper becomes agony to contemplate.

'Idle the whole day,' records the British history painter Benjamin Haydon in May 1810. 'All this whole week has been passed in sheer inanity of mind, fiddle faddling imbecilly & insignificantly. I don't think at this moment I could draw a great toe.'

In August 1884 Degas succumbs to a summer lassitude. 'I stored up all my plans in a cupboard,' he tells his friend Henri Lerolle, 'and always carried the key on me. I have lost that key. In a word I am incapable of throwing off the state of coma into which I have fallen. I shall keep busy, as people say who do

nothing, and that is all.' In January 1949, Keith Vaughan, the modern British painter who kept a touching and revealing diary, anatomizes his

Demoralising bouts of self-doubt and helplessness. Conviction that my whole position is a fraud and far from being the result of any innate gifts is simply the result of perfecting a technique of dissimulation, acting out the person I would like to be. However, there is no choice now but to go on until I'm found out. The exhaustion of doing nothing. Fears of being unable to work again, that I'm living on some sort of false credit which will run out. Feelings of guilt at watching all the people who go off to work in the morning past my studio window, and envy at seeing them come back in the evening to their simple pleasures earned – *Ils sont dans le vrai* – but it doesn't make it any less painful.

Zola draws a sexual image when describing the plight of his painter-protagonist Claude Lantier in the novel *L'Oeuvre* (1886): doubt about his own ability descends upon him and makes him 'hate painting with the hatred of a betrayed lover who curses his false mistress though tortured by the knowledge that he loves her still'. This is the duplicitous capacity of art to let one down. For Haydon, on the other hand, sex may be the cure to artistic self-doubt. Or it would have been, had he been able to get any. On 19 June 1841 he records, 'Like Johnson's hypochondriasm, there I sit, sluggish, staring, idle, gaping, with not one Idea. Several times do these journals record this Condition of Brain. It goes off always after connection with Women. But now my wife is ill, & my fidelity keeps me correct. I think I suffer by becoming cloudy & thick.'

There are many tricks to avoid creative block. Some writers advocate never stopping work at the end of the day with a completed paragraph. Leave it midstream, so that there is always a theme to resume that gets you running in the morning. That's

more difficult for an artist or a sculptor, who overnight may have lost the light, his model, or his relish for what is often a more physical engagement with what he's making than the sedentary writer's. Sometimes the only cure is time. Or drink. But in the art buyer's imagination those phases of blockage add value to what ultimately emerges from the artist. No pain, no gain.

Degas

I am fascinated by Degas. To me, he embodies the French genius in art. He was probably the greatest draughtsman of the nineteenth century, and a supreme technical innovator with a sublime compositional eye. As a man he was obnoxious, cynical, witty, devious and reclusive. He never married: he was too self-absorbed. He made a plea early on for his own independence and for the freedom to paint without constantly thinking about what other artists were doing. 'It seems to me,' he wrote aged twenty-two,

that if one wants to be a serious artist today and create an original little niche for oneself, or at least ensure that one preserves the highest degree of innocence of character, one must constantly immerse oneself in solitude. There is too much tittle-tattle. It is as if paintings were made, like speculations on the stock markets, out of the friction among people eager for gain. All this trading sharpens your mind and falsifies your judgement.

The Goncourt brothers, those perceptive chroniclers of the Parisian cultural world, first met Degas in 1874 and were

intrigued by him. 'An original fellow, this Degas,' they reported in their diary, 'sickly, neurotic, and so ophthalmic that he is afraid of losing his sight; but for this very reason an eminently receptive creature and sensitive to the character of things.'

Degas casts a cynical (if ophthalmic) eye over the art world in Paris and regularly comes up with the telling phrase. In April 1890 he goes to the Japanese Exhibition at the Beaux-Arts: 'Alas! Alas! Taste everywhere!' he reports to his friend Bartholomé. When Degas wants to draw attention to the coexistence within his fellow artist Gustave Moreau of a visionary and a commercial streak, he describes him as 'a hermit who knows the train timetable'. He identifies 'a certain sort of success that is indistinguishable from panic'. He is funny in his opposition to the mindless painting of nature in the open air: 'Ah, those who work from nature!' he complains to André Gide in 1909. 'What impudent humbugs! The landscapists! When I meet one of them in the countryside, I want to fire away at him. Bang! Bang! There ought to be a police force for that purpose.' In a dig at Monet's obsession with painting out of doors, he says that whenever he thinks of Monet he turns up his coat collar.

But he could be a spoiled brute too. He had a private income, which immunized him from the travails of his poorer Impressionist colleagues, and he was less than sympathetic to their troubles. Almost manically anti-Semitic, he was guilty of some appalling outbursts in the course of the Dreyfus affair. At times it was as if Degas knew he was behaving badly but could not help himself. In a moment of frankness he explained to Evariste de Valernes the different forces that influenced his personality and behaviour: 'I was or I seemed to be hard with everyone through a sort of passion for brutality, which came from my uncertainty and my bad humour. I felt myself so badly

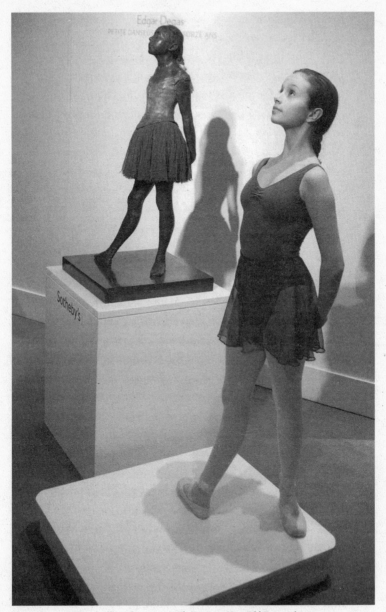

Degas's all-too-knowing *Little Fourteen-Year-Old Dancer*, bronze,
mixed media, 1880, set against the refreshing innocence of a real-life
English version (Sotheby's, February 2009)

made, so badly equipped, so weak, whereas it seemed to me that my calculations on art were so right.'

As I say, there is something quintessentially French about Degas: perhaps that's what struck the auction room at Christie's in 1889 when for the first time a French Impressionist painting came under the hammer in a London saleroom. It was Degas's *In a Café* and it made the English art-buying public very uneasy. They were upset by something so new and so foreign, and they hissed it. The masterpiece realized a paltry 180 guineas.

I recalled the incident in 2009 when Sotheby's in London sold a cast of the famous Degas bronze of *The Little Fourteen-Year-Old Dancer*, one of the greatest sculptures of the nineteenth century (it fetched $19 million). For pre-sale publicity a real live fourteen–year-old dancer was borrowed from the Royal Ballet School to pose next to Degas's 1880 version. It was a great success as a promotional exercise and the English dancer of 2009 was sweet. She stood in an identical position next to the sculpture for long tracts of time while the press photographed the two figures together. What was fascinating to compare was the subtle differences in their pose. Ostensibly, it was the same: right foot forward, at right angles to the left, hands behind the back, head held back so that the eyes' natural field of vision is down the nose. But when you compared them, you noticed a bit of a cynical slouch to the French 1880 original, the suggestion of the coquette, her head and eyes at such an angle as to communicate a look simultaneously proud, mercenary, slovenly and knowing. What a joyous contrast was evident in the English 2009 version. She was fresh-faced and well built, holding herself upright, graceful and healthy, bringing with her a faint whiff of the hockey field. Her gaze was pure, vibrant and clear-eyed; a young ballet dancer to make Betjeman weak at the knees, and a telling illustration of why Degas could never have been English.

Diarists *(Artists as)*

I am always interested in painters who can write. Some artists
of course remain resolutely mute, unable or unwilling to express
themselves verbally. That doesn't make them less good paint-
ers. One doesn't demand of writers that they should paint in
order to give the fullest account of themselves; if one did, only
a relatively small number would qualify to be taken seriously:
Strindberg, Victor Hugo, Edward Lear and Ruskin; perhaps also
Goethe and William Morris. But because I enjoy diaries I am
particularly drawn to painters who keep them. Their journals
can attain a revealing and sometimes touching articulacy. The
best of them – the sympathetic but ridiculous Benjamin Hay-
don, or the ever-observant Delacroix, or the mercilessly self-
analytical Keith Vaughan in the twentieth century – use their
diaries to discover verbal equivalents for visual experience, and
to give expression to the pleasure and frustration of painting.

Painting is an essentially solitary activity, which encourages
introspection, and many artists' diaries shed fascinating light
on how pictures actually get painted (or don't). If a writer's
intimate journal is a book about how hard it is to write a book,
then an artist's is a book about how hard it is to paint a picture.
There is plenty of torment and frustration, but there are also the
good days when – in Haydon's words – 'nectar flows through
the interstices of the brain'. The solitude demanded by painting
also breeds eccentricity. Artists' diaries are valuable first-hand
dispatches from the bohemian front line, intimate records of the
anarchic, obsessive, destructive and sometimes downright comic
ways in which creative people live. As early as 1555 Jacopo

Pontormo is interspersing an account of his painting of the frescoes in the church of San Lorenzo in Florence with neurotic notes about his own diet and digestion. Three hundred years later Gustave Courbet confides that whenever he finishes paintings for exhibition it brings on his haemorrhoids.

The essential quality of a diary is its immediacy, what Virginia Woolf calls 'the rapid haphazard gallop at which it swings along . . . the advantage of the method is that it sweeps up accidentally several stray matters which I should exclude if I hesitated, but which are the diamonds of the dustheap.' This is something that the best artist-diarists understand, that diaries should be written straight off without correction or polish, the literary equivalent of a spontaneous sketch. The first touch is the best, because it is the sincere one. When you run your eye over the handwritten page of a diary you should see minimal crossings-out. It should flow without revision, like a study without pentimenti.

Another important quality is a willingness to consider and embrace your own inadequacy and ridiculousness. Haydon, for instance, is the victim of a debilitating *folie de grandeur* as a painter, but as a diarist he expresses an endearing awareness of his own personal fallibility. The tension between the two lies at the heart of his appeal. It is impossible not to sympathize with a man who can write:

The mortalities, the filthy mortalities of life, are enough to make one's heart sick. *I* that should drink nothing but nectar, sleep only upon fleecy clouds, waft with angels by day, & kiss only such by night, *I* with a keen cutting relish for all the beauties of divine being, who would live and quaff the glories of godhead, have been obliged to have a nasty, filthy, stinking, putrid, ulcerous blister! Yah – to relieve a nasty, thick, puddled, slimy sore throat, I was sick at heart.

Andy Warhol, another revealing diarist, has similar moments of private candour about himself: 'It was a beautiful day,' he records on 15 March 1983. 'Walked on the street and a little kid, she was six or seven, with another kid, yelled, "Look at the guy with the wig," and I was really embarrassed, I blew my cool and it ruined my afternoon. So I was depressed.'

A diary often represents the therapeutic externalization of painful internal motions of the soul. Writing it down makes it better, more comprehensible, more copable with. And for some it is a means of imposing discipline on life: Ford Madox Brown meticulously records the number of hours he has put in at work in the studio each day. And one dull Sunday in Geneva, on 7 September 1856, Ruskin calculates 'the number of days which under perfect term of human life' he might have left to him to live: 11,795, he concludes, and solemnly reduces that figure by one on each successive diary entry. He keeps it up for nearly two years.

What does all this mean commercially? I am not saying that Delacroix is across the board a more expensive artist because he kept a journal. But I do think the value of a specific painting by him would be enhanced if revealing light were shed on its creation by an entry in that journal. The best diaries round out the personalities of the artists who keep them; they are guidebooks to that broader hinterland which enriches our appreciation and increases our valuation of art.

Female Artists

A year or two ago a census was undertaken of the 2,300 artists whose work was at that point on view at London's National Gallery. In the process it emerged how many of them were women. There were four. It seemed a bit of an imbalance.

Of course one can't change history. The National Gallery's focus is on painters working before 1900, and women artists were in a small and heroic minority up until that point. Certainly they were the victims of male prejudice. Albrecht Dürer wrote in his diary on 21 May 1521: 'Master Gerhart, the illuminator, has a daughter, 18 years of age, called Susanna, who illuminated a small panel of the Saviour, for which I gave her 1 gulden. It is remarkable that a woman is able to do such things.' Two and a half centuries later, attitudes haven't changed very much. Goethe, writing about Angelica Kauffmann in August 1787, observes wonderingly: 'She has an incredible and, for a woman, really immense talent.'

Women artists in history are less successful and numerous than women writers, but more prominent than women musicians. Before 1800 women who painted were largely seen as bringing a feminine meticulousness to their craft, bent over their canvases as if over embroidery. Rachel Ruysch (1664–1750) was a Dutch still-life painter, particularly adept at flowers; Mary Moser (1744–1819) painted similar subjects in London and was an early exhibitor at the Royal Academy. A brave few attempted to be taken seriously as figure painters. Artemisia Gentileschi (*c.* 1597–1651/3) is a pioneering heroine in this respect. Her father, Orazio, a Caravaggio follower, was court painter to Charles I, and she

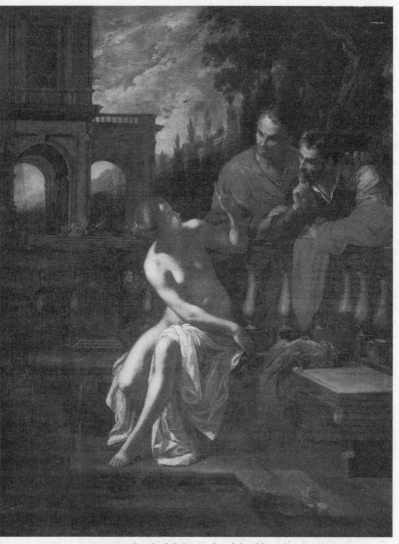

Artemisia Gentileschi's *Susannah and the Elders*, oil on canvas, 1610;
or 'Self-Portrait with Male Oppressors'

joined him in London in 1638–9. Her *Susannah and the Elders* is replete with a particularly piquant sort of feminist irony. Here is an accomplished figure painting executed by a woman operating in an exclusively male world, depicting the naked female form being relished by two male voyeurs. Rosalba Carriera (1675–1757) and Elisabeth Vigée-Lebrun (1755–1842) were representatives of that rare phenomenon, the successful lady portraitist. But it is noticeable that their sitters tended to be female: few men would risk the undermining of their masculinity implicit in having your likeness captured by a woman.

The second half of the nineteenth century saw women artists emerge in larger numbers. There were establishment painters who won high reputations in specific genres: Rosa Bonheur (horses), Henriette Ronner (cats), and the redoubtable Lady Butler (battle scenes). But many women gravitated to the avant-garde: having stormed the citadel of male dominance in art, you were also likely to assert your opposition to conventional academicism. Berthe Morisot, Marie Cassatt and Eva Gonzalès all made significant contributions to Impressionism, as did Rodin's pupil Camille Claudel to modern sculpture. In the following generation modernism was carried forward by many women, including Gwen John in England, Käthe Kollwitz, Paula Modersohn-Becker and Gabriele Münter in Germany, Suzanne Valadon and Marie Laurencin in France, and the Russian Expressionist Natalia Goncharova.

Over the past fifty years, there has been no shortage of art historians, critics and curators prepared to fight the feminist battle, to redress the injustices of history. How much impact does this have on the market? Does being a woman artist make a difference to how her work is perceived commercially today? Would Berthe Morisot – as the critic Brian Sewell has rather ungallantly suggested – be less expensive if she were called Bert

Morisot? I am not sure how to read the evidence of the market performance of, for instance, Gwen John. Over the past gen-eration she has emerged from the shadow of her more feted and flamboyant brother Augustus. The world-record price for a Gwen John (£169,000) now stands at appreciably more than that for Augustus (£139,000). In their lifetimes such a thing would have been incredible. Is it because she's a woman? Or is it because she's finally been recognized as the better painter?

Fictional Artists

Our perception of what an artist should be is reflected and conditioned by the depiction of artists in literature. In the same way that artists make good diarists, they also make rewarding characters for novelists. I emphasize 'characters'. The fictional works of art that these characters create are more problematic. The visual makes demands that the verbal cannot supply, and a fictional work of visual art is almost invariably unsatisfactory unless treated satirically, which takes us into different territory [see **S***poofs* below]. What follows is a dictionary within a dic-tionary, a selection of some memorable fictional painters:

Ralph **BARNBY** is a British modernist painter of the years between the wars who figures in Anthony Powell's A Dance to the Music of Time cycle of novels. Barnby is described as 'dark, thickset, and rather puffed under the eyes', with 'short, stubby hair, worn *en brosse*'. He is someone who 'knew how to look after his own interests, though in a balanced and leisurely

manner'. He paints in a French-influenced, semi-abstract style, aligning himself in the late 1920s with what Powell describes as the 'self-consciously disillusioned art of that epoch'. He is also a prolific portrait painter, largely of women. He is indefatigable in his pursuit of the opposite sex, ruthlessly exploiting his prey's susceptibility to the romantic allure of the artist. In the Second World War Barnby works in RAF camouflage ('disguising aerodromes as Tudor cottages'). He meets his death in a plane shot down in 1941.

Joseph **BRIDAU** is one of two brothers who are the central characters of Balzac's *La Rabouilleuse* (1842). Joseph is a Romantic painter of great nobility of spirit, but when it comes to the practicalities of life he's an idealistic ditherer: he is described as loving 'Byron's poetry, Géricault's painting, Rossini's music and Walter Scott's novels', pretty much a recipe for disaster. His brother, Philippe, on the other hand, is a man of action and an unscrupulous opportunist. Philippe, needless to say, is the one who ends up marrying into the aristocracy and making a fortune. Joseph is a talented painter, a fictional Delacroix, but constantly encounters money difficulties. His great mistake, in Balzac's words, is 'not to please the bourgeois fancy. That class, from which the money comes today, never unties its purse strings for disputed talents.'

Edgar Bosworth **DEACON**, who appears at regular intervals in the first volumes of Anthony Powell's A Dance to the Music of Time series, is a painter of an earlier tradition than Ralph Barnby. He was born in 1871, and painted grandiose canvases on classical themes. 'Bosworth' is an excellent touch: most English artists successful in the Edwardian era cultivated pretentious middle names. Indeed a real-life painter of highland cattle was the redoubtable Louis Bosworth Hurt (1856–1929).

For Deacon in the early years of the twentieth century there is
no shortage of faithful patrons, mostly newly rich men from
the Midlands, who buy his colossal works with titles like *The
Boyhood of Cyrus*, *Pupils of Socrates* and *By the Will of Diocletian*.
Deacon's concentration on the unclothed male form echoes the
fixation of Henry Scott Tuke (1858–1929), who exhibited end-
less Cornish fisherboys swimming naked across the walls of the
Royal Academy; but, unlike Tuke, it leads in Deacon's case to
an unfortunate incident in Battersea Park and an enforced exile
in Paris. After the Great War, Deacon's hour as a painter has
passed. He is reincarnated as a pacifist antique dealer, with a by-
line in erotic books and an embarrassing fondness for sandals.
He dies after a fall downstairs in a nightclub where he has been
celebrating his birthday. But decades later in 1971 his reputation
is revived in a centenary exhibition which proves a critical and
commercial success.

ELSTIR is the painter invented by Proust, a character
who recurs throughout *In Search of Lost Time.* His name is a
coalescence of Whistler and Helleu; he is an elegant and fash-
ionable figure with a wife who was once a beauty. As a painter
there are elements of Degas, Renoir and Monet in him, and also
a whiff of Sargent. One of his most admired works is entitled *Le
Port de Carquethuit*, which is imaginable as an Impressionistic
landscape. The Duc de Guermantes is disdainful of Elstir; he
says his painting is shallow. 'One doesn't need to be an expert to
look at that sort of thing. I know of course that they're merely
sketches, but still, I don't feel myself that he puts enough work
into them.' Similar criticism was levelled at both Sargent and
Whistler in their lifetimes.

Dick **HELDAR** is the very English hero of Rudyard
Kipling's *The Light That Failed*, published in 1891. To counter

the dangerously effeminate aspect of being an artist, Kipling makes Heldar just about as virile as an Englishman can be. He is a war artist in the Sudan, covering combat for the London illustrated papers. When he comes back to London, his initial success is as a painter of warfare. He dismisses the aesthetes who talk about art and the state of their souls as 'man-millinery'. But he's in love with Maisie, also an artist, who doesn't reciprocate. Maisie shares a studio with a red-haired girl who's an Impressionist, so we know we're in dangerous territory. Heldar shares rooms with another very masculine war correspondent. There's a fox terrier called Binkie to whom, one suspects, Heldar is even more devoted than to Maisie. A model called Bessie, who's no better than she should be, sits to Heldar, for the work that is going to be his masterpiece, an evocation of melancholia. He 'falls to work, whistling softly, and is swallowed up in the clean, clear joy of creation'. But Bessie, irked by the fact that no one in the Heldar ménage will sleep with her, takes revenge by scrubbing out Heldar's masterpiece. Heldar goes blind overnight so he doesn't register what she's done. He ends up back in the Sudan, eyelessly being mown down by 'Fuzzies'.

Gulley **J I M S O N** is the first-person narrator of Joyce Cary's *The Horse's Mouth* (1944). He's been through the mill: 'Impressionism, Post-Impressionism, Cubism, Rheumatism'. 'Art is my misfortune,' he bewails. 'Art and religion and drink, all of them ruin to a poor lad.' A string of troublesome women runs through his life, mostly models, some wives. He never has any money, and is constantly on the lookout for cash, legal or illegal. As a result he has been to jail at least twice. 'What is art? Just self-indulgence. You give way to it. It's a vice. Prison is too good for artists – they ought to be rolled down Primrose Hill in a barrel full of broken bottles once a week and twice on public

holidays, to teach them where they get off.' But actually art is the only answer: 'Talk is lies,' he reflects. 'The only satisfactory form of communication is a good picture.' He pinpoints the difference between himself and the occasional rich patrons he has dealings with: 'They make money for fun and need art to keep alive; I make art for fun and need money to keep alive.'

Otto **KLEISNER** is a central character in Wyndham Lewis's 1918 novel *Tarr*. Set in pre-First World War Paris, *Tarr* is a dispatch from the bohemian front line, a territory of absinthe, artistic experiment and self-conscious sexual emancipation. Kleisner, a German painter on the scrounge, is a truculent, abrasive troublemaker, and a charmlessly dogged chaser of women. A recent girlfriend has irked him by marrying his father, an event that is doubly galling as he's simultaneously dependent on his father's monthly cheques. Kleisner is not a successful artist, having sold only one painting in his career (for £4 10s). When sketching a subsequent girlfriend, a fellow German art student named Bertha, he tells her that she has arms like bananas, which is probably a reflection of the primitive quality of Kleisner's draughtsmanship. He provokes a duel with a Polish artist and inadvertently kills him; thereafter he takes his own life in a police cell.

Mendel **KUHLER**, the eponymous hero of Gilbert Cannan's 1916 novel *Mendel: A Story of Youth*, is barely a fictional character at all, so clearly is he based on the British painter Mark Gertler. Mendel is a supremely talented and visionary young artist tormented by art, women and his own Jewishness. London is his milieu, 'the roaring fiery furnace of London in which he was burning alive, while flames of madness shot up above him . . .' Women are a constant problem. He exclaims: 'An artist wants women as he wants his food, when he has time

for them . . . there is a thing called art which matters more to me than all the love and all the women and all the little girls in the world.' But he falls for another artist, a girl called Morrison (clearly based on Dora Carrington, herself infatuated with Lytton Strachey). He alternately yearns and lusts after her, rejects her and returns to her. Morrison is described as 'just an English girl with all the raw feeling bred out of her. She is true to type: impulsive without being sensual, kind without being affectionate.' Poor Carrington: no wonder she was a bit frosty to Cannan after the publication of his book. As was Gertler, although he had precipitated the novel's existence by recounting to Cannan his life story at self-indulgent length while staying with him in his country cottage. But Cannan suffered more than anyone. Soon after the book hit the bookshops he went mad and was thereafter confined to an asylum.

Claude **LANTIER**, the hero of Zola's *L'Oeuvre*, is a painter who moves in advanced Parisian literary and artistic circles. Zola's long friendship with Cézanne was already precarious when this book was published, and *L'Oeuvre* seems to have collapsed it, but it is hard to see why. Lantier clearly isn't Cézanne. From what he paints he sounds more like an unsuccessful Puvis de Chavannes, forever battling with large allegorical scenes that people don't understand. Lantier is beset by tragedy: he mistreats his admirably supportive wife; his child dies. He paints a picture of his dead child, which is 'skied' in the prestigious Salon Exhibition so that no one can see it. He is driven mad by his own passion for art, a quasi-sexual pursuit of the ultimate woman in the ultimately expressive picture, and ends up in effect taking his own life.

Adolf **NAUMANN** is the German Nazarene painter encountered by Dorothea Casaubon on her honeymoon in

Mark Gertler, the original of Mendel Kuhler (Mark Gertler, *Self-Portrait with Fishing Cap*, oil on canvas, 1909)

Rome in George Eliot's *Middlemarch* (1872). Dorothea is introduced to him by her troubled admirer the romantic Will Ladislaw, himself a bit of a painter. Naumann, an earnest 'renovator' of Christian art, is at work on a composition on the theme of 'Saints Drawing the Car of the Church'. A tour of his studio reveals 'Madonnas seated under inexplicable canopied thrones', and 'saints with architectural models in their hands, or knives accidentally wedged in their skulls'. Naumann parades himself in a dove-coloured blouse and a maroon velvet cap, and unexpectedly endears himself to the pompous and pedantic Dr Casaubon by asking him to sit for the head of St Thomas Aquinas. He sketches Dorothea as St Clara and, becoming rather too appreciative of her beauty, has to be rebuked by Ladislaw: 'Mrs Casaubon is not to be talked of as if she were a model.'

Charles **RYDER** is the narrator of Evelyn Waugh's *Brideshead Revisited* (1945). His Oxford friendship with the beautiful but doomed Sebastian Flyte, and his subsequent affair with Sebastian's sister Julia, are the meat of the book. But a background theme is Ryder's gradual emergence as an artist. While staying at Brideshead, he undertakes some mural decorations which sound very much as though they might have been painted by Rex Whistler, a real-life painter who shared with Ryder a similar social aspiration and fondness for lengthy stays in grand houses; later Ryder makes a successful living as a painter of exotic landscapes encountered on his travels. Like Waugh himself (who also had artistic pretensions), you suspect that Ryder is in later life more likely to be encountered at lunch in White's than in the Chelsea Arts Club.

Franz **STERNBALD** is the hero of *Franz Sternbald's Wanderings*, a novel written in 1798 by Ludwig Tieck, who was perhaps the most versatile and productive writer of the German

Romantic Movement. Sternbald, a pupil of Albrecht Dürer, wanders early-sixteenth-century Europe painting and drawing, and mooning after his beloved Marie, the quest for whom finally ends in Rome. 'You cannot believe how much I want to paint something which exposes totally the state of my soul,' he declares fervently. Such talk of the soul and its exposure reveals him for what he is: an artist with the preoccupations of the German Romantic Movement anachronistically at large two centuries earlier.

Charles **STRICKLAND** is the Gauguinesque painter in Somerset Maugham's *The Moon and Sixpence*, published in 1919. Recast as an Englishman, Strickland-Gauguin behaves pretty poisonously to those around him, giving up his career as a stockbroker in the City in order to run away to Paris and paint, abandoning his wife and children, and trampling on anyone, including his mistress, who gets in the way of his absolute determination to give his art its fullest expression. He's a coarse, bleak character: 'I don't want love,' he says. 'I haven't time for it. I am a man, and sometimes I want a woman. When I've satisfied my passion I'm ready for other things. I can't overcome my desire, but I hate it; it imprisons my spirit; I look forward to the time when I shall be free from all desire and can give myself without hindrance to my work.' Finally he escapes to the South Seas and ends up in Tahiti. The public don't understand him in his lifetime: they are shocked by the crudeness of his colour and the clumsiness of his drawing. But a generation after his death, Maugham tells us, Strickland is understood to have been one of the great architects of modernism alongside Van Gogh and Cézanne.

Géricault

Théodore Géricault was the ultimate Romantic artist. He lived dangerously. Had he been born 200 years later, he would have ridden a very powerful Harley-Davidson and probably taken drugs. As it was, he had a passion for fast horses, and a taste for extremes: for intense introspection, and for bursts of extravagant, unmeasured endeavour.

The masterpiece of his short life was the most extraordinary painting, *The Raft of the Medusa,* a canvas the size of a two-storey house showing the aftermath of a shipwreck. It was a piece of contemporary history, almost a news item: the *Medusa* was a government ship that had gone down two years earlier in 1816 off the coast of Africa. Her survivors are depicted spilled across a storm-tossed raft, an agitated mass of male figures, some naked, some clothed, some living, some dead, surging over the composition with an anguished and relentless energy. A strange, unearthly light is conjured from the darkening, dramatically clouded sky to play over the straining sinew, a bilious yellow-green lending a jaundiced, unhealthy pallor to the flesh.

Across the precarious platform the miserable victims lurch forward, creating a crescendo of upward movement. At the peak of this crescendo two figures wave frantically towards a tiny sail in the distance. Here is the hope of rescue: but have they been seen? Is the minuscule ship on the horizon coming towards them or going away? The groupings of the figures on the raft seem to mirror the swell and churning of the sea; they undulate with their conflicting passions, with hope, with fear, with exultation and despair.

Géricault spent more than a year painting the picture. He read the recently published account of one of the survivors, Henri de Sevigny, the ship's surgeon. He sought out the ship's carpenter, who had actually helped build the raft after the ship-wreck, and got him to make a model of it in miniature. Then he rented an especially large studio to make room for the canvas. He shaved his head and spent every waking hour working on the picture. Visitors were turned away. The artist lived like a monk. Once he'd finished, he had a mental collapse and went into the early-nineteenth-century equivalent of rehab. Although the immediate catalyst for Géricault's breakdown may have been the effort expended on the painting of the *Medusa*, its roots went deeper and further back.

Géricault was brought up in Paris, the only child of prosper-ous, well-to-do parents. When he was sixteen, his mother died; it was a crucial event in his life, one from which perhaps he never really recovered. The rest of his upbringing devolved into the hands of his weak-willed father, and his uncle and aunt (his mother's older brother and his much younger wife). Géricault wanted to be a painter. Against his family's better instincts, he turned his back on commerce and studied art in the studios of various eminent masters. He loved horses. From an early age he drew and painted them. He entered the studio of the equestrian painter Joseph Vernet. One of Géricault's horses, said an admir-ing critic, would eat six of Vernet's for breakfast.

There was clearly an obsessive strain to Géricault's character. He drove himself hard. He painted grand battle pieces featuring heroic Napoleonic cavalrymen. But there were contradictions in his militarism, as there were to many aspects of his life. Géri-cault was not a supporter of Napoleon. He was a Royalist. He paid a poor peasant to stand in for him to avoid conscription (or his father did). There is an obsession with death in his

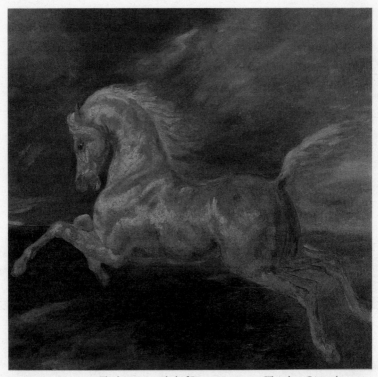

The horse as symbol of Romantic passion (Théodore Géricault,
A Horse Frightened by Lightning, oil on canvas, 1810–12)

painting, a taste for violence; a macabre streak, which attracts
him to suffering. He paints cadavers and dismembered limbs
that he purloins from Paris hospitals. And he is prey to self-
doubt: 'I am disorientated and confused,' he writes in 1816. 'I
try in vain to find support; nothing seems solid, everything
escapes me, deceives me. Our earthly hopes and desires are only
vain fancies, our successes mere mirages that we try to grasp. If
there is one thing certain in this world, it is our pains. Suffering
is real, pleasure only imaginary.'

Around 1814, a new subject enters his work: an extraordinar-

ily powerful series of erotic drawings, of satyrs coupling with nymphs, of naked men and women driven to frenzies of desire. Lovers wrestle rather than caress; gigantic limbs lock in muscular contortion. The artist is evidently in the grip of an overwhelming sexual passion.

More than 150 years later the truth about this affair emerged. A researcher investigating documents in the archives of the city of Rouen in 1973 came across evidence that a child fathered by Géricault had been born in 1818. The mother of this child was revealed as his uncle's wife, Alexandrine-Modeste Caruel. It was a Byronic, quasi-incestuous relationship and it clearly provoked volcanic passion and immense guilt. Was the *Medusa* an attempt at its exorcism?

From the brief personal accounts we have of him Géricault remains a sympathetic character. He was described in 1817 as being fairly tall and elegant, with an energetic, vivacious face that also showed great gentleness. Apparently he blushed at the slightest emotion. In an effort to get away from France and set his life straight, he travelled to England in 1821. Charles Cockerel met him in London and noted

his modesty so unusual and remarkable in a Frenchman, his deep feeling of pity, the pathétique . . . at the same time vigour, fire and animation of his works. Solemn at the same time, profound and melancholy, sensible singular life – like that of the savages we read of in America . . . lying torpid days and weeks then rising to violent exertions, riding tearing driving exposing himself to heat cold violence of all sorts.

Géricault's health declined. A series of falls from his horse exacerbated a tumour on his spine and he died in 1824, aged just thirty-two. His short life conforms perfectly to the Romantic template of immoderate passion and early death, a template to which the buying public remains enduringly susceptible. On

top of that his prices are enhanced by the rarity value of his limited output. But I sometimes wonder how he would have developed had he lived longer. Would he have kept up the pace and fervour of his art? One inspiring experience would have been North Africa and the Arab world [see Part II, **E**xoticism]. Supposing he had gone there with his friend and pupil Delacroix in 1832: it is a tantalizing thought.

Images (Famous)

There are a very small number of paintings and sculptures of such fame and familiarity that their images transcend their original functions as works of art. Immediately recognized all over the world, even by people who have no interest in art, they constitute a slim but extraordinarily powerful visual lexicon. It is a lexicon regularly raided by cartoonists, advertising agencies and marketing men in search of an image that will communicate a universally understood idea powered by the authority of art.

Leonardo's *Mona Lisa* would be number one on most people's list of a top ten of such images. The Gioconda's ambiguous smile makes her the most famous painting in the world. She is timeless and absolute, and her different interpretations by succeeding generations tell us less about her as a work of art than about the eras that generated the interpretations. On the rare occasions that the *Mona Lisa* has left the Louvre the painting has created a sensation. The first was in 1911 when it was stolen (and recovered in Italy two years later) [see Part IV, **T**heft]; then on two post-war occasions it was intentionally sent abroad, once

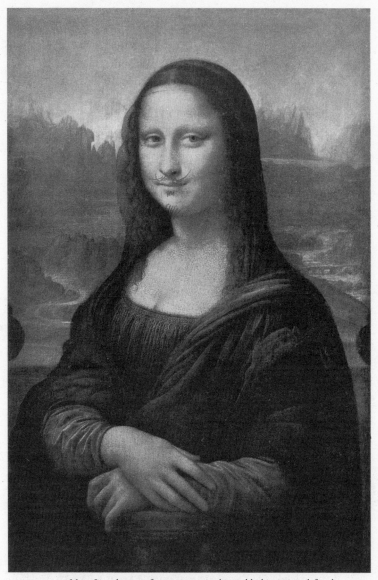

Mona Lisa: the most famous image in the world, this time as defaced by Marcel Duchamp (*L.H.O.O.Q.*, pencil and gouache, 1964)

on exhibition in the United States where it attracted more than two million visitors, and once in Tokyo where it precipitated a similar stampede of enthusiasts.

Few people would argue against Edvard Munch's *The Scream* as number two. The century and a bit since the work was executed has seen man's attention turn inwards and focus remorselessly on himself. It has been the era of shrinks, complexes and depression, of syndromes, anxieties and panic attacks, and *The Scream* is the image that launched a thousand therapists. It is the ultimate embodiment of fear, angst and alienation, and by extension it has come to symbolize a negative emotional reaction to just about anything. *The Scream* also goes beyond its function as a shorthand symbol that communicates a universal idea or emotion: like the *Mona Lisa*, it has attained a further dimension of fame simply as a familiar image, connoting very little except its own celebrity. Thus it has found its way on to mugs and dishcloths and T-shirts the world over, proclaiming a reassuringly familiar point of visual reference common to a large part of humanity.

Something else that *The Scream* has in common with the *Mona Lisa* is that it has also been stolen, in *The Scream*'s case twice in the past twenty years. After each theft, thankfully, the work was returned just about intact to the Norwegian museum from which it was removed. People feel strangely insecure when the original of one of the staple images of their culture goes so conspicuously missing. An indication of the worldwide popular concern at its disappearance is that a reward was offered for its return by a well-known brand of confectionary. It was an ingenious marketing stunt, of course, but two million M&Ms were to be paid out for information leading to its return. In the end the financial value of the sweets was donated to the Munch Museum in celebration of *The Scream*'s restoration to its rightful home.

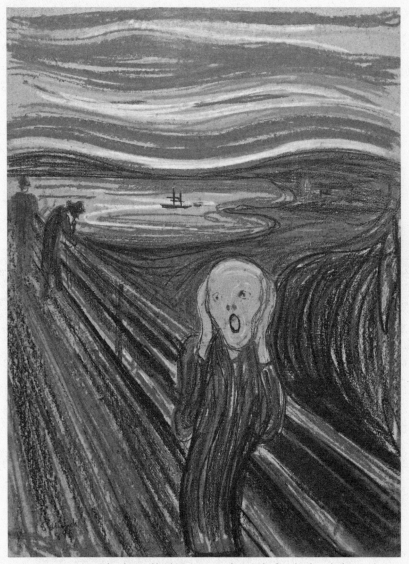

Edvard Munch's *The Scream*, pastel, 1893: the face that launched a
thousand therapists

Had this list of the world's most famous and familiar art-works been compiled in the mid nineteenth century, it would probably have included Rembrandt's *Night Watch*, *The Dresden Madonna* and *Madonna della Sedia*, both by Raphael, as well as the *Portrait of Beatrice Cenci*, then attributed to Guido Reni. None of these are candidates for today's top ten. The images that would fill the remaining eight places after the *Mona Lisa* and *The Scream* are sprinkled more liberally with modernism. Nonetheless I propose another Renaissance masterpiece, Michelangelo's *Creation of Man*, as number three. This famous detail from the Sistine Chapel shows the finger of God pointing to, but not quite touching, the pointing finger of man. It is a powerful and enduring image of creativity and divine inspiration. Numbers four and five could be Rodin's sculptures of *The Kiss* and *The Thinker*. They are of interchangeable significance, because they symbolize the human heart and the human head, the constant interplay between passion and intellect, between emotion and reason. It helps that they are nude. Sculptors have learned that human beings must shed their clothes to attain timelessness and universality.

The next two images in the top ten (six and seven) are widely recognized symbols of human beauty. Michelangelo's *David* (another nude) is the sculpture that beyond any other expresses the classical ideal of male bodily perfection. And Botticelli's *Birth of Venus* is perhaps the equivalent icon of female beauty. She is not necessarily the most beautiful woman ever painted in art, but she is the most familiar beautiful woman. After that we are in more contentious territory. At number eight I suggest Van Gogh's *Sunflowers*, more because of the painting's enormous art-historical familiarity than as a symbol of a universal idea, unless the idea is the irony of the optimism of the sunflower being painted by the world's most tortured artist. The ninth image

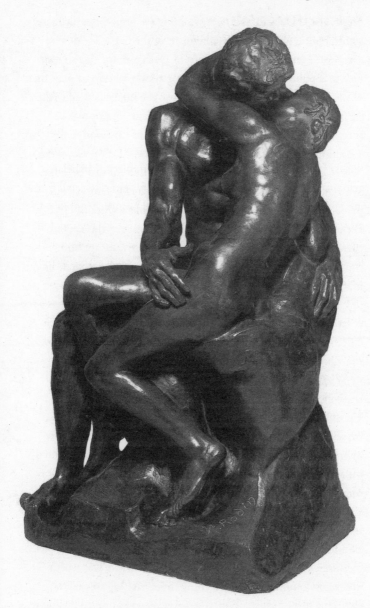

Image that does duty as international shorthand for Love (Auguste
Rodin, *The Kiss*, bronze, 1886)

on my list is Delacroix's *Liberty Leading the People*, the ultimate symbol of revolution and the heroism of the battle for democracy. You don't need to have heard of Delacroix for this to resonate as a political rallying cry, a pictorial exhortation to man the barricades in support of whatever cause the image is deployed.

If we are talking about today's great images of popular culture, then room must be found at the end of this top ten for something by Andy Warhol. Perhaps it should be the *Campbell's Soup Can*, although it's a bit of a cheat in this context because Warhol took an everyday image that was already famous and made it even more famous by presenting it as a work of art. Perhaps his portrait of Marilyn would be a better choice, but then again the same applies. And, a trifle incestuously from the point of view of this list, Warhol has also appropriated the image of *The Scream* for the purposes of his own art. This act of homage to Munch by the leading exponent of Pop Art has a certain logic. Warhol's search for resonating images of popular culture to play with would have drawn him naturally to any of the works on this list.

What would it be like actually to sell the original of one of these globally recognized images? What would it be worth? Up until recently, one could only fantasize. And then I found myself being asked to enact the dream: in 2012 Sotheby's were approached to sell Edvard Munch's *The Scream*. Munch painted four versions. Three of them are in museums; ours was the only one in private hands.

My colleagues and I met to discuss what it might make. We had very little to go on. The existing world-record price at auction for a work by the artist was the $37 million paid for an oil painting, *The Vampire*, in 2008. Surely *The Scream* was worth appreciably more? There is nothing more exciting to experts than this sort of speculation. The consensus shot up to thrilling

heights: might it not even be worth $100 million? But it's not an oil painting, warned a colleague; it's only a pastel. Oh. Did that mean it was only worth $30 million or $40 million? Yes, but the other three versions of *The Scream* are all pastels, said someone else. It's how Munch wanted them to be: raw and elemental and immediate. He deliberately executed them on rough board surfaces to emphasize the grainy expressiveness of the strokes of pastel. This was exciting talk. The consensus shot up again. It's got to be worth $70 or $80 million, surely? This is one of the most famous images in the world, we reminded ourselves. Think of the media coverage. Think of the momentum that will build as the sale date approaches. Acquiring *The Scream* really would be the ultimate trophy. One voice counselled caution. 'I think you're too high,' he said lugubriously. 'What if it doesn't sell? It would be a disaster. Failing to get it to its reserve and the consequent negative publicity would be a sacking offence.'

The sale date was fixed for 2 May 2012, in New York. The announcement that *The Scream* was to be sold created a worldwide media sensation, bigger than that generated by any other single object in Sotheby's history. When the work was put on pre-sale exhibition in London for five days, 7,000 people came to see it. It was shown as a single work in its own gallery, into which viewers trooped, having been carefully security-checked. Apart from *The Scream* itself, which was blasted with light, the gallery was darkened, creating an effect somewhere between a chapel and a nightclub (a bit like Sotheby's itself, I reflected).

Despite the storm of publicity, on the eve of the auction we still had no idea who was going to buy it or what it was going to make. Would the buyer be someone seduced by the media hype, a rich person acquiring the global fame and familiarity of the image as a symbol of their own status, buying it for no deeper reason than as an assertion of the fact that they could afford it?

Or would they be someone who cut through the media hype and focused simply on the painting's art-historical significance, its importance as a document in the evolution of man's perception of himself? Or would no one come forward to bid enough to acquire it? Would it be bought in, having failed to reach its reserve price? The lugubrious voice in my head said, 'I told you so.'

In the end it sold for $119,900,000, the highest price ever paid for a work of art at auction. Five different people from far-flung ends of the globe competed for it. The successful bidder remained, as usual in these cases, resolutely anonymous. It had been a momentous sale and a highly educative experience. But one thing bothered me. Such had been the worldwide interest in *The Scream* in the weeks before the sale that bookmakers had offered odds on what its price would be. You could put money on it realizing any figure, from $30 million to $200 million, a reflection of the uncertainty even among the art world's finest specialists; but the shortest odds offered in the betting shops were at $125 million. They nearly got it spot-on. Somewhere in the employment of the bookmakers lurks an expert better informed than any of us.

-I*sms*

Art history is now defined by -isms. These useful terms emerged as describers of movements in contemporary art from the nineteenth century onwards. Some were clearly later constructs, which helped to make sense of history and impose a retrospec-

tive sequence of development on it. I am sure that Cézanne and Van Gogh and Gauguin didn't go round introducing themselves as Post-Impressionists, but that was how Roger Fry announced them later to a dubious British public. But I think Seurat may have called himself a Neo-Impressionist. Cubists called themselves Cubists from pretty early on, as did Fauvists, apparently flattered to find themselves described by their first critics as wild beasts. The Surrealists actually invented their -ism for themselves.

So -isms are created by art critics, art historians and, once they had got the hang of it, early in the twentieth century, increasingly by artists on their own. Dealers, too, invent -isms as a means of legitimizing new work they are selling. The first -ism, I suppose, must have been Classicism. The word first appears in English in 1837 in the sense of 'adherence to classical style'. Then came Romanticism, defined as the distinctive qualities or spirit of the Romantic school in art or literature, which appeared soon after in 1844. Naturalism is first used in 1850, and Realism in 1856. But all these -isms had been used earlier in France. The first exclusively British -ism is probably Pre-Raphaelitism (1848). By the time the British came up with another one – Vorticism (1914) – a new century had dawned with its multiplicity of -isms under the overarching umbrella of modernism.

What a capacious umbrella it is, sheltering beneath it Divisionism, Expressionism, Futurism, Constructivism, Dadaism, Actionism, Imagism, Formalism, Gesturalism, Minimalism, Photo-Realism, Situationism, Tachism and a hundred others, and a hundred more under the convenient younger umbrella of Post-Modernism. You can sympathize with the ageing Gulley Jimson [see **F***ictional Artists* above] in his wearied description of his own artistic trajectory: 'Impressionism, Post-Impressionism, Cubism, Rheumatism'.

In order to be understood by the public, artists need to be

fitted into -isms. The setting of the artist in his -ism is another aspect of the branding process [see **B**randing above]. And in the same way that buyers are reassured by a typical work by an individual artist, so a work that can be marketed as typical of an -ism is also sought after.

Jail (Artists In)

Artists are individuals in combat with society, challenging its prejudices and undermining its certainties [see **B**ohemianism above]. As a result they sometimes find themselves in jail. There are three main reasons why artists are imprisoned: debt, political subversion and obscenity.

The heroically unsuccessful British history painter Benjamin Haydon is the classic example of the first. His inability to manage his own money was catastrophic. He was constantly borrowing from friends and fathering expense-inducing children with his long-suffering wife, Mary. His plight was made worse by a chronic *folie de grandeur* which convinced him that he was probably the greatest painter since Michelangelo and it was only a matter of time before his vast historical canvases were recognized for the works of genius that they were and money poured into his pockets. A typical diary entry in March 1822:

On this day I write this without a single shilling in the world, with a large Picture before me not half done, yet with a soul aspiring, ardent, confident, trusting in God for protection & support. Amen, with all my being.

I shall read this again with delight – and others will read it with wonder.

A year later, on 22 May 1823, he is writing from jail, at this point in English history still the punishment for those who could not pay their debts:

Well, I am in prison! So was Bacon, Rawleigh & Cervantes! Vanity, vanity, here's a consolation. I started from sleep repeatedly during the night, from the songs & roaring of the other Prisoners. All I hope in God is that dearest Mary's strength will support her. At this moment mayst thou be at home, smiling at thy lovely baby, in peace & quiet. Ah Mary, there is a balm in thy lovely face that soothes one's soul.

Poor Mary. She had to put up with her husband's detainments in prison as his creditors periodically lost patience and fore-closed on him. Then some other kind benefactor would bail him out and the whole process would start again. The contem-porary art world never came round to Haydon's own assessment of himself as a painter, and he took his life in 1846.

Gustave Courbet was an instinctive rebel whose style of vigorous Naturalism, applied to subjects drawn from everyday contemporary life, shocked mid-nineteenth-century Paris and opened the way for the Impressionist revolution. Bohemian, vain, rancorous, but hugely energetic, his politics were resolutely left wing and after the French defeat by the Prussians in 1871 he became an enthusiastic Communard. On 30 April 1871 he writes to his family:

Here I am thanks to the people of Paris, up to my neck in politics . . . Paris is a true paradise! No police, no nonsense, no exaction of any kind, no arguments! Everything in Paris rolls along like clockwork. If only it could stay like this for ever. In short, it is a beautiful dream. All

the government bodies are organised federally and run themselves. And it is I who presented the model for it with artists of all kinds.

In our free time we fight the swine at Versailles. We take turns going there. They could fight as they are doing for ten years without being able to enter our territory and when we let them enter, it will be their tomb.

Unfortunately the swine at Versailles got back into Paris within a few weeks, and almost immediately Courbet found himself under arrest for his part in the destruction of the Vendôme Column.

'I was arrested last night at 11 pm,' he writes to the critic Castagnary on 8 June 1871. 'They took me to the Ministry of Foreign Affairs, and then, at midnight, they brought me to the police station. I have slept in a corridor packed with prisoners, and now I am in a cell, no. 24. I think I shall be taken to Versailles soon.' He adds mournfully: 'My situation is not bright. This is where the heart leads.'

Where the heart led was to the payment of a large fine and exile from Paris to Switzerland, where Courbet died in 1877.

The Austrian Egon Schiele was held in prison in 1912 on a charge of obscenity. One of the greatest draughtsmen of modern times, he led a short, wild, disturbed life. It is tempting to interpret his art in terms of the Freudian psychology simultaneously emerging in Vienna. There is a marvellous fluency to his line, but it is tense with neurosis. Some of his drawings are highly erotic, featuring naked female models (and occasionally himself) in states of sexual arousal [see Part II, **E**roticism]. The trouble started in 1911 when Schiele moved out of Vienna and took up residence in the small provincial town of Neulengbach. Here he began using local children as his models. One of them – a girl aged thirteen – ran away from home and sought refuge

Egon Schiele's depiction of himself as St Sebastian, the tortured
martyr, pencil, 1914

in Schiele's house. Although she returned unharmed to her fam-
ily several days later, the authorities arrested Schiele on charges
of kidnapping, statutory rape and public immorality. The first
two were dropped, but Schiele was convicted of the third on the
grounds that minors had seen indecent works in his studio. One
hundred and twenty-five drawings were taken away, deemed
obscene. He kept a brief, resentful diary when in jail, culminat-
ing in the following final entry on 8 May 1912:

For 24 days I was under arrest! Twenty-four days or five hundred and
seventy-six hours! An eternity!

The investigation ran its wretched course. But I have miserably
borne unspeakable things. I am terribly punished without punishment.

At the hearing one of the confiscated drawings, the one that had
hung in my bedroom, was solemnly burned over a candle flame by a

judge in his robes! Auto-da-fé! Inquisition! Middle Ages! Castration! Hypocrisy! Go then to the museums and cut up the greatest works of art into little pieces. He who denies sex is a filthy person who smears in the lowest way his own parents who have begotten him.

How anyone who has not suffered as I, will have to feel ashamed before me from now on!

It is an exaggeration to suggest that their jail sentences make these artists more desirable to the market today. But imprisonment has burnished their images as painters with an aura of daring and the heroism of persecution. In Haydon's case this is not enough to cause people to reappraise his doggedly pedestrian painting; but Courbet is certainly a hero of the political left, even if the political left are not big art collectors. Schiele, as a sexual emancipator, probably strikes most of a chord in today's buyers. His stay in jail, rather like Van Gogh's in the St-Rémy Asylum, does him no harm in the current market.

Madness

'We owe the invention of the arts to deranged imaginations,' wrote the French essayist Saint-Évremond in the seventeenth century. 'The Caprice of Painters, Poets and Musicians is only a name moderated in civility to express their Madness.' Creativity is never far removed from insanity; and the loneliness of artistic activity, its tendency to turn you in upon yourself, often produces depression, oddity and alienation. When introduced to the work of Edvard Munch on a state visit to Norway, a baffled

member of the British Royal family is said to have asked, 'Did the fellow paint like this because he was mad, or did he go mad because he painted like this?' It is a question that goes to the heart of the relationship between art and mental disturbance.

Besides Munch, a large number of painters have suffered bouts of insanity. Géricault, Landseer, Richard Dadd, Van Gogh, Kirchner and Jackson Pollock all had periods of confinement within asylums or psychiatric hospitals. What is the effect of madness on what painters paint? Out of Géricault's brush with madness in 1819, and what seems like an attempt at psychiatric treatment on him by the pioneer alienists Jean Esquirol and Étienne Georget, there evolved a magnificent series of portraits that he did of the madmen under Georget's care. Richard Dadd murdered his father under the delusion that he was the devil, and spent long periods of his life in Bethlem and Broadmoor hospitals. It is tempting to interpret the extraordinarily intricate, almost obsessional detail of his fairy paintings as the product of a disordered but nonetheless engaging imagination. Research conducted into the medical histories of the New York school of Abstract Expressionists came up with some interesting data. The artists studied were Bradley Walter Tomlin, Adolph Gottlieb, Mark Rothko, Arshile Gorky, Clyfford Still, Willem de Kooning, Barnet Newman, James Brooks, David Smith, Franz Kline, William Baziotes, Jackson Pollock, Philip Guston, Ad Reinhardt and Robert Motherwell. Nearly one half of these, it transpired, suffered from depressive or manic-depressive illness. Assuming that some consulted professional help, and that this medical intervention had some effect on them, and in view of the close relation between mental disturbance and creativity, it makes you wonder at what point the production of a work of art becomes a collaboration between artist and shrink.

Haydon describes a phase of depression with graphic insight

on 6 October 1824: 'The melancholy demon has grappled my heart, & crushed its beatings, its turbulent beatings, in his black, bony, clammy, clenching fingers. I stop till an opening of reason dawns again on my blurred head!' And he is equally graphic in his description of the process of artistic inspiration in a diary entry of 1830: 'What an extraordinary, invisible sort of stirring are the impulses of genius. You first feel uneasy, you can't tell why. You look at your Picture & think it will not do. You walk for air – your Picture haunts you. You can't sleep: up you get in a fever, when all of a sudden a great flash comes inside your head, as if a powder magazine had exploded without any noise. Then come ideas by millions – the difficulty is to choose.' The description is very close to that given by modern bipolar sufferers of their experience of an 'up'.

Or here is Vincent Van Gogh, writing to his brother, Theo, in September 1888 from Arles, showing a corroborative awareness that for every episode of creative 'up' there lies in wait a melancholy 'down' to balance it: 'I have a terrible clarity of mind at times, when nature is so lovely these days, and then I'm no longer aware of myself and the painting comes to me as if in a dream. I am indeed somewhat fearful that that will have its reaction in melancholy when the bad season comes, but I'll try to get away from it by studying this question of drawing figures from memory.'

Some seek remedies through professional help. Yet there is an underlying fear in many artists that curing their madness will damage them as painters or sculptors. Does psychiatric treatment have to result in happier but blander and less imaginative artists? A doctor told Edvard Munch that psychiatry could rid him of many of his sufferings. He replied, 'They are part of me and my art. They are indistinguishable from me, and it would destroy my art. I want to keep those sufferings.' In fact, he went

further: 'For as long as I can remember I have suffered from a deep feeling of anxiety which I have tried to express in my art. Without this anxiety and illness I would have been like a ship without a rudder.' Nonetheless he submitted to treatment.

It is arguable that the art Munch produced after 1909 (when he put himself in a psychiatrist's hands in Copenhagen) is of an inferior power to that of his earlier years. Many of his works from that later period are more innocuous and decorative, far removed from the angst of the 1890s. Indeed it caused one American collector to assume that they were the work of two different painters. He didn't like the earlier more fraught works by the artist called Munch. But he collected the later, gentler, more colourful paintings by an artist he knew as Munch (to rhyme with 'lunch').

On the other hand, Van Gogh said, 'If I could have worked without this accursed disease – what things I might have done . . .' But he may have been wrong. His months in the asylum at Arles had little or no calming effect on his agony as a painter. Perhaps it was better for him as an artist, if not as a human being, that they did not.

There is an alternative view of the relationship between art and madness. Rather than being a symptom or a cause of madness, could art be the means by which artists heal themselves of their affliction? 'Sometimes I wonder how all those who do not write, compose or paint can manage to escape the madness, the melancholia, the panic fear which is inherent in the human condition,' wrote Graham Greene. 'Man is the only animal that laughs and weeps,' says Hazlitt, 'for he is the only animal that is struck by the difference between what things are and what they ought to be.' For some, art can be the means of bridging that gap.

The artist's madness is part of his myth, part of the romance

and mystery of creativity. To have grappled with madness and produced art out of the struggle enhances the brand of the artist. Writers of catalogue notes in auction houses are very sensitive to information that may damage the saleability of the work of art that they are describing. Thus mention of physical diseases is discouraged. If an artist is revealed as having been ill or old when he painted something, that work is assumed by the market to be compromised, not as good as if the painter had been fully fit. The interesting thing is that mental afflictions, by contrast, are not necessarily subject to the same reservations. That a painting is produced in the throes of psychological rather than physical torment is judged positively: a brainstorm might be conducive to a work of genius.

Middlebrow Artists

A regrettable snobbery exists in the art world. Certain artists are looked down upon because they are popular, or middlebrow. They are not considered serious because people like them too much, and their appeal is dismissed as too easy. But while none of them would be in danger of a retrospective at Tate Modern or the New York Museum of Modern Art, all of them have made high prices on the international art market and given much pleasure to their admirers. Here is a dictionary of a representative group:

Bernard **BUFFET** (1928–99) Made an early impact as one of the key figures of post-war Misérabilisme, a style of spiky

shapes and low-key colouring. In 1950 he was even nominated in the French press as one of the two most important artists in the world, the other being Picasso. But he never moved on. His painting lapsed into stereotype. Picasso detested him and constantly disparaged him, as you do when you glimpse in someone else the failure that you might have become yourself. Heavily supported by Japanese buying, Buffet reached a price apogee around 1990 when a work sold for $800,000. Although his prices dipped from this peak, he has never lost his popularity. But like one of his own sad clowns – a favourite motif – the despair finally got to him and he committed suicide in 1999.

Jean-Pierre **CASSIGNEUL** (b. 1935) A French painter of pretty women, very much in the style of Kees Van Dongen. They don't do much, these women, except look elegant, but they are none the worse for that. His prices have gone as high as $350,000.

Bernard **CATHELIN** (1919–2004) Undemanding and restful, Cathelin did a lot of flowers, and faintly minimalist landscapes and interiors evocative of a fashionable Buddhism. A typical title is *Jardin Zen*.

Beryl **COOK** (1926–2008) An English painter who stands in the same relation to highbrow art as the popular poet Pam Ayres does to W. H. Auden. Cook painted fat women who look like something Stanley Spencer might have produced if he had been set to design a seaside postcard.

Montague **DAWSON** (1890–1973) Dawson's skill is as a painter of sleek yachts on green, foam-flecked seas. It is perfectly acceptable to own one or two if you are a keen sailor, but less

so a roomful as a statement of your standing as an art collector. The equivalent painter of railways, if you are keen on trains, is Terence Cuneo.

Jean-Gabriel **DOMERGUE** (1889–1962) Another French painter of pretty women. His roots were in the Belle Époque, and there essentially he stayed, never moving on to anything more challenging than the depiction of female elegance characterized by an oddly docile coquettishness.

Marcel **DYF** (1899–1985) Born Marcel Dreyfus, Dyf is a French painter of flowers, country landscapes and Parisian girls in various states of undress. His works are unthreatening and good to look at, the visual equivalent of a work of popular romantic fiction.

Dietz **EDZARD** (1893–1963) Started off promisingly and painted a self-portrait in 1913 that is respectably Expressionist and could be by Otto Dix on a less good day. But later in life Edzard developed into a sort of German Marcel Dyf, all pretty girls and easy-viewing experience.

William Russell **FLINT** (1880–1969) Technically wizard at depicting nubile gypsy girls spilling out of rumpled frocks, Flint painted like Augustus John commissioned by *Playboy* magazine. Flint was a very skilful artist with a somewhat repetitive repertoire. His work has fetched over £300,000 at auction, which is appreciably more than anything by Augustus John.

Eugène **GALIEN-LALOUE** (1854–1941) Painted endlessly repetitive views of Parisian street scenes with great facility, usually in gouache. His success is the apotheosis of the tourist postcard. He had a marginally inferior imitator in Édouard Cortès.

One of William Russell Flint's nubile gypsy girls (*Nicollet*, oil on canvas, undated)

Edward **SEAGO** (1910–74) Resolutely middlebrow painter in a studied Impressionistic style of landscapes evocative of an essential Englishness, even when they depict France or Italy. Popular in the shires.

Dorothea **SHARP** (1874–1955) Another who hit on a subject matter with a wide popular appeal – children playing on sunlit beaches – and made it her brand.

Jack **VETTRIANO** (b. 1951) Vettriano's subject matter mostly consists of rather stylish renditions of film noir-ish scenes involving ladies in black underwear, gentlemen in stylish braces,

Jack Vettriano's most famous painting, *The Singing Butler*, oil on canvas, 1992

and butlers with umbrellas. Unrepresented in major museum collections, Vettriano has nonetheless gone from strength to strength, poster reproductions of his work selling in their hundreds of thousands. Auction houses initially took a rather disdainful view of him. Then Sotheby's allowed one in for sale with a reluctant estimate of £150,000–£200,000 (a reflection of his gallery prices) and it made £744,000. Since then his work comes up at Sotheby's and Christie's quite regularly.

Thomas **KINKADE** (1958–2012) I have left the most extreme example till last. Kinkade's work is so kitsch and saccharine that the major auction houses do not sink to handling it. However, when Kinkade died in 2012, aged fifty-four, he

was probably the most collected artist in the United States. His trademark themes are impossibly cosy cottages, mountains turning purple in the setting sun, and trees bending under the weight of lurid pink blossom. It is a never-never land, a kind of pictorial air freshener for the lounges of America. God was his art agent, he claimed: his mission was to inspire and reassure people by reminding them of the beauty of God's creation.

His work was disseminated through a network of franchised outlets in shopping malls which sold limited-edition repro-ductions of his originals in various grades of price according to whether the master had actually applied paint to them or whether they had merely been touched up by 'master highlight-ers' in the Kinkade studio. At its peak in 2000 his business had sales of $250 million.

Kinkade himself, despite his Christian affiliation, sometimes took the touching-up process too far. He was alleged to have fondled a woman's breasts at a signing session in Indiana. Strong drink may have been to blame: later that evening he lashed out at an ex-colleague's wife who tried to help him when he fell from a bar stool. There was worse, to quote from his obituary in the *Daily Telegraph*:

On another occasion he had disrupted a Las Vegas performance by the illusionists Siegfried and Roy by repeatedly yelling the word 'codpiece' from his seat. He had also been seen urinating in public – in the lift of a Las Vegas hotel and on a model of Winnie the Pooh in Disneyland. 'This one's for you, Walt,' Kinkade was reported to have said.

Curiously Kinkade did not deny the allegations. Alluding to his practice of urinating out of doors, he explained he had grown up 'in the country' where it was commonplace. When asked about the Las Vegas lift incident, he admitted that 'there may have been some ritual territory marking going on'.

Models and Muses

The artist's model is one of art's clichés. There she sits for hours on end, totally naked, being intimately and minutely studied by a man with a pencil or a paintbrush in his hand. Or a group of men, if it's a life class. As a situation, it's sexually highly charged.

Some artists play it down. Matisse, for instance, wore a long white coat while painting his nude models, suggestive of a doctor performing a clinical procedure in which sexual attraction played no part. 'Look,' the white coat says, 'the fleshy shapes I'm painting are no more than shapes; it could just as well be a landscape where the breasts and buttocks are the hills and the undulations of the hips are sweeping coastlines or bending rivers.'

But for every Matisse there's a Van Dongen shamelessly trying to have it both ways by declaring 'a woman's body is the most beautiful landscape', or a Picasso behaving like a priapic satyr with his models. Or even a Delacroix: here he is with his model Emilia on 24 January 1824: 'Today I began working on my picture again [*The Massacre at Scio*]. I drew and painted in the head and breast, etc. of the dead woman in the foreground. I again had *la mia chiavatura dinanzi colla mia carina Emilia* [my key in dear Emilia's keyhole]. It in no way damped my enthusiasm. You have to be young for this kind of life.' Actually, age was no barrier to carrying on with your model. In September 1856 Ford Madox Brown records with a mixture of disapproval and awe: 'Mulready at seventy has seduced a young model who sits for the head and has a child by her, or rather she by him, & old Pickersgill in his own house is found on the rug *en flagrant délit* by the maid who fell over him with the coal scuttle.'

As an artist's model, there is a progression ahead of you if you choose to follow it. The first step is to become the favourite model of a painter; the second step is the challenging one upwards to becoming his muse. A muse is very special indeed. 'All she had to do was look at a man, place her hand on his arm, and immediately he found the proper expression for something over which he had been brooding helplessly, unable to give it artistic form for some time. It was she who released the thoughts of these bards struggling to create in pain and suffering.' That is the verdict of the writer Frank Servaes on Dagny Juel, the Norwegian temptress who variously tormented and inspired Edvard Munch and a bevy of other artists and poets in Berlin in the early 1890s.

Essentially a muse is a person who becomes an artist's inspiration. Muses are generally female, and tend to be recruited by artists from their models, girlfriends or wives. Do all models, girlfriends and wives become muses? Certainly not. As an artist, do you always get to sleep with your muse? Not necessarily: for some artists, whose creativity is fuelled by unsatisfied yearning, a muse can become a muse precisely because she doesn't succumb to his advances. Mental instability, artistic creation and sexual energy are closely related, which makes painters colourful lovers; it also means that the pictures they paint are very often influenced by their passionate relationships. It seems that the artistically productive elements of a relationship with a muse can be divided into the following four categories:

1. The physical beauty of a particular model

2. The stimulus of a love affair

3. The celebration of physical love

4. The exorcism of an acute romantic unhappiness

There is no doubt that where an artist–muse relationship has entered the legend of art history, works by the artist that feature his muse have a premium of interest that is reflected in financial value. If a muse also meets with an untimely and/or violent death – as they often did – then so much the better. Here are a few classic artist–muse relationships:

Rembrandt and Hendrickje Stoffles

In 1649, in one of those awkward domestic upheavals that artists are prone to, the widower Rembrandt got rid of his existing housekeeper, Geertje Dircx, and replaced her with a younger maidservant, Hendrickje Stoffles, who soon found herself sharing his bed. Physically she suited and stimulated him. He used her as his model, clothed and naked, and she featured in a number of his best-known pictures, notably the lovely *Bathsheba at Her Bath* (1654). By using people familiar to him domestically for his models for grand historical and biblical painting, Rembrandt achieved an unprecedented degree of realism. His studies of Hendrickje are definitely naked rather than nude, intimate rather than idealized, particularly in a series of etchings that he did of her washing and dressing. But the idyll came to an end when she died of bubonic plague in 1663.

Rossetti and Lizzie Siddal; and Jane Morris

Rossetti had a penchant for picking up beautiful shop girls – 'stunners' – for use as models. Lizzie Siddal was one; she died young and in an excess of grief Rossetti buried his poems with her. Art is long and life is short, so Rossetti thought better of it

Jane Morris, object of Rossetti's yearning (Dante Gabriel Rossetti, *Mrs William Morris*, chalk, 1865)

and dug them up a few years later. If only he'd saved them on a memory stick. Then he took up with Jane, wife of his friend William Morris. There was a lot of yearning, but not a lot of action. 'From the available evidence, neither Jane nor Gabriel seems to have been highly sexed, and probably neither regarded copulation as a necessary symbol of overpowering emotion,'

writes Jan Marsh. But the relationship was productive in its formulation of a type of Pre-Raphaelite beauty featuring exaggeratedly sensual lips and big, curly, cascading hair.

Tissot and Mrs Newton

James Tissot was a fashionable and successful French painter who came to London in the wake of the Franco-Prussian War and spent the decade of the 1870s painting scenes from fashionable English life: ballrooms, yacht decks, drawing rooms, punts. He always used the same mysterious model, like a film director with a favourite actress. She was Mrs Newton, a divorcee whom Tissot set up as his mistress in a house in St John's Wood. Then she died of consumption and Tissot returned to Paris, devoting the rest of his life to painting biblical scenes of a penitential nature.

Munch and Dagny Juel

Munch's life was one long conflict, a simultaneous flight from and attraction to women. They were vampires, sucking his blood from him. They were hideously alluring. Woman was the whore 'who at all times of day and night seeks to outwit man, to cause his fall'. Woman was the earth mother, the producer of children. Dagny Juel was special to him: she was the niece of the Norwegian prime minister, and before arriving in Berlin, where Munch had set up his studio in 1893, she sent her photo on ahead 'to awaken interest'. She had heavy eyelids and a secretive smile, and the most luscious body. She was enigmatic, unpredictable and promiscuous. He used her as his model for a series

of intense images – *Jealousy*, *Madonna* (one of the great erotic images of art), *The Day After* and *Puberty*. In her time she was both sensual goddess and mother-saint to him. She ran off with a Polish poet and some years later ended up being shot dead by another lover in the Grand Hotel, Tbilisi.

Bonnard and Marthe

Sometimes an artist is a happily married man and his wife is his muse. Marthe was Bonnard's wife and his model. He painted her frequently as a silent component of quiet interiors (often of bathrooms); these images of domestic bliss seem to have involved her taking a lot of baths. 'Marriage is the essential condition for the good, solid, regular work required of anyone who means to produce anything worthwhile today,' maintains Zola's writer Sandoz in *L'Oeuvre*. Bonnard would have agreed with Sandoz, who further declared that 'the Woman seeking whom she may devour, the Woman who kills the artist, grounds down his heart and eats out his brain was a Romantic idea and not in accordance with the facts'.

Modigliani and Jeanne Hébuterne

Modigliani met Jeanne Hébuterne in spring 1917. She was shy, quiet and delicate, and exceptionally beautiful, and Modigliani painted her often. His inevitable elongations of her face and figure capture her grace but miss the voluptuousness that is evident from her photographs. She moved in with him, which must have been a challenge given his consumption of drink and drugs and his wayward lifestyle; on top of that, he was suffering from

advanced tuberculosis. But she adored him. In November 1918 their daughter, Jeanne, was born in Nice where they were wintering for his health. In January 1920 she was pregnant again, when Modigliani finally died. The day after the distraught Jeanne Hébuterne threw herself to her death from her parents' fifth-floor apartment, also killing her unborn child.

Picasso and various women

Where to start with Picasso? Would he have been able to paint at all without the stimulus of a new woman in his life every five or ten years? Fernande Olivier – Olga – Marie-Thérèse – Dora Maar – Françoise – Sylvette – Jacqueline (and several in between): each of them conjures up a different artistic period in his life, almost a different artist. Except Cyril Connolly would argue that the women were the symptoms not the cause, an after-effect rather than an inspiration: 'So far as we can generalise, it would seem that the welling up of the desire for artistic creation precedes a love affair,' he writes in *Enemies of Promise*. 'Women are not an inspiration of the artist but a consequence of that inspiration.' That rather puts paid to the whole theory of muses, if artists only use them as aids to 'warming down' after the big game rather than motive forces before or during it. It doesn't ring true with Picasso.

Salvador Dalí and Gala

'For me eating Gala would be the deepest expression of love,' wrote Dalí of his wife, mistress, model and muse. Here's how their collaboration worked: Dalí's diary for 6 September 1956

Gala, whom Dalí wanted to eat (Salvador Dalí, *Ma femme nue*, oil on canvas, 1945)

reads: 'We drove down to the market at Figueras, where I bought ten crash helmets and Gala bought chairs of different heights. The helmets are made of straw like those worn by small children to protect them when they fall. Back home, I put each crash helmet on a chair. The semi-liturgical look of this arrangement gave me a slight erection.'

Jeff Koons and La Cicciolina

If you are a Pop artist whose working material is kitsch objects
produced by the commercial world, there is a logic to making
your muse a pornography star. La Cicciolina, the Hungarian-
born Ilona Staller, is an Italian porn actress who also pursued
a career in Italian politics, being elected to Parliament in 1987.
Possibly her most famous political pronouncement was an offer
at the outset of the Gulf War to have sex with Saddam Hussein
in return for peace in the Middle East. She came into Koons's
life in the late 1980s, marrying him in 1991, but they broke up
in 1992. Their most famous co-operation produced the Made in
Heaven series, which records a startling range of acts of congress
between artist and model, many in the form of garishly tinted
photographs or sculptures.

Francis Bacon and George Dyer

Bacon had a colourful private life. He met George Dyer in 1964
when he caught him breaking into his home. Dyer, who came
from an East End criminal family, moved in permanently soon
after and gave up crime in order to devote himself full-time to
drinking. He became the subject of much of Bacon's painting, a
presence at once physical but surprisingly tender. Dyer himself
commented, 'All that money an' I fink they're really 'orrible'; but
he liked the attention the paintings brought him. In October
1971 Dyer accompanied Bacon to Paris for the opening of the
artist's retrospective at the Grand Palais; in the hotel room they
shared Dyer died of an overdose of barbiturates. Thereafter the
theme of death haunted Bacon's work, in particular in his three
Black Triptych masterpieces.

Quarters and Colonies

Where artists live and work is an important part of their myth,
literally their hinterland. The archetypal artists' quarter is the
Paris suburb of Montmartre. It goes back to the Romantic
Movement and the early 1800s, when the Vernet family of
painters settled there and others followed, including the young
Théodore Géricault, who moved in just up the road to 23 Rue
des Martyrs. In the second half of the century it was the cradle
of modernism. The Impressionists danced at the Moulin de la
Galette, a café and dance hall near the famous windmill. A
commune of artists, including Picasso, Modigliani and Van
Dongen, set up in the ramshackle Bateau-Lavoir building in
the early 1900s and lived there disgracefully. The Café au Lapin
Agile became an important meeting point and watering hole.
These names are legendary now.

Other artists' quarters sprang up in other European capitals
in the later nineteenth century. Chelsea (where I was brought
up in the 1950s and 1960s) became London's Montmartre. 'Of
course you will settle in Chelsea,' said Whistler to the young
William Rothenstein, back in London after studying in Paris
in the 1890s. Earlier in the nineteenth century most artists in
London had lived further east, in an area contained by Pall Mall
in the south and Cavendish Square in the north, stretching east
to Covent Garden, but no further west than Piccadilly. As the
century unfolded, Chelsea was discovered. The original attrac-
tion of the place was the river and its light. Turner had a house
overlooking the Thames in the 1830s; in 1863 came Whistler,
seduced into lyricism by the views across the water:

And when the evening mist clothes the riverside with poetry as with a veil, and the poor buildings lose themselves in the dim sky, and the tall chimneys become campanili and the warehouses are palaces in the night and the whole city hangs in the heaven before us – then . . . Nature, who for once has sung in tune, sings her exquisite song to the artist.

The river sang its song to two Chelsea boatmen, the brothers Walter and Henry Greaves, who attached themselves to Whistler as acolytes and became painters themselves.

The Pre-Raphaelites also came to Chelsea in the middle of the nineteenth century, Holman Hunt first and then Gabriel Rossetti, who took the lease of 16 Cheyne Walk in 1862. The household Rossetti established was a fascinating ménage of eccentricity. The lodgers and hangers-on at various times included the poet Swinburne, a disreputable but charming wheeler-dealer called Charles Augustus Howell, Whistler himself, briefly, and an assortment of 'stunners', girl models that Rossetti picked up from the streets and hat shops of the metropolis and brought back to draw from and yearn over. There was a large and overgrown garden at the back where Rossetti kept a small zoo of exotic animals – kangaroos, a wallaby, a chameleon, salamanders and wombats, an armadillo, a marmot, a woodchuck, a deer, a jackass, a raccoon, plus Chinese owls, parakeets and peacocks. The peacocks became so noisy that the Cadogan Estate, still extensive landlords in Chelsea, have specifically banned the keeping of peacocks on their property as a condition of all leases since.

Rossetti and Whistler were the two star Chelsea artists of the second half of the nineteenth century. They set the trend. By 1901 the *Westminster Review* was announcing: 'Chelsea now accommodates nearly two thousand devotees of the brush and mallet.' The artists' yearbook lists them, mostly forgotten now, but glorying in splendidly Edwardian names: A. Hounsum

'The evening mist clothes the riverside with poetry': a Whistler
lithograph of the Thames at Chelsea, 1878

Byles, J. Prinsep Beadle, Louise Joplin Rowe, Eleanor Fortes-
cue Brickdale. Where did all these painters and sculptors live?
Certain streets were particularly artistic: Cheyne Walk and
Cheyne Row, of course, and there were newly built studios in
Tite Street, Glebe Place, The Vale, Manresa Road and Beaufort
Street. The sculptor Henri Gaudier-Brzeska, being a poverty-
stricken Frenchman, had to make do with quarters down the
cheaper end of the Fulham Road, close to the recently con-
structed football stadium at Stamford Bridge. On top of all his
other problems – shortage of commissions, English xenophobia,
women trouble – he therefore had to contend with the difficulty
of working when Chelsea were playing at home.

What gave a sense of community to artists in Chelsea was
the Chelsea Arts Club. It was originally founded at 181 King's
Road in 1891, and in 1902 it moved to its present premises in

Old Church Street. It was a place where artists could come to get a sustaining meal, and even more sustaining drinks, meet each other, quarrel, play billiards, etc. It's hard to imagine such a formal organization in Paris, where a much less structured café life prevailed. But the English have always been clubbable, even in bohemia. In 1913 the artists' models even got their own club in Chelsea as well. It was a sort of employment agency cum girls' hostel where, according to a contemporary account, 'every room is a smoking room, for there are two things which are essential to the comfort of the girl model, and they are cigarettes and chocolates'. But it wasn't all cigarettes and chocolates. A less fortunate artists' model was Dolly O'Henry, who took a flat in Paultons Square. On 9 December 1914 her boyfriend, the very promising young Slade graduate John Currie, unbalanced by his passion, shot and killed her, then turned the gun on himself.

Having been in the vanguard of modernism because Rossetti and Whistler lived there, the character of Chelsea as an artists' quarter changed in the twentieth century. Paradoxically, it grew rather stuffy. The fashionable portraitist Sargent lived there (Tite Street), as did the conventional English Impressionist Philip Wilson Steer (Cheyne Walk) and the professional bohemian Augustus John. But when Roger Fry looked about for suitable English artists to exhibit in his second great Post-Impressionist Exhibition in 1912 alongside Picasso, Braque and Matisse, Augustus John refused. Of those chosen – painters such as Spencer Gore, Duncan Grant, Vanessa Bell and Wyndham Lewis – not one was based in Chelsea. The centre of gravity of London's modernism had moved north-east, in the direction of Camden Town and Bloomsbury. In 1914 Chelsea was characterized by Christopher Nevinson as 'outmoded', the home of 'sub-Rossettis with long hair beneath their sombreros, and other kinds of traditionalist rubbish'.

But the artistic atmosphere clung on to Chelsea until the mid twentieth century, manifesting itself slightly differently in the modishness of the swinging King's Road in the 1960s. By then other Chelsea heroes had emerged: the question that preoccupied me as a boy, as I stared fascinated by the Thames views of Henry and Walter Greaves that hung in Chelsea Public Library, was whether the two brothers could conceivably be distant uncles of Jimmy Greaves. Today Chelsea is no longer a meaningful artists' quarter. There are painters at work – generally members of the Pinstripe School with comfortable private incomes [see **B**ohemianism above] – but it has become too expensive an area to remain the home of the indigent modernist. Its gilded streets now house bankers and hedge-fund managers. To understand what Chelsea was like either side of 1900, you have to go to the East End of London in the early twenty-first century, to Shoreditch or Hoxton. And to find a Chelsea where artists congregate more meaningfully today, you must go to the one in New York, where the contemporary art scene has spread from the lofts of Soho.

If artists' quarters were urban, then artists' colonies were their rural equivalent, generally summer resorts where painters might meet up to take the sun, paint and profit from associating with each other. Colonies are a phenomenon of the late nineteenth and early twentieth centuries, and their emergence may have had something to do with the spread of railway travel, which made such resorts more accessible to city-based painters [see Part II, **R**ailways]. Their effect was to bring various artists into sometimes temporary alignment with each other. Break-ups occurred, and painters moved on to different phases and sympathies, but while they lasted the mutual exchanges out of which 'colony styles' evolved were important creative influences. Again, they are a form of branding, adding value. If a painting can

be described, for instance, as a classic Pont-Aven School work, it contextualizes it pleasingly to the buyer and makes it more desirable.

Artists streamed to Pont-Aven in Brittany in the summers; some, like Gauguin and Émile Bernard, were spending most of the year here by the later 1880s. Bernard's interest in Mediaeval art, combined with Gauguin's primitivism and exoticism, created a distinctive Pont-Aven style that was important to the development of modernism; other artists, on the periphery, contented themselves with depictions of the picturesque Breton fisherfolk and peasantry.

A number of younger English artists who had spent summers in Brittany looked to replicate the experience in Cornwall, which shared many of the same landscape features and also offered fisherfolk subjects. By the summer of 1885 twenty-seven artists were reported to be in summer residence at Newlyn. These included Stanhope Forbes, Walter Langley, Frank Bramley, Norman Garstin and Henry Scott Tuke (whose work showed a weakness for naked fisherboys). They painted in an atmospheric, *plein-air* style that owed a lot to the popular French painter Jules Bastien-Lepage. At the peak of the colony's activity the Great Western added a van to its Penzance–London Express to accommodate Newlyn's submissions to the Royal Academy Summer Exhibition. And, being English, the Newlyn artists behaved heartily. Besides painting, there were amateur dramatics, golf and cricket (a match against St Ives was played). In England, cricket validated art. The landscape painter Philip Wilson Steer used to make a point of carrying his artist's materials in a cricket bag when he travelled. He said he found he got better service that way.

About the same time in Denmark a group of naturalist painters gathered around Peter Kroyer and Michael Ancher at Ska-

Kirchner's painting of his friends disporting *textilfrei* in the
Moritzburg lakes, oil on canvas, 1910

gen on the coast north of Copenhagen, to paint and enjoy the
long summer days with their idyllic blue nights. Skagen was yet
another fishing community. What was it about fisherfolk that
so enchanted late-nineteenth-century painters? Something to do
with their picturesque costume and their timeless peasant values,
presumably. Some socio-economist should make a study of fish-
ing yields in places where artists gathered; dips in production
must surely be evident in those fishing villages across Europe
where painters depleted the fleet's capacity by redeploying its
manpower as artists' models.

The artists of Die Brücke in Germany also enjoyed colony
life, but being avant-garde eschewed golf and cricket in favour

of some serious nude bathing. During the years 1905–11 in
Dresden the Brücke artists – Heckel, Schmidt-Rottluff, Pech-
stein and Kirchner – evolved the mixture of violent colour,
liberated brushstroke and a reversion to the primitive virtues
of nature that characterized the great early productions of
German Expressionism. A feature of the movement was the
Freikörperkultur, or Free Body Culture, the nude bathing and
exercise cult that swept Germany in the first years of the twen-
tieth century. The healthy mind in the healthy body was to
be achieved by naked free-movement amid the untrammelled
beauty of the natural world, unfettered by the restraints of civil-
ization. With their girlfriends in tow, the members of the group
took regular excursions to the Moritzburg lakes set in the gently
undulating countryside of Saxony. Here they painted, exercised
and frolicked by the waterside in the prescribed *textilfrei* state.

In fact German Expressionism evolved out of colony life:
simultaneously the artists of Der Blaue Reiter (The Blue Rider)
were enjoying productive summers in Bavaria. Here Kandinsky
was very much in charge: his girlfriend Gabriele Münter and
the other members of the group gravitated to him as their leader
and mentor. Long summer days were spent painting in the hills
and lakes round Munich. Kandinsky was the guide in more
ways than one. As they roamed the countryside, he would alert
and summon the rest of the group to particularly promising
views for painting by sharp blasts on a whistle he kept for the
purpose. It was a domestic rural idyll: in the evenings Münter
would cook dinner for them from the kitchen garden she had
planted at Murnau.

The last great painters' colony before the First World War was
at Collioure on the Mediterranean coast of south-west France,
with an offshoot at Ceret, a village in the Pyrenees a few kilo-
metres inland. The advantages of the place were its colour, its

light, and its cheapness after Paris. Resources could be shared:
not just the food, the wine and the accommodation, but some-
times also the women, which lent an explosive potential to
colony life. At Collioure Matisse and Derain spent a long, hot,
colourful summer in 1905 evolving the Fauve landscape with
a series of vivid paintings of the coastline and (yet again) the
fishing fleet. Braque, Picasso and Juan Gris arrived at Ceret
in the years that followed, relocating the Bateau-Lavoir in the
sunny south, and taking important steps in the development
of Cubism.

Montmartre, Chelsea, Soho, Pont-Aven, Newlyn, Murnau,
Skagen, Collioure: they are all places that have entered the
mythology of art. Pictures painted in these locations reinforce
the brand and take on an added value to the market.

S*poofs*

It is good to be reminded now and then of the absurdity and
pretension of artists and what they produce, not least for the
artists themselves. A little satirical mocking, in the form of
humorous imitations or spoofs, can be rather invigorating. The
curious thing is that sometimes the spoofs themselves take on an
artistic – and commercial – value of their own. There is a point
at which a spoof stops being a spoof and becomes a Dadaist or
Surrealist artwork in its own right.

The Incoherents

The Incoherents were a little-known group of artists in Paris
in the 1880s whose work anticipated by forty years some of
the most avant-garde developments of the twentieth century,
particularly Dadaism and Surrealism. Their first exhibition,
in October 1882, was entitled 'Arts Incoherents' and featured
among other things what seems to have been the first docu-
mented example of a monochrome painting, a black rectangle
by Paul Bilhaud called *Negroes Fighting in a Cellar at Night*. In
the exhibition of the following year Alphonse Allais showed a
totally white rectangle that he titled *Chlorotic Girls at Their First
Communion in a Snowstorm*. Allais also expanded his activity
into music, publishing an empty musical score which he entitled
'Funeral March for the Deaf'. Other Incoherent works included
sculptures made from bread and cheese, and a reproduction
of the *Mona Lisa* with a smoking pipe added to her mouth, a
conceit imitated many years later by Marcel Duchamp when he
added a moustache to the same image to make a major Dadaist
statement [see Part I, **I**mages (Famous)].

The Incoherent artists – some of them on their own admis-
sion not artists at all but 'people who don't know how to draw
making drawings' – were mounting a challenge to academic art.
What differentiated them was that they did so with an endear-
ing humour rather than with the earnestness and dogmatism
that characterized the more serious rebels who came a gener-
ation later.

Quintin Septule (fl. 1910)

A splendid show was mounted at the Chelsea Arts Club in December 1910, just after Roger Fry's first Post-Impressionist Exhibition in London. It was entitled 'Septule and the Racinistes'. The catalogue described the Racinistes as 'that brave band of fighters who gathered round Quintin Septule after his flight from Paris, and formed the little artists' colony at Châteaudun'. These revolutionaries were on the very cutting edge of modern art; Septule himself was a Cubist painter, and the work exhibited by him showed a surprisingly assured command of the new visual vocabulary. The point was, of course, that Septule never existed, and the painting was a spoof by the cartoonist H. M. Bateman, a member of the Chelsea Arts Club. Great fun was had inventing other artists for the exhibition: Charles Turletin, for instance, 'whose uncompromising independence had closed to him the gates of all public exhibitions'. Another work was actually signed 'Henri Matisse', the name alone being enough to raise a laugh. Other brilliant geniuses were called Schufflin, Rotton, Gaga and Aspic. It was noted that all these men had variously shot themselves, gone mad, become drug addicts or died in convulsions from the poisonous exhalations of certain pigments of their own invention.

Bruno Hat (fl. 1929)

In the summer of 1929 an exhibition of the work of Bruno Hat was announced, to be held at the London house of the socialite Bryan Guinness. The artist had apparently been discovered by Guinness working in obscurity in a small village in the West

Country. His painting was trumpeted as a revelation, a triumph of English modern art. The event was carefully planned. A catalogue was produced, with an introduction by Evelyn Waugh writing under the nom de plume 'A. R. de T.', called 'Approach to Hat'. The artist himself even appeared at the private view, although no one was allowed a very close look at him. The pictures on view were painted in an avant-garde contemporary continental style, and were good enough to be taken seriously by some of the reviewers invited.

The truth emerged before too long. Hat was a hoax, the brainchild of Guinness's dilettante friend Brian Howard. Tom Mitford, in heavy disguise, played the part of the artist. It was all a glorious mockery of the earnestness of modern art, possibly even a parody of the recent genuine discovery of an unknown painter, Alfred Wallis, in the autumn of 1928 by Ben Nicholson and Christopher Wood. But who had actually painted the Bruno Hats, which weren't bad at all? The original theory, that Brian Howard had done them, was rejected because they were too good. The most likely painter was John Banting, a friend of Howard and later a distinguished Surrealist. When an original 'Bruno Hat' came up at Sotheby's in 2009 it fetched a respectable £18,700. The market had delivered its verdict: this was a Banting price rather than a Howard price. And in retrospect the whole Bruno Hat hoax could be read as an impressive work of Surrealism in its own right.

Nat Tate (1928–60)

On April Fool's Day 1998 a well-attended party was held at the artist Jeff Koons's studio in Manhattan. The host was David Bowie, and the event was to launch William Boyd's biography

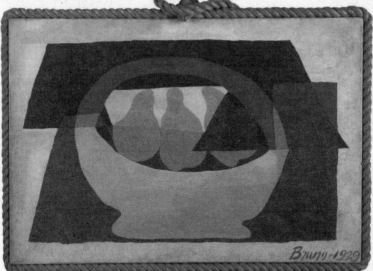

A rare extant work by Bruno Hat, *Still Life with Pears*, oil on canvas,
first exhibited in 1929

of the artist Nat Tate, a forgotten American painter. Tate, after a
brief but successful career in the orbit of Abstract Expressionism,
had at the end of his short life gathered together as many of his
own works as he could lay hands on, made a bonfire of them
and then committed suicide. Carried away by the emotion of
the occasion, guests talked openly of their memories of Tate,
warmly remembering aspects of his life, shows of his they had
attended, reflecting on the sadness of his premature death.

Nat Tate never existed. He was the creation of Boyd's imagin-
ation: the name was an amalgamation of the two leading public
galleries in London. Boyd had not intended the publication
of his book to be a hoax. 'My aim was to prove how power-
ful and credible a pure fiction could be,' he wrote later, 'and at
the same time, to try to create a kind of modern fable about

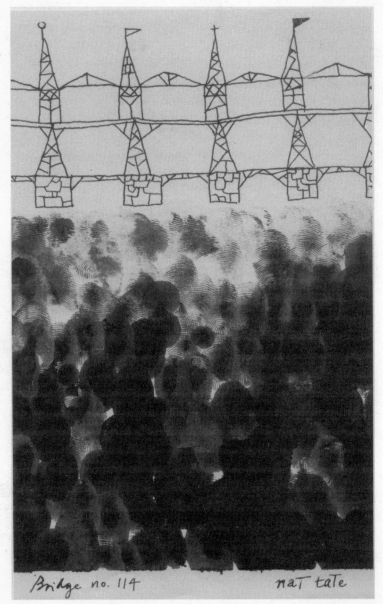

Bridge no. 114

nat tate

The drawing by Nat Tate sold at Sotheby's in 2011

the art world.' That fable was the story of a fairly indifferent artist achieving fame and wealth, something which, in Boyd's assessment, is a not uncommon occurrence in the 'unending brouhaha' of the contemporary art market, which is more about promotion than about talent. In Tate's case, confronted by his own ultimate inadequacy, he held his bonfire and jumped off the Staten Island Ferry. Plenty of real-life artists, confronted by the same realization, just went on painting.

The last-minute bonfire was a neat way of explaining the absence of almost any surviving works by Nat Tate. But a very few emerged afterwards (painted light-heartedly by Boyd himself). One, a slight pen-and-ink drawing incorporating the artist's thumbprint, came up at auction in Sotheby's in November 2011. It fetched £6,500, which – with all due respect to Boyd's ability as an artist – probably proved his point about promotion being more important than talent.

Suicides

Artists as a profession are peculiarly susceptible to suicide. The solitary nature of their work and the consequent potential for disproportionate self-doubt represent a toxic combination. Oscar Kokoschka even claimed it as an artistic privilege: 'My work contains everything that will die with me,' he wrote to Anna Kallin in 1923, 'and nothing that will reach beyond me or outlive me. The only right an artist has in a materialistic age is that when he has no more illusions left – that is, when he is exhausted – he has the freedom to take his own life.'

Some, like Edvard Munch, who turned a gun on himself in 1909 but succeeded only in damaging his fingers, or Géricault in a London hotel room in 1821, tried and failed to commit suicide. Others went the whole way, including the tragic Benjamin Haydon and the modern British painter Keith Vaughan, two great diarists who both made poignant last entries in their journals on the very days that they killed themselves.

Hazlitt was in no doubt about the tragic potential of artists' lives.

Artists in general (poor devils!), I am afraid, are not a long-lived race. They break up commonly about forty, their spirits giving way with the disappointment of their hopes of excellence, or the want of encouragement for that which they have attained, their plans disconcerted, and their affairs irretrievable; and in this state of mortification and embarrassment (more or less prolonged and aggravated) they are either starved or drink themselves to death.

Vincent Van Gogh's death in June 1890 is perhaps the most famous suicide in art history. The details have been assiduously chronicled: how in May 1890 Vincent left the asylum at St-Rémy for lodgings in Auvers-sur-Oise where he was cared for by Dr Paul Gachet. How on 27 July 1890 Vincent went for a walk in the fields and shot himself in the chest. How an unfinished draft of a letter to Theo, his brother, written on 23 July was found in Vincent's pocket in which he says: 'Ah well, I risk my life for my own work and my reason has half foundered on it.' How two days later Vincent finally died of his wounds with Theo at his side. His death is deeply entangled with our image of him. It has become so famous that the revisionists have been at work on it. A recent biography speculates – not totally convincingly – that the suicide never actually took place; that Van

Gogh went for a walk in the fields and was accidentally killed by
a young man out shooting rabbits.

This theory somehow diminishes his stature as an artist.
We need him to have taken his own life in order to validate
the tortured paintings that went before. If he died accidentally,
we would feel somehow short-changed. Could it be that, if
incontrovertible evidence was produced that Van Gogh died in
a shooting accident rather than taking his own life, his prices
would suffer? There's little doubt that suicide or early death is
a good thing for the value of an artist's work. It is tragic in a
romantic way, and it abbreviates the number of examples avail-
able to the market, cutting off the supply of probably inferior
work that the artist might have produced had he lived into old
age.

Subject and Style

Abstract Art

Abstract art is exciting. It marks a true revolution. For centuries artistic progress had been measured by the dexterity with which painters reproduced the world they saw about them, got closer to an illusory ideal of absolute fidelity to nature. Then, in the years approaching 1900, things changed. The distortion of nature was accepted as a means of artistic expression; and that distortion pointed the way down a road that led ultimately to the eradication of all figurative reference in painting and sculpture.

The young Russian painter Wassily Kandinsky started dreaming dreams. In 1895 he went to a gallery in Moscow where he saw the French Impressionists for the first time. Standing in front of one of Monet's Haystacks series he had a revelatory vision. 'Suddenly for the first time I saw a *painting*,' he records in his *Reminiscences*.

That it was a haystack the catalogue informed me. I could not recognise it. I dully felt that the object of the painting was missing. But what was entirely clear to me was the unsuspected power of the palette, which had up to now been hidden from me . . . unconsciously the object was discredited as an indispensable element of a painting.

Although the philosophical basis of abstract art can be traced back to Plato, who identified the absolute beauty inherent in straight lines and curves independent of any figurative significance, its emergence as an art form was accelerated by two developments in the second half of the nineteenth century. One was the popularization of photography, which seemed to have achieved a scientifically accurate reproduction of nature that

rendered the painting of it irrelevant; another was the romantic notion that all arts aspire to the condition of music, gloriously emotional, suggestive and ultimately non-figurative. Abstract art, according to Apollinaire writing in 1912, was going to stand in the same relation to traditional art as music did to literature. It was going to open up a whole new world of expression.

Apollinaire's claims for visual abstraction were optimistic. Static shapes and colour never achieved the impact of musical sound. The imprecision and amorphousness of abstract art is also a challenge to the market. How do you define and measure its quality? How do you price it? In order to impose a structure, the market turns to art history. A narrative is imposed: Impressionism is established as the first link in an inexorable chain that leads Kandinsky over the next twenty years after his first encounter with Monet to the invention of abstract art. In 1913 he does it with his Improvisations; it's almost a dead heat with the Russian Suprematist Kazimir Malevich and his geometric shapes in 1914, and Robert Delaunay with his discs of colour. Once invented, abstract art conforms to the old *Classic* v. *Romantic* template. The classical strand is represented by the hard-edged, geometric shapes of Malevich and his fellow Suprematists, by the pared-down ovals and thin, curving verticals of Brâncuşi, by the grids of Mondrian; the romantic is the looser, more subjective Abstract Expressionism that climaxes in the anarchic freedom of Jackson Pollock and the infinite suggestiveness of Rothko.

In valuing the abstract art of the past, it helps to be able to fit it into this art-historical framework. At the same time, the minimalism of abstract art focuses judgements down to very basic aesthetic questions. Like colour: a blue Miró is worth more than a brown one. And line: the straightness of the incision of a Fontana slit is something particularly valued by his

Malevich's contribution to abstraction (Kazimir Malevich,
Suprematist Composition, oil on canvas, 1916)

admirers. These are simple but momentous considerations. Even among the classic purists, disputes could arise. Mondrian's grids inspired Theo van Doesburg, but a rift grew up between them over the diagonal: van Doesburg maintained its dynamism; Mondrian would have none of it. As a result they didn't speak to each other for several years. If you compare Mondrian's prices to van Doesburg's today, Mondrian's view seems to have prevailed.

The market's quest for structure also meant that the works of a number of earlier artists were reappraised as good or significant (and therefore valuable) in so far as they could be seen as stepping stones to the ultimate ideal of pure abstraction, 'anticipated' it, in that term so dear to the hearts of art historians. A minor artist such as the writer Victor Hugo was dredged from obscurity because he experimented with ink blots. The blot drawings of the eighteenth-century watercolourist Alexander Cozens were also re-examined with excitement. He advocated spreading random blots or dots of ink across a sheet of drawing paper that would suggest to the artist a landscape or other composition, which could then be worked out in full. Abstract art reverses the process, taking the landscape and obliterating it in a reversion to the blots. That's what happened to Monet. Suddenly, late Monet was more important than early. His vast water lilies, in which the effects of light on a horizonless surface of water are rendered in ever-broader brushstrokes, were seen as magnificent examples of Abstract Expressionism, when they are equally interpretable as the strivings of a great Impressionist to cope with his failing eyesight.

Abstract art leads deep into the mystery of artistic creation, a mystery all the more relevant once art becomes non-figurative, once art cuts its ties to the objectively identifiable and becomes unknowable, infinitely interpretable. Can you make works of art by chance? Strindberg thought you could. He wrote an article

in 1894 in the *Revue des Revues* entitled 'On Chance in Artistic Production' that formulates a theory of 'art automatique' in which the artist works through a 'happy mixture of conscious and unconscious creation'. Chance has a significant part to play in abstract art, particularly Abstract Expressionism: the ink blots of Hugo and Cozens; the serendipitous felicity of the marks created by a bicycle ridden over a canvas; the happy effect of a loaded brush flicked across the paint surface or allowed to drip randomly from a single stroke. In this respect a great abstract artist must be lucky as well as talented.

But that at least is not difficult for the market to come to terms with: if there is one thing that markets reflect it's the role that luck and chance play in all human exchanges, particularly commercial ones [see Part V, **L**uck].

Anger and Angst

There are two sorts of anger in art, one bad and one good. The bad one is the emotion which when it occurs in traditional representational painting is not well received by the market. Smiles are better than scowls on the face depicted. Generally people prefer happiness in pictures, serenity rather than conflict, intimations of pleasure rather than of pain. This simple formula is fundamental to the appeal of the Impressionist painting [see **I**mpressionism below].

It is extraordinary how much difference the line of the mouth in the principal figure in a painting can make to its value. A Matisse interior offered not long ago at auction had everything

in its favour: a colourful background and a graceful female figure in an elegant dress. But there was one drawback: the line of the lady's mouth turned down into a scowl. It was just a single, cursory line in the composition, but because it turned down rather than up at its ends it made a disproportionate difference. Just straightening the line of the mouth into neutrality would have been enough to double if not treble the painting's value. A smile would have quadrupled it. The temptation to get a restorer to make a minor adjustment to this single stroke of the artist's brush was almost irresistible. Sometimes the negligence of painters in these matters strikes one as staggering. What can Matisse have been thinking of? Had he no feeling for future generations of art dealers and auctioneers in their valiant struggle to find a buyer for the painting?

The second sort of anger, the positive one for the saleability of a painting, is angst. Angst is effectively an invention of modernist art, specifically Expressionism. Angst is a good thing commercially. It is the sort of existentialist torment that is the trademark emotion of twentieth-century man, which became more and more desirable as the focus of artists turned from the outside world inwards to their own feelings. It's no coincidence that 'angst' is a German word, because German Expressionism feeds on strong emotional meat. Conflict and frustration become the feelings of choice, the imprimatur of artistic sincerity. The battle cry comes from Edvard Munch: 'As Leonardo dissected corpses, so I want to dissect the soul.' Thus Munch announces a new direction in what was to become marketable in modernist art.

Animals

Animals as subjects are perennially popular, both in traditional
and modern art. Cats, dogs, horses, farm animals and wildlife
were portrayed in pictures from the Renaissance onwards. They
still are, by a number of successful modern artists, particularly
sculptors: horses by Marino Marini or Elizabeth Frink, hares by
Barry Flanagan, cats and dogs by Giacometti, sheep by Henry
Moore. But something happened in the nineteenth century that
established a new direction for animal painting. It was rampant
anthropomorphism. In the Victorian era furniture became
animal (as the feet of tables and chairs developed paws and
talons), and animals became human (as cats and dogs developed
souls). The delightful Dorothea Casaubon in George Eliot's
Middlemarch (1872) even believes in 'the gratitude of wasps'. The
result was a deluge of sentimentality that broke over the picture-
buying public: impossibly cute kittens, puppies and ducklings
frolicked over the walls of the Salon and the Academy, meeting
the taste of a new middle-class patronage. This sort of Victorian
animal painting still exerts a commercial appeal today.

The pioneer of anthropomorphism was that eminent Victor-
ian Sir Edwin Landseer, not just in England (where Englishmen
have traditionally found it easier to express emotion in relation
to their dogs than their human dependents) but across the con-
tinent. The French critic Théophile Gautier observed in wonder:
'Landseer gives his beloved animals soul, thought, poetry and
passion; he would if he dared take away their instinct and
accord them free will.' Not only did Landseer paint animals
extremely well, but he also created in them an expressiveness

bordering on the human. His work includes a string of famous pictures featuring canine character and emotion, from the tragic as in *The Old Shepherd's Chief Mourner* (a sheepdog turning impossibly sad eyes on his deceased master) to the comic as in *Dignity and Impudence* (a small Scottish terrier teasing an older, more stately bloodhound).

Undermined by Landseer's tear-jerking vision of the animal kingdom, the rest of Europe weakened and collapsed. A new sensibility stirred in Brussels as bourgeois taste asserted itself and Henriette Ronner-Knip emerged, a Belgian who became one of the most popular female artists of the nineteenth century. She specialized in cats and kittens, often misbehaving – playing with balls of wool, upsetting milk jugs – in the sort of affluent middle-class salon that was the natural habitat of her adoring patronage. Madame Ronner-Knip has never become a feminist icon. Why not? She fitted too cosily into the existing order of things, and she painted a subject matter that was totally unthreatening to men.

The Victorians loved what Landseer and Ronner-Knip purveyed. The piquancy of animals behaving like human beings, or at least showing evidence of recognizably human emotions, is part of the enduring appeal of many popular nineteenth-century paintings. Sometimes the pictorial message would be underlined with suitably comic explanatory titles: Briton Rivière, RA, calls his painting of a dog backing guiltily away from an upset vase *Thus Conscience Doth Make Cowards of Us All*. In others, even plants were made to talk: a view of a ragwort-strewn meadow by an English landscapist, John Clayton Adams, is poignantly entitled *Call Us Not Weeds*.

Painters of wildlife succumbed to the anthropomorphic urge less frequently than those specializing in domestic animals. It was difficult for even the most sentimental to imbue a partridge's

Briton Rivière, RA, plucking at Victorian heartstrings
(*Compulsory Education*, oil on canvas, 1887)

features with much profundity of character, which was probably
for the best, in that the urge to paint game birds was an exten-
sion of the urge to shoot them [see **S***port* below]. Today paint-
ings of game birds remain popular because they are bought by
those who hunt them. But even here a certain sense of decency
and decorum prevails: game birds are worth more pictorially
alive than dead. There is a deep-seated prejudice against paint-
ings of peacocks, partly because there used to be an odd art-
trade superstition that they brought bad luck, and partly perhaps
because it's not good form to shoot them. In so far as human
emotion enters into the painting of wildlife, artists were fond of
emphasizing the heroism of the fallen stag, or the arrogance of
the reclining lion. Landseer's *The Monarch of the Glen*, familiar
from a million whisky bottles, is the archetype here.

The heroic or human qualities of cattle and sheep were
harder to evoke convincingly, even for the Victorians. Some
made a stab at it: August Schenck, a French artist popular for
his scenes of the farmyard and meadow, was described by *Le
Figaro* in 1878 as a painter who 'finds more sweetness in sheep
than in women'. One understands what *Le Figaro*'s critic was
trying to say; but I have an uneasy memory of going to visit a
collector in Amsterdam at the end of the 1970s, a collector who,
it transpired, ran a brothel. The pictures that he had assem-
bled on the walls of his place of work were exclusively of sheep
and cattle, sanitized evocations of contented beasts painted by
Dutch and Belgian nineteenth-century artists. I asked him why.
'I like them,' he told me. 'They're well painted. And the punters
like them. I suppose they find them reassuring.'

He was right. Sheep and cows, unthreateningly emblematic
of the rural idyll to urban collectors, remain popular today. The
nineteenth century's most celebrated painter of farm animals,
the Belgian Eugène Verboeckhoven, recognized that his sheep

A ewe and two lambs by Eugène Verboeckhoven (lambs optional),
oil on panel, 1874

and cows had become a currency in their own right. A prospect-
ive buyer once visited him in his studio, to be offered a painting
showing a mother ewe with two lambs. He was quoted a price
of 800 francs for the ewe and 200 francs per head of lamb. But
the client could only afford 1,000 francs. Unfazed, Verboeck-
hoven took up his brush, painted out one of the lambs, and
knocked 200 francs off the price.

The Munich painter Alexander Koester specialized in ducks.
There was a boom in collecting his work in the late twentieth
century, when it seemed that few Bavarian homes of any aspir-
ation to wealth and culture could afford to be seen without one.
Koester's work is rather repetitive, generally portraying ducks
in a pond, and the only variable is the number of ducks in the
composition. Thus the price of his pictures became computed
simply on the quantity of ducks depicted. Here at last was art

neatly packaged as a quotable commodity. Thus, at his peak in the mid 1980s, when an eighteen-duck Koester sold for $270,000, the Koester duck rose as high as $15,000. If only all art valuation were as simple.

Banality

In the context of contemporary art, banality sells. Indeed it is an imprimatur of seriousness, of engagement with the ordinary and therefore with the nitty-gritty of life. Here are a few instances of the growing power of the banal in subject matter and treatment.

Excrement

In *Swann's Way* Proust describes a posturing painter at Madame Verdurin's soirée holding forth about the inadequacies of another artist's work. He declares that it's 'impossible to say whether it was done with glue, with rubies, with soap, with sunshine, with leaven, with cack!' It was intended as a declaration of the most outlandish artistic medium conceivable, but later the same century cack as a medium of expression had indeed entered the modernist canon.

First, Piero Manzoni. He went through a phase of tinning his own excrement and exhibiting the labelled receptacles. Most collectors took it on trust that the tin contained what it claimed, although it was possible to imagine that the ritual opening of the tin – a bit like the uncorking of a priceless bottle

The ultimate artistic relic: Piero Manzoni's tinned excrement (*Merda d'artista*, tin box and printed paper, 1961)

of Latour '65 – was the ultimate aesthetic pleasure distillable from the artwork, simultaneously its apotheosis and its destruction. One tin is rumoured to have been opened in a museum, for conservation purposes, and found, distressingly, to be empty. It is an interesting concept, the excrement of the artist, at once a relic-worship of the creative intelligence and a joke, a subversion: bad painting is colloquially described as 'crap'.

Then there were Andy Warhol's Piss Paintings. His method is described as follows by Vincent Freemont, an eyewitness: 'He painted the canvas with different kinds of metallic paints, either

gold or copper. Then Ronnie Cutrone, Victor Hugo and others, including some female participants, were invited into the back room at various times to pee on the canvas under his direction.' A sponge mop would help with the application. There were nuances: on 28 June 1977 Warhol records that he 'told Ronnie not to pee when he gets up in the morning – to try to hold it till he gets to the office, because he takes lots of Vitamin B so the canvas turns a really pretty colour when it's his piss'.

Then came Chris Ofili. He has used elephant dung as a collage to bring more interest to the surface of his canvases, particularly in his Captain Shit series. He also sometimes rests his paintings on elephant dung, explaining that 'it's a way of raising the paintings off the ground and giving them the feeling that they've come from the earth rather than simply being hung on a wall'.

And Liu Wei. His mixed-media sculpture *Indigestion II* represents a massive turd, 83 × 214 × 89 cm, executed in 2003–4 with alarming realism. Its owner, Charles Saatchi, says, 'I don't think the artist intended people to feel comfortable looking at a giant poo. He's not an interior decorator.'

Found Words and Jokes

Paintings of words are but one of many examples of the way modern art engages with banality and even celebrates it. A typical Richard Prince, entitled *The housewife and the grocer*, consists of a canvas painted in acrylic with seven lines of text, as follows:

A housewife selected three small tomatoes and was
told by the grocer they were 75 cents.
 "What!" she exclaimed, "75 cents for those small

tomatoes? Well, you can just take them and you
know what you can do with them!"

"I can't, lady," replied the unhappy grocer, "there's
a 95 cent cucumber there."

As a joke, it's mildly funny; some spectators may have heard it
before. But that need not matter. Just because people know the
story of Diana and Actaeon, that's no reason to deter a Titian
or a Rubens from painting it. But why has Prince chosen to
elevate this humble joke to the status of a work of painterly art?
A contemporary critic explains: 'Matter-of-fact, tactless and
funny, these handwritten gags were the antithesis of the pseudo-
expressionistic painting being produced at the time.' So Prince
is fighting high-flown aestheticism with deliberate banality. It
is the same impulse that impelled Marcel Duchamp to exhibit
Fountain, his urinal – the first 'found' object – as a gesture of
rebellion against academicism. These groups of words presented
as paintings – phrases, advertising slogans, jokes – are 'found'
groups of words, disconnected from their frequently banal ori-
ginal function, dusted down and presented as works of art. It is
the tension between the spectator's awareness of the ordinariness
of their original function as words and the grandeur of their
new-found status as works of art that gives them their piquancy.

On a very simple level, the words depicted constitute the
meaning of the painting. It is tempting to see them as the
modern equivalents of Victorian samplers, only without the
seamstress's skill. But actually what they should be compared
to is Victorian narrative painting, those enormously popular
subject pictures that were readable like scenes from novels [see
Narrative below]. Prince's writing-pictures and the Victorians'
story-pictures are both types of art in which content is para-
mount. In the nineteenth century the aesthetic movement

with its amoral insistence on art for art's sake was the reaction against such subject-heavy machinery. In the twentieth century, Duchamp, Surrealism, Conceptual Art and Pop Art are the heirs to subject-driven art, while Expressionism, Abstract Expressionism and pure painting sit on the aesthetic, form-driven side of the divide.

Another modern artist who paints words a lot is Ed Ruscha. A 1979 pastel by him depicts the words

I DON'T WANT
NO RETRO
SPECTIVE

Obviously the words are artfully chosen, modishly echoing the Rolling Stones' lyric 'I Can't Get No Satisfaction', while at the same time introducing a specifically art-world term in the form of the word 'Retrospective'. The artist does not want a retrospective. He's a rebel, who has broken free of the bourgeois confines of the conventional artistic career. He's gone beyond the idea of the coronational exhibition that celebrates the full spectrum of his artistic achievement (although the fact that the word is brought in at all implies that all else being equal it's definitely on the cards, he's certainly successful enough to have one). At the same time the arrangement of the words in the picture space is calculated and carefully composed. The way the words and lines are chopped up gives it the deliberation and momentousness of a modern poem. So the piquancy is derived not just from a two-way but from a three-way tension: it's not only a painting, it's also a group of words with meaning; and it's not only a group of words with meaning, it's also a poem.

Sometimes artists play with just a single word. Robert Indiana produced a sculpture of the four letters L-O-V-E. I once

admired it in the collection of a French client. If in doubt in front of a collector's work of art, it's a good plan to comment intelligently on its subject matter. 'Love,' I said rather vacuously. 'What did you say?' he asked, surprised. 'Love,' I repeated. 'You know, the artist is playing with the word.' 'But it doesn't say "Love",' he replied, 'I bought it because it says "*Vélo*" and I'm very fond of bicycling.'

Kitsch

Contemporary art's engagement with banality extends to a fascination with kitsch. Kitsch, said Clement Greenberg in 1939, is vicarious experience and faked sensation. It comes from the German word '*verkitschen*', to make cheap. Its artefacts are the products of popular culture, such as tourist models of the Eiffel Tower, T-shirts printed with the image of the *Mona Lisa*, music-al ashtrays that play the theme tune of *The Godfather* when you stub out your cigarette in them, and the sort of jokes and every-day words, signs and advertisements deployed by Richard Prince and Ed Ruscha. Kitsch as a term has come to encompass art that is sentimental (such as Victorian genre painting), art that makes things too easy for the viewer, art that relaxes rather than stretches; in this sense it is a portmanteau word for bad taste.

But in the second half of the twentieth century a new atti-tude to kitsch developed. Pop artists took kitsch objects and looked at them in a new way. By shining the torch of irony on these works, the artist was able to say, 'Yes, I know this is kitsch, but from my superior "knowing" position I am endowing this work of popular culture with a new significance as a statement about contemporary life.' And in the process the notion of 'camp' was invented, which is neatly defined as precisely that

ironic attitude towards kitsch. It's a process of deconstruction. If you're Richard Prince or Gustav Metzger or Jeff Koons, you start with a joke or a bag of rubbish or a piece of porn. That's the original construction. It is then deconstructed by the addition of irony to become a 'joke' or 'a bag of rubbish' or 'a piece of porn'. (This is what some modernist critics refer to as 'italicization', so maybe I should be saying *a joke* or *a bag of rubbish* or *a piece of porn*). Finally it's gloriously reconstructed and presented as a work of Pop Art.

An ace exponent of this deconstructive irony is, as we've seen, Richard Prince. He does the same thing with his Nurse series, which takes the covers of the subgenre of romantic fiction set in hospitals, deconstructs them and redeploys them as images of modern art celebrating late-twentieth-century consumerism. The mass media are now repeatedly mined for similar material: hostility towards popular culture, which marked the early stages of modernism, is replaced by direct engagement with it on the part of the avant-garde, albeit with an ironic eye.

Rubbish

Gustav Metzger, the pioneer of Auto-Destructive Art, held his first public demonstration of the movement in 1960. In 2004 the artist recreated the event at Tate Britain. Crucial to the installation was a bag of rubbish. Unfortunately a cleaner at Tate Britain removed the bag to the skip. Although the 1959 manifesto of Auto-Destructive Art states 'the artist may collaborate with scientists and engineers', collaborating with cleaners was apparently a step too far; and, although Auto-Destructive Art was further defined as 'art which contains within itself an agent which automatically leads to its destruction within a period of time

not to exceed twenty years', the accelerated destruction effected by the skip was deemed inadmissible; so, although it was retrieved from the skip, the artist declared the first bag ruined and created a new bag, with new rubbish, as a replacement.

All the contemporary art investigated above sells precisely because it is banal, but it wouldn't work without the essential pinch of Irony, or italicization, which endows it with a knowing and modish irreverence. Irony is the crucial ingredient in the equation of what makes banality attractive to the contemporary art buyer, an equation that can be expressed as follows:

Banality + Irony = Art

Banality − Irony = Do you think I'm stupid, trying to sell me this bag of rubbish for £100,000?

Caravaggio

Easily the sexiest old master artist in the view of the early twenty-first century is Caravaggio (1571–1610). Hardly a month goes by without some new book about him appearing, often in the form of a racy historical novel, focusing on his volatile personal life and his voracious appetite for his own sex. The way he painted, with its dramatic effects of light and dark, its high-keyed colour and intense realism, is also very sought after, so that any seventeenth-century painter who imitates his style is appealing to the market. In fact Caravaggism is to old master painting what Fauvism is to the modern market: exciting, striking, easily recognizable, deeply fashionable. And expensive.

Cardinals

I arrived at Christie's fresh and idealistic after a History of Art degree at Cambridge, which had fed me a constant diet of masterpieces, either absorbed first hand in the great museums of Europe and America or second hand through photographs in libraries. So it came as a shock when the first painting I was asked to catalogue in the Christie's warehouse was a 'cardinal' picture. What on earth is a 'cardinal' picture? I had no idea either. I knew nothing about bad art, about good painters having off-days (or indeed bad painters having good days). Or that a whole world of bad, frankly commercial 'popular' art existed for which people were prepared to pay good money.

It became clear that the domestic antics of the princes of the Roman Catholic Church had exerted a powerful fascination to a number of popular painters and their patrons in the second half of the nineteenth century, and that this popularity had continued deep into the twentieth. These intimate scenes, set behind the closed doors of the private quarters of a cardinal's palace, constitute a clearly defined genre of painting in their own right. Their popularity proved remarkably durable: in 1886 Collis Huntingdon paid the enormous sum of $25,000 for *The Missionary's Story* by the French academic painter Jehan Georges Vibert; almost as extraordinary was the 1,400 guineas paid at auction in 1950 for François Brunery's *The Toast of the Chef*. The same sum would at that time have brought you a passable Renoir or Monet landscape, or a small Picasso.

The superficial appeal of such pictures is obvious: today's buyers are seduced by the high technique lavished upon them,

and relish colour compositions which revel so unashamedly in large expanses of episcopal purple and crimson. On top of that the treatment is comic and full of character. But when they painted them, the artists were also motivated by a degree of anticlericalism. The late-nineteenth-century audience took pleasure in the sight of noble figureheads of the Church reduced to banal, even undignified, proportions. It suited the prevailing political mood.

At first artists turned to the Vatican for subject matter in a spirit of curiosity rather than mockery. Merely to depict a cardinal in the privacy of his intimate surroundings delighted the voyeuristic instincts of the nineteenth-century clientele. There was an aura of grandeur, mystery and intrigue about the inner sancta of the Roman Catholic Church, which was fascinating when opened to keyhole scrutiny. What artists revealed was a clerical susceptibility to the trials and tribulations of the ordinary man. A cardinal is shown sitting down on the palette of an embarrassed visiting portraitist, or leaping for the safety of a stool at the appearance of a mouse. Andrea Landini – an Italian – depicts a sumptuous dinner where fine wines and rich food are being dispatched to eminent bellies with a gusto that borders on excess. The ubiquitous Vibert presents a scene of meditation in which the cardinal concerned is not in his private chapel but at the end of his fishing rod. Unfortunately the tip of his fishing rod has inadvertently caught the bag holding his catch, and the fish are escaping back into the water.

The implications of such pictures are there to be drawn: if the Pope's right-hand men are to be sent scampering for safety at the approach of one small mouse, what price the authority of the Church? If they lived so grandly and self-indulgently, how could they care for their flock? And what was to be said for them at all if they couldn't even fish properly?

Artists who painted this sort of comic ecclesiastical picture came predominantly from France, Belgium, Italy, Spain and southern Germany, all Roman Catholic countries where political conflict between liberal state and conservative Church, exacerbated by jealousy of the wealth of certain religious orders, had promoted anticlericalism. The most rigorous anticlericalist painter was Gustave Courbet. In his *Return from the Conference*, drunken priests are shown rollicking home on a country road, gross rather than comic. A Vibert, a Croegaert or a Brunery is underpinned less by hatred than by humour: it provoked a wry grin in the spectator, rather than sending him out to man the barricades.

Nonetheless, there was often a sting in the joke. Brunery shows a cardinal reading a newspaper distracted by a fly that settles on his nose. At first sight, this is merely comic. But looking closer one sees that the newspaper is *La Croix*, the reactionary Catholic journal that maintained a resolutely anti-Semitic line in the Dreyfus affair; in this context the proximity of the fly to the cardinal's person can be read as an image of decay. In Vibert's *The Indulgence*, a plutocratic cardinal happily examines a poster advertising indulgences; again, closer inspection reveals evidence of a different sort of indulgence on the part of the cardinal: he is smoking a cigarette and beyond is a table richly laden with food and drink. In another Brunery, an eminent cleric awkwardly dandles an infant on his knee, while a pretty young nurse looks on. This is comic enough, but does the title of the picture, *The Cardinal's Nephew*, hint at the possibility that the relationship is even closer?

Two Spanish painters of ecclesiastical genre, José Gallegos (1859–1917) and Pablo Salinas (1871-1946), offer an interesting thematic subsection. They specialized in the close juxtaposition of priests and pretty young women, in a variety of scenarios. The

George Croegaert, *Private Indulgence*, oil on panel, *c.* 1890

confessional gave excellent opportunities for prurient delight
(often manifested in exaggerated expressions of priestly horror)
in the sins being admitted to by attractive girls with large breasts
in shadowy churches. Salinas's cardinals attend tea parties given

Francis Bacon, *Untitled (Pope)*, oil on canvas, *c.* 1954

by rich and beautiful women and grin lasciviously at their hostesses' opulent endowments. No one has yet written a thesis on the significance of Pablo Salinas (who lived until 1946) to the anticlericalism underpinning the Nationalist agenda in the Spanish Civil War, but it is perhaps only a matter of time.

The higher reaches of the Roman Catholic Church continue to provide subject matter, even for artists of impeccable modernist credentials. Francis Bacon paints popes who scream. Maurizio Cattelan creates popes who fall over. There is an enduring anticlerical agenda here, reflecting the broader truth that irreverence for the institutions of the Establishment has long been a theme that sells works of art rather well.

Conceptual Art

The pile of sweets assembled by Félix González-Torres and exhibited on the floor of the Tate Gallery is a much-quoted example of Conceptual Art. The original sweets might perish, or be filched by hungry art-handlers, but the work itself is allowed to be replenished with new sweets, or indeed exhibited on the other side of the globe comprised of a whole new set of sweets. That makes it, of course, infinitely repeatable. But only the pile of sweets assembled by the person in possession of the certificate of authenticity issued by the artist or his estate can claim it as the original.

Implicit in Conceptual Art is the principle that the idea, or concept, is more important than the execution of the work. With a Duchamp ready-made, with texts as paintings, even with

The famous pile of sweets: Félix González-Torres, *Untitled (Lover Boys)*, installation with individually wrapped candies, 1991

the Surrealism of Magritte, the impact is created – in varying degrees – by the idea of the object, rather than by the quality of its execution, which is at best purely functional, a means to the end of expressing the concept. In fact in some cases the execution becomes irrelevant, with the problematic result for the art market that there is no durable physical work of art to trade.

Market ingenuity rises to the challenge, however. Ownership of an idea becomes a viable commercial proposition: it can be bought and sold in the same way as ownership of a physical

painting. The physical manifestation of a work of Conceptual Art is not so much a work of art as a record of the idea of that work of art. Such records of the physical manifestations of pieces of Conceptual Art can also do duty as 'tradeable' objects, standing in a similar relationship to the idea as a print to the original painting that it reproduces, or the bronze cast to the original sculpture. But sometimes it is simply a certificate that changes hands, a bit like a share certificate, to be framed and traded on at a profit in due course.

Eroticism

I may not be the most reliable authority on erotic art, having published a novel that won the London *Literary Review* Bad Sex Prize in 1994. It was an embarrassing experience to be judged to have written the worst passage about sex in any British novel that year. It also confirmed one thing to me, that what constitutes good or bad erotic art is subjective territory. This first dawned on me at Cambridge where, most mornings of my undergraduate life, I worked in the library of the Fitzwilliam Museum. Getting there involved a pleasant stroll through several galleries, the long view through which was dominated at the far end by Titian's *Rape of Lucretia*: Tarquin, one knee bent on the edge of Lucretia's bed, leans imperiously over the struggling naked figure of Lucretia with his arm raised to force her submission. She is disconcertingly plump. I remember my supervisor, Professor Michael Jaffe, asking me if I did not feel that this work was a masterpiece of eroticism. I was too overawed to disagree

but felt privately that there were two other works in the Fitzwil-
liam Collection much more deserving of the description. These
were Hogarth's pair of paintings *Before* and *After*. In the first a
young man presses his attentions on a young woman in a wood-
land glade. She seems recalcitrant. The second shows them as
they lie back panting, her resistance having proved flimsy, their
disarranged clothes testament to the urgency of their recent
coupling. Titian had nothing to say to the undergraduate who
spent hot Wednesday evenings in the college disco; Hogarth (or
at least the first part of his sequence) certainly did.

If, as Rothko asserts, the purpose of art is the communica-
tion of emotion from the artist to the spectator, then shouldn't
erotic art be judged in terms of the amount of lust it provokes?
No: what is being communicated is a broader empathy for the

An eighteenth-century seduction: *Before* and *After* by William
Hogarth, oil on canvas, 1731

human condition in all its intimate physical detail, in the visual language of a merciless realism. 'In art,' says Rodin, 'immorality cannot exist. Art is always sacred, even when it takes for a subject the worst excesses of desire. Since it has in view only the sincerity of observation, it cannot debase itself.' Pornography treats the same subject matter but with the intention to titillate. If art provokes lust, then it's probably pornography.

It's fine to collect erotic art, and serious people do. It's more compromising to collect pornography. Thus the distinction has to be carefully demarcated, as much for the market's sake as for morality's. People will buy a work of erotic art. They won't buy it if it's sold to them as pornography. On that basis, it's important to remember that Schiele is not a pornographer, even when he depicts himself sitting astride a stool anxiously contemplating his own erection; he is not a pornographer even though most of his more intimate self-portraits, the drawings showing tortured

A piece of merciless realism (Egon Schiele, *Seated Woman in Violet Stockings*, gouache and black crayon, 1917)

and twisted contortions of his body and the guilty severing of his hand and limbs, can also be interpreted as images of masturbation. He is only a merciless realist. The same could be said for Courbet when he painted *L'Origine du monde*, a close-up of a woman's sexual organs, even though its original Turkish owner probably derived titillatory pleasure from it, hiding it behind a pair of velvet curtains in his Parisian apartment.

But some French Salon painters of the nineteenth century are pornographers, in the soapy, knowing coyness of their naked nymphs and Venuses. They can be redeemed and made acceptable to the market only if presented, with a superior irony, as objects of Kitsch [see **B**anality above]. Similarly Jeff Koons makes images that are frankly pornographic, for instance photographs of himself having sex with his muse La Cicciolina, but he doesn't sell them as pornography. He decontextualizes

[see Part V, **G**lossary] them and recontextualizes them as Pop Art. As such they are worth many hundreds of thousands of dollars. And though the image may remain pornographic, the work of art into which it is transformed isn't. If you see what I mean.

The key to selling erotic art successfully is to emphasize the art rather than the sex. Don't say to the client: 'Look at the incredibly provocative way her skirt's riding up her thigh.' Do say: 'What an uncompromising piece of realism.' Or: 'What a marvellously ironic visual take on our consumerist society.'

Exoticism

A Delacroix from his first African journey of 1832, a Van Gogh ink drawing of Provence in Japanese reed-pen, a Gauguin of Tahiti: these are highly desirable works by three of the most sought-after names in the present-day art market. Why? Because exoticism sells. People respond to artists who draw on their experience of distant or unfamiliar parts of the globe to create images that shock, amuse, innovate, titillate or induce wonder and awe.

From the sixteenth century onwards, Italy was the place of artistic pilgrimage, simultaneously the source of excitingly different landscape, light and customs, and of the ultimate standards of beauty. Then at the beginning of the nineteenth century North Africa and the Arab world began to open up. The pioneer orientalists, French painters such as Delacroix and Théodore Chassériau, gravitated to the east as romantics in search of adventure and uncovered a rich seam of novel and colourful

subject matter for successive generations of visiting European painters. Japan became accessible in the middle of the century, and the discovery of its indigenous art had lasting effects on European modernism. And at the end of the century Gauguin went to Tahiti in a renewed attempt to invigorate tired old Europe with the innocent virility of primitivism.

Italy

Italy was the first source of the exotic in art, certainly to northern Europeans. 'What are the pleasures of an Italian journey?' asked Stendhal in October 1824, and answered his own question as follows: 'To breathe a gentle, pure air; To see magnificent scenery; To have "a bit of a lover" [written in English in the original]; To see fine pictures; To hear fine music; To see fine churches; To see fine sculpture.'

For an artist, all the above attractions applied. From the sixteenth to the nineteenth centuries, a steady stream of painters from northern Europe coursed through the Alps to Rome, in the belief that by absorbing something of Italy's classical spirit and the sheer physical beauty of the country they might enhance their own art. Some artists returned home after a brief visit, others settled down for longer stays than they had planned, many came back again and again throughout their careers and a few, utterly seduced, simply never left. The stream from the north was swollen in the eighteenth century by the Grand Tourists, many of whom returned to their native lands not just uplifted by contact with magnificent originals from antiquity and the Renaissance, but bearing those originals with them as trophies of their great engagement with Italian culture.

French artists, some of them winners of the annual Prix

de Rome offered by the state, came to Italy to paint the land-
scape. The archetype here was Claude Lorraine, who created a
vision of Italy that would permeate the European imagination
for two centuries. His luminous, idealized evocations of the
Roman Campagna constituted a brand, a look, readily adapt-
able and redeployable on the landscapes of their own countries
by a number of inferior imitators, Dutch, Flemish and English.
Germans and Scandinavians came in increasing numbers from
the early nineteenth century onwards, particularly Danes. You
could take the Dane out of Denmark, but you could never quite
take Denmark out of the Dane, even when it came to painting
Italy. The Italian landscapes of Rorbye, of Eckersberg, of Lun-
dby, are unmistakable: they painted the Roman Campagna as
if it were lit by the glacial light of the Copenhagen sun. Even
into the twentieth century artists continued to flock to Rome,
Florence, Naples and of course to Venice (Boudin, Whistler,
Sickert, Renoir and Monet were all there in the years either side
of 1900). Italy as subject matter for an artist retains an enduring
appeal. Buyers will always be stimulated by the knowledge that
the landscape they are being offered depicts Italy. They recognize
they are approaching an artistic gold standard.

Stendhal's third reason for going to Italy (to have 'a bit of
a lover' as he puts it, lapsing tellingly into English) was also
a compelling one for visitors from northern Europe. It was a
northern prejudice to attribute the perceived libidinousness and
availability of Italian womanhood to the heat of the Italian sun.
Byron certainly agreed, contending that 'What men call gal-
lantry, and the gods adultery / Is much more common where
the climate's sultry.' Since then many things have changed in
Italy, of course, including the invention of air conditioning.

The Arab World

The first artist-travellers who arrived in North Africa found a civilization barely touched by western culture; its rich colouring, extravagant costume and unfamiliar customs provided a wonderful new range of subject matter to brighten the walls of the Paris Salon. The first generation of these painters, who became known as orientalists, saw themselves as observers and reporters, painting the fascinating everyday scenes they saw before them. 'I am really in a most curious country,' writes Delacroix from Tangier in February 1832. He goes on to record the intensity of light and colour, the lushness of the orange groves and the totally different rhythm of life of the people. 'It must be hard for them to understand the easy-going ways of Christians and the restlessness that sends us perpetually seeking after new ideas,' reflects Delacroix. 'We notice a thousand things in which they are lacking, but their ignorance is the foundation of their peace and happiness. Can it be that we have reached the end of what a more advanced civilisation can produce? In many ways they are closer to nature than we . . . We have gained science at the cost of grace.'

The second half of the nineteenth century saw painters from many other European countries converging on the Arab world. They roamed further afield: to Egypt, the Holy Land, Syria, Turkey and even Persia. As Théophile Gautier pointed out, the Middle East was usurping Italy as a place of pilgrimage for artists: 'There they will learn about the sun, study the light, find original characters, customs, and primitive, biblical attitudes.' But by the third quarter of the century, the path from the Salon to the Sahara was becoming rather too well trodden. In 1854 the English painter Thomas Seddon was already writing of Egypt: 'The country is a spectacle of a society falling into ruins, and the

manners of the east are rapidly submerging into the encroaching
sea of European civilisation.' As the Arab world became more
westernized, it lost much of its mystery and elusiveness, and in
turn the exoticism recreated by visiting painters grew more con-
trived and camp. Artists began to produce images of the Arab
world that were increasingly Europeanized, that is to say, pack-
aged for the easy consumption of the bourgeois patron in Paris
or London. Some even painted orientalist scenes without ever
setting foot in an Arab country. Why not? They had produced
convincing renderings of classical Rome or seventeenth-century
Holland without ever having been there.

There was one aspect of the Middle East that exerted a con-
tinuing fascination for artists throughout the century. That was
the harem, with its adjunct subjects the slave market and the
baths. When Maxim du Camp wrote of the Cairo slave markets
that 'people go there to purchase a slave as they go here to the
market to buy a turbot', the average European might outwardly
affect horror, but then again he might speculate rather wistfully
to himself the next time he passed the fishmonger. The public
baths were reserved for women in the afternoons, and were
visited by members of harems who brought their own personal
slaves to rub them down. Such massage scenes were pictorial
dynamite in the Paris Salon: often the slave would be black and
the concubine white, this contrast in naked female flesh being
dwelled on with particular relish. The erotic was shielded by the
exotic. Don't worry, the European public was reassured, these
are foreigners from a distant place; this is the way they behave.
But the naturalism of the depiction of the girls, their physical
reality, was not thereby compromised. Indeed one factor which
conveniently heightened the realism for the European specta-
tor of these paintings was that Muslim women were forbidden
to sit for artists, so most of the ladies portrayed are European

models, suitably decked out with eastern accessories. Indeed the line of division between the Parisian boudoir and the eastern harem becomes hazier as the century unfolds. The inhabitants of the harem, as portrayed in later orientalist paintings, with their cigarettes and languid poses, grow to resemble the *filles de joie* available in the French capital: only their setting is a little more exotic. This is the road that leads in the twentieth century to the romances of Elinor Glin, to Rudolf Valentino as the Sheik, to advertisements for Fry's Turkish Delight.

The geological accident of vast oil deposits beneath the lands depicted in many nineteenth-century paintings of Arab life has meant that the present-day descendants of the people portrayed have enormous wealth with which to acquire these desirable pictorial records of their culture in a past century. They are eagerly pursued: the market for orientalist paintings has been strong for some decades. Ironically the very pictures originally painted by Europeans to interpret the Middle Eastern world to other Europeans are now being bought and borne home in triumph by Arabs as emblems of their own civilization. Studied closely, they will tell their new owners just as much about the fevered dreams of Europeans.

Japan

If orientalism had an exotic – and lastingly popular – influence on the subject matter of European art, then Japonism had an even more significant effect on its style. The look of modernist European art in the second half of the nineteenth century would have been very different without Japan. A lot of what people like today about Impressionist and Post-Impressionist art can be traced to Japanese influence.

Ladies of the harem at the baths: an Arab fantasy by the French
academician Jean-Léon Gérôme, oil on canvas, 1881

In 1853 Commander Matthew C. Perry of the United States
Navy sailed his Pacific Fleet into Tokyo harbour. Japan had been
a closed country for two and a half centuries up until this point.
The arrival of Perry – a prototype for Pinkerton in *Madame
Butterfly* – was the beginning of the modern era of trade be-
tween Japan and the western world. With trade came cultural
relations. By the late 1850s examples of Japanese art were appear-
ing in the curiosity shops of Paris and London. They were a
sensation in advanced circles. People were fascinated by Japan,
this exotic closed society that produced objects of a strange
and novel beauty. Here was a wholly different tradition of art,
a completely new aesthetic. These pieces created an excitement
which reached fever pitch in Paris: the painter Whistler and the
critic Zacharie Astruc had to be restrained from physical vio-
lence over a particularly choice Japanese fan that they both came
across simultaneously in a shop in Paris.

The coloured prints and pen-and-ink drawings from Japan
made the strongest impact on artists in the west. By the time
of the great International Exhibition in Paris in 1867 Japanese
prints were everywhere and the names of Japanese draughtsmen
and printmakers such as Hokusai and Hiroshige were on every-
one's lips. This was particularly true among the Impressionists, a
generation in their impressionable twenties. What was it about
the Japanese aesthetic that so entranced them?

First of all, Japanese art was a novelty; it was excitingly dif-
ferent. Traditional art in Europe in the middle of the nineteenth
century had just about hit the buffers. Academic painting was
moribund. Romanticism was waning. What Japanese art offered
to young French artists was a stimulating new vision. It influ-
enced the design and composition of their paintings and it
influenced their approach to colour. The Impressionists adopted
the Japanese fondness for unusual vantage points in landscape,
for strong diagonals – often bridges or roads – that dissect the

Renoir's portrait of his sister-in-law Rapha shows how fashionable the
Japanese look had become in Paris in 1871, oil on canvas

picture space and lead the spectator's eye from the foreground to the background. The elimination of inessential detail that characterized Japanese prints, especially in their snow scenes, was important in helping the Impressionists achieve the immediacy they sought. They also learned from the Japanese how to exaggerate perspective foreshortening, and thereby funnel the spectator's eye quickly to the background of a scene, thus heightening the impact of the impression and emphasizing the overall envelope of atmosphere.

Then there was the Japanese fondness for arbitrarily cutting off compositions. In the hands of the Impressionists, particularly Degas, this device heightens the realism by echoing the randomness of everyday existence. The economy of the Japanese print opened up for Degas a means of rendering contemporary life more vividly than the painstaking detail of academic art permitted. Degas's friend Marie Cassatt went even further. Some of her prints of the late nineteenth century could almost be mistaken for Japanese originals.

The simplification of detail inherent in the Japanese technique encouraged painting in planes of pure, unmixed colour. The Parisian art critic Théodore Duret wrote in 1886: 'Before the arrival among us of Japanese picture books, there was no-one in France who dared to seat himself on the banks of a river and put side by side on his canvas a roof frankly red, a green poplar, a yellow road and blue water.' It could be a description of a Van Gogh landscape. Van Gogh was passionate in his admiration of Japanese art. He owned a collection of more than 200 Japanese prints, which sometimes feature in the background of his paintings, notably in his *Self-Portrait with Bandaged Ear*. He was also fascinated by Japanese draughtsmanship, particularly the reed-pen-and-ink drawings of Hokusai, a technique that Van Gogh redeployed to great effect amid the olive orchards of Provence.

Tahiti

As the nineteenth century reached its close, artists had to travel further and further afield to find the genuinely exotic. Gauguin's arrival in Tahiti in 1891 and his excited reaction to the colours and the mood of the South Seas echoes that of the first orientalists in North Africa. There is the same pleasure in untouched innocence, and the same anxiety that encroaching European civilization will shortly ruin the place. There is an element of sexual tourism, a relish of the relaxed morality of a primitive society. And the result is a further significant emancipation of European art under the influence of an exotic culture. In the South Seas Gauguin achieved a freedom of design and colour that had a lasting effect on the development of Expressionism in particular and western modernism in general. All this is reflected very clearly in today's financial valuation of works by Gauguin: to the market an example from his Tahitian period is in a different league of desirability from anything he painted earlier.

Genre

'There must be, of course, a certain healthy demand in London every spring for pictures which mean nothing,' wrote John Ruskin in a review of the Royal Academy Annual Exhibition in 1856,

just as there is for strawberries and asparagus. We do not always want to be philosophical . . . and all this is perfectly right and refreshing.

Nonetheless, a body that takes upon itself as its sole function, the supply of these modest demands of the British public, must be prepared ultimately to occupy a position much more corresponding to Fortnum and Mason.

A new patronage emerged in the nineteenth century, demanding a new sort of picture, and creating an international popular market for works that catered for the new buyer. What appealed in Munich generally appealed in London, Paris or in Rome: given minor regional differences, taste was remarkably uniform throughout all those European countries whose industrial revolutions and other upheavals had transformed the class of people who had money and the inclination to spend it on pictures. What was this new taste? Thackeray gave a perceptive analysis of it in 1843:

The heroic has been deposed; and our artists in place cultivate the pathetic and the familiar . . . The younger painters are content to exercise their art on subjects far less exalted; a gentle sentiment, an agreeable, quiet incident, a teatable tragedy, or a bread-and-butter idyll . . . Bread and butter can be digested by the very many . . . unlike Prometheus on his rock, or Orestes in his strait-waistcoat, or Hector dragged behind Achilles' car, or Britannia, guarded by Religion and Neptune, welcoming General Tomkins in the temple of Glory.

It is an enduring taste and is still popular today. The phenomenon which this new sort of 'bourgeois' painting represents is the triumph of genre, the depiction of everyday domestic scenes on as intimate – and often as trivial – a level as possible. Artists of the Academy still took off on the grand, ennobling flights of the imagination beloved of their forefathers, but with decreasing relevance. The second half of the century saw the proliferation of genre across Europe: from London to Moscow, from Madrid to Budapest to Stockholm, the official exhibitions were full of

Sir Lawrence
Alma-Tadema,
RA, transposes a
bourgeois Victorian
courtship to classical
antiquity (*A Peaceful
Roman Wooing*, oil
on panel, *c.* 1900)

saccharine infants being dandled upon their mothers' knees, of rosy-cheeked children engaged at play, often with animals whose heart-rending expressiveness of feature bordered on the human [see **A**nimals above], of old gentlemen exchanging dewy-eyed reminiscence of younger days in the cosy interior of some establishment purveying alcoholic beverages.

In the pursuit of genre, artists found new areas in which to indulge their public's taste for 'the pathetic and the familiar'. In the process an additional and characteristically Victorian pleasure was discovered and exploited, a pleasure that could be described as a pictorial delight in the invasion of privacy. What people were up to, particularly behind closed doors, became of consuming interest, and artists began to specialize in a keyhole vision of domestic incidents. Most important, the piquancy of such incidents was heightened by their placing in times or societies not immediately familiar to the contemporary spectator. Bulwer-Lytton wrote of 'the bond which unites [us to] the most distant eras – men, nations, customs perish: the Affections are immortal!' The public took a constant delight in being reminded by artists that people's emotions and behaviour in the past were essentially no different from those of the present.

Thus genre entered history painting, for example: a typical scene is laid on a sun-drenched Aegean terrace, *c.* 400 BC, sumptuously decked in flowers and populated by languorous Grecian ladies in attitudes of ease, exchanging the latest scandal of smart Athenian society. In a second such picture, a splendidly arrayed cavalier, his sword and plumed hat temporarily laid aside, holds in his arms yet one more of those timelessly sugary infants to the fatuous admiration of its onlooking mother. In yet another, a shimmeringly clad Regency lady moons about the shadows of a luscious garden, torturing herself with recollections of an unhappy amour. All these scenes are historical in that they

are drawn from the past, but they are a far cry from the grand, apocalyptic subject matter of the traditional history painter. All are essentially personal, private revelations, calculated to maintain a popular link with the present by emphasizing the timeless domestic or human element with which everyone could identify.

It is possible to interpret what is happening here in terms of modernist art criticism, as a process of decontextualization [see Part V, **G**lossary]. The original contextualization is as genre, the everyday human experience of the present day. Genre is then decontextualized to become timeless and placeless. Its recontextualization is as 'antique genre' or 'historical genre'; or indeed as 'ecclesiastical genre' or 'orientalist genre', because it was not just the past that was raided for this sort of trivializing exploitation. Artists also turned for tempting subjects to areas removed from the contemporary spectator not so much by time as by geographical, cultural or social distance. For instance, the large number of nineteenth-century pictures of cardinals shown in intimate episodes in their palaces, or of monks at play in their monasteries, seem at first sight a curious iconographical phenomenon [see **C**ardinals above]. In fact they are part of the same urge to see behind closed doors, here of the Vatican or the cloister, to savour the intrusion into a rarely penetrated privacy which nonetheless reveals the same trivialized everyday human experience. A similar voyeuristic vision, often mixed with an element of coy sentimentality, was turned on the Middle East [see **E**xoticism above].

This was painting to amuse and divert rather than to improve and educate. A popular culture had emerged, with different terms of reference from the old elitist art of grand history painting, meeting the needs of an expanded moneyed bourgeoisie who were not ashamed of their taste and preferences. 'The nation as a whole is middle class,' declared the English critic

Popular art: *Kittens at Play* by Henriette Ronner-Knip,
oil on canvas, 1898

M. H. Spielmann in 1898, 'and from those ranks have sprung
the greatest of her sons. So true is this that I believe not a single
work of importance by Sir John Millais, not in a National or
Municipal Gallery, is in the hands of other than "middle class"
people.' The French academic painter Meissonier, whose histor-
ical costume pieces were highly sought after by the middle class,
took the point further. 'Don't talk to me of works of art which
are overlooked by the public and appeal solely to the academic
taste of the initiated,' he declared. 'It is a principle I have always
controverted.'

It was the beginning of a lasting dichotomy between popular art and elitist art. It still exists today [see Part I, **M**iddlebrow *Artists*], with the difference that elitism is no longer represented by classical history painting. The new elitist art from 1900 onwards became what was produced by modernism and the avant-garde. Thus the major auction houses today sell paintings in categories that make this differentiation: Victorian pictures are offered separately from the rest, to meet the enduring popular taste for genre. Modern British, Impressionist and Modern, and Contemporary sales, on the other hand, cater for very different sorts of buyers of art, generally speaking a more earnest and serious-minded clientele. You don't tend to find a cardinal painted by François Brunery in the same collection as a screaming pope painted by Francis Bacon; nor a cat painted by Henriette Ronner-Knip in the same collection as a cat sculpted by Alberto Giacometti.

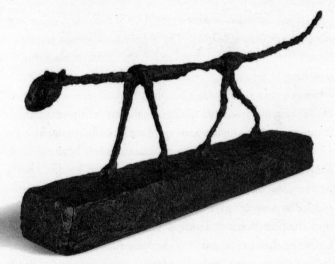

Modernist art: *Cat* by Giacometti, bronze, 1951

Historical and Biblical

History painting is difficult to sell. It is too histrionic, violent
or obscure for modern taste, and the iconography is perplexing:
not many punters at loose in the art market have had a classical
education. A historical theme treated with the frigidly camp ele-
gance of Neo-Classicism can still stimulate competition in the
saleroom. But its appeal is as a statement of interior decoration,
and the question of its subject matter will be a minor element in
its attraction, if indeed it is registered at all.

Modern demand for old master paintings depicting biblical
subjects is similarly weak, owing to a tendency for the subject
matter to involve death. A crucifixion dampens buyers' spirits.
People shy away from most scenes of martyrdom. The excep-
tion – for a specialist market – could be St Sebastian, the martyr
whose death (he's killed naked by arrow-shot) offers a certain
homoerotic appeal. One German gallery tried to exploit this
by selling St Sebastian pincushions in its museum shop, but
without a great deal of success. Other biblical scenes with more
chance of selling well include Susannah and the Elders (a nubile
young woman taking her bath spied on by male admirers),
David and Bathsheba (ditto), and that great epic of unsuccessful
seduction, Joseph and Potiphar's wife.

The above rules can, of course, be transcended in a great
picture by a major master. On the face of it the graphic depic-
tion of an act of mass infanticide should have been bad news;
but when Rubens's *Massacre of the Innocents* was offered for sale
at Sotheby's in 2004 the market forgot its inhibitions and bid it
up to £46 million [see Part IV, **M***issing Pictures*].

Impressionism

You only have to list the preferred subject matter of the Impressionists to understand why the movement is so popular and why people pay so much money for it. It's a pictorial antidepressant, anxiety therapy by dappled sunlight, as attested by the number of reproductions of Impressionist pictures you find in doctors' and dentists' waiting rooms. Here is a brief dictionary of Impressionist themes:

Beaches

Blossom

Bridges

Cafés

Concert halls

Conviviality (*no anguish, discord, death or disaster*)

Cornfields

Flags and bunting

Gardens

Holidays

Parasols

Picnics

Racecourses

Recreation

Repose

Restaurants

Sea views (*but not shipwrecks*)

Snow scenes (*preferably sunlit*)

Streets

Sunshine (*the better the weather and the brighter the colours, the more saleable the picture*)

Theatres

Undulating, unthreatening landscape (*nothing too precipitous*)

All you want from an Impressionist painting: Monet's *Lady with Parasol*, oil on canvas, 1876

Individual Artists

The list below comprises the fifty or so most expensive and sought-after modernist artists, the names you are most likely to find in a top-quality evening sale of modern art at Sotheby's or Christie's. But within the oeuvres of these artists there are some subjects and periods that are more desirable to the market than others [see Part I, **B***randing*].

BALLA, *Giacomo* (1871–1958) One of the leading Italian Futurists, and as such most sought after for his work in the few years leading up to the Great War when his art is at its most dynamic. Beware of his post-1920 work, however. It's anaemic. The fight has gone out of him.

BECKMANN, *Max* (1884–1950) This German Expressionist is valuable at most phases of his long career, but tends to be most sought after when most angst-ridden. His mercilessly pessimistic self-portraits are particularly prized, as are subjects involving his favourite model (and later wife), the ubiquitous Quappi. There is a resistance to the mild and the decorative in his work: some of his landscapes of the Mediterranean coast and blander still lifes are not strong enough meat for his admirers.

BOCCIONI, *Umberto* (1882–1916) Like Balla, an Italian Futurist; but unlike Balla he had the bad luck (but good market instinct) to lose his life on the battlefield in 1916. As a result what remains is largely the high-quality body of work he put together in the peak years of Futurism, including some masterpieces of Futurist sculpture (a rare commodity). His earlier work, painted in a more realistic and colourful divisionist

style, while less expensive than his Futurism, also attracts buyers (but generally different ones).

BONNARD, *Pierre* (1867–1947) His early Nabi paintings, works from the 1890s in a pared-down Japanese-influenced style, are very highly regarded; also his very colourful later landscapes. But the classic Bonnard is probably his series of nudes; his long-suffering model Marthe (later his wife) depicted in colourful interiors, just before or just after the process of taking a bath. But what really entrances buyers are the rare ones when she's actually in the bath, painted at strange angles with her legs oddly distorted beneath the water.

BOUDIN, *Eugène* (1824–98) This early Impressionist (from whom Monet learned a lot) is now a trifle old-fashioned. But I include him because the public response to his subject matter is an egregious case of social snobbery. Boudin's most desirable beach scenes depict the upper-middle classes at leisure with plenty of crinolines and elegant gentlemen in top hats. Appreciably less expensive are his beach scenes with humbler fisherfolk going about their business.

BRÂNCUŞI, *Constantin* (1876–1957) What the market wants from Brâncuşi is sculptural abstraction, heads reduced to ovaloid shapes and bodies expressed as thin, elongated curves. The more representational early work is less prized; prices start rising as his Lovers become less and less readable as entwining bodies and more and more monolithic as interlocked blocks of granite. Up until recently there was one left unguarded as the headstone on a grave in the Montparnasse Cemetery in Paris. Fortunately the first person to recognize it was an art historian rather than a thief and it is now in more secure safe keeping, insured for $20 million.

BRAQUE, *Georges* (1882–1963) Braque has three desirable phases in his career: the Fauve period, in 1905–6, when his colour is briefly as exciting as anything produced by Derain or Vlaminck; the Cubist period of 1909–14 when he and Picasso ('chained together like mountaineers') produced revolutionary works that are very difficult to tell apart; and a late period of Cubism revisited culminating in the monumental studio interiors of the early 1950s. But there is a phase of terribly boring and repetitive still lifes painted in the 1920s and 1930s in commercially suicidal earth colours.

CAILLEBOTTE, *Gustave* (1848–94) This great early patron of the French Impressionists developed into a highly talented Impressionist painter himself. His most desirable subjects are Parisian street scenes viewed from balconies or other odd vantage points. When his colour is high-keyed he can be almost as desirable as Monet. But there are less appealing phases of drabber colouring and treatments that are regressively conventional.

CÉZANNE, *Paul* (1839–1906) The market wisdom on Cézanne is that his most desirable subjects are his still lifes of fruit, particularly apples; slightly below those are his bathers; and then his unpeopled landscapes. But if the landscape shows Mont Ste-Victoire, an upward reassessment is called for. And a really great figure subject, ideally featuring card players, has been known to trump the lot. Cézanne, like his fellow post-Impressionists Gauguin and Van Gogh, is an artist judged by the market to have got better as he got older. His early works are strange improvisations somewhere between Delacroix and Guercino; his Impressionist phase is unremarkable; but in his late years he became so advanced that he almost invented Cubism. These are the works most prized by modernist collectors.

CHAGALL, *Marc* (1887–1985) The earlier the better with Chagall. What people want most are the works of his youth in Russia, or when he first came to Paris; failing those, the paintings of the 1920s or 1930s. His works of the 1950s or 1960s get increasingly repetitive, but are generally valuable in proportion to the amount of blue they contain. The relative merits of his subject matter are dictated by delicate religious nuances: frankly, crucifixions are bad news.

DE CHIRICO, *Giorgio* (1888–1978) The metaphysical period of the years 1910–17 is absolutely the peak for de Chirico, as the artist himself came to realize, repeating his compositions of that period throughout the rest of his life and dating them mendaciously early. His old master pastiches of artists like Canaletto, etc., no matter how hard you try to present them as modernist irony, cut little ice with the punters.

DALÍ, *Salvador* (1904–89) You can't do better than the 1930s with Dalí, when he marries his high-quality technique to a mad and compelling Surrealism. The higher the finish the better. Latterly his technique becomes lazy. A great portrait of the 1930s will do the trick. One of the 1950s or 1960s of a rich society lady won't.

DEGAS, *Edgar* (1834–1917) The most desirable works by Degas are generally regarded as his ballet dancers; then his bathers; lower down the list are his laundresses. His racing scenes come somewhere between his laundresses and his bathers. He is also one of those unusual artists whose graphic ability and innovation was such that his pastels are often worth even more than his oil paintings.

DELVAUX, *Paul* (1897–1994) This Belgian Surrealist painted some of his best work in the early 1940s. Later on it

becomes a trifle repetitive. The erotic content is important: his nudes make the market's heart beat faster, the bigger and the more oddly juxtaposed the better: in a railway-station waiting room, perhaps, or in the embrace of a skeleton.

DERAIN, *André* (1880–1954) There is only one period when Derain really matters: his Fauve years of 1905–7 (1904 is too early; by 1908 he has lost it). Yes to the high-intensity vibrant colouring. No to anything in which figures predominate, particularly after the First World War when his palette becomes depressingly darker.

DIX, *Otto* (1891–1969) The glorious years are the 1920s: street scenes, interiors, cafés, nightclubs of the Weimar Republic, perfect material for his unflinchingly cynical realism. There was also an early phase of Dadaism, much sought after. Be careful of anything later: Dix reached an unfortunate rapprochement with Nazism and his work of that period becomes to today's taste politically and therefore aesthetically unacceptable.

ERNST, *Max* (1891–1976) The most expensive and desirable works by Max Ernst date from the 1930s and early 1940s when he went through his phase of classic Surrealism. Early Surrealist works of the 1920s are the next most prized; and after those the works of the 1950s and 1960s. People like his surfaces: the more pronounced and contrasted the effects the better (collage, frottage, etc.).

FEININGER, *Lyonel* (1871–1956) Most sought after are the colourful, elongated, faintly fairy-story figures that populate his compositions of 1908–14. Thereafter he became more Cubist, and often less colourful, which makes these later works relatively less expensive.

The ideal Cubist: Jean Gris: *Le pot de géranium*, oil on canvas, 1915
A less desirable, later Jean Gris: *Pierrot aux mains jointes*, oil on canvas, 1924

GAUGUIN, *Paul* (1848–1903) There is a similar progression with Gauguin to that of Cézanne. His early, straight Impressionist works are less prized than what came after. The paintings of his Pont-Aven period (late 1880s), when Brittany peasants are miraculously transformed into colourful symbolist fantasies, are appreciably more expensive. But they are trumped by anything done once he decamped to Tahiti (1891 onwards).

GIACOMETTI, *Alberto* (1901–66) The Giacometti look – long, emaciated, nobbly bodies expressive of vague existentialist angst – is what people really want. His early work would have curiosity value. But as with most modern sculptors, there is a major price differential between bronzes cast in the artist's lifetime and those turned out posthumously.

GRIS, *Juan* (1887–1927) Spanish Cubist, friend of Picasso and Braque. His work follows the same trajectory as theirs:

the best is that executed between 1913 and 1916. Gris adds the welcome element of colour to his work in that period, often missing from the others. But his Cubism of the 1920s, which is repetitive and stylized, is rather less sought after.

JAWLENSKY, *Alexej von* (1864–1941) Unquestionably his most expensive work is the series of very Expressionist portraits that he produced in the years leading up to the First World War. The best have a jagged blue haze round their contours, as if framed by lit gas rings. His post-war work is more meditative and less expensive, as if the gas has been turned off.

KANDINSKY, *Wassily* (1866–1944) In order of commercial preference, the phases of his career are as follows:

1. The chaotic compositions of 1913–16 when all natural representation is finally drained from his madly colourful shapes and abstract art is invented

2. The great Expressionist pictures of 1908–12

3. The Bauhaus-influenced more geometric abstraction of the post-First World War years

4. The late abstract works on black backgrounds

KIRCHNER, *Ernst Ludwig* (1880–1938) In many ways the leading German Expressionist, and his prices reflect it. A great Berlin pre-war street scene has made $37 million. After the First World War, in common with so many of his Expressionist colleagues, Kirchner went off the boil, painting pleasant but less challenging scenes of the mountains round Davos where he went to live. Kirchner did two things that damaged his brand: one, he was fond of retrospectively redating his first Expressionist works, making them a year or two earlier in order to increase his own art-historical importance; and two, he would

also rework in the 1920s some pre-First World War composit-
itions, thus devaluing them to today's market.

KLEE, *Paul* (1879–1940) Because he's a visual poet who
deals in fantasy, his subject matter is difficult to quantify com-
mercially, and a masterpiece is possible at any date in his career
(though the later the less likely). Watch out for anything eman-
ating from his trip to Tunisia with Macke in 1914: it will be
rare, colourful and painfully desirable.

KLIMT, *Gustav* (1862–1918) The market prizes most
highly his beautiful women of the Viennese belle époque
painted in his trademark mosaicized art nouveau manner; next
are the jewelled, often square landscapes of Austrian lakes done
from 1910 onwards; and after that the moodier, darker, more
symbolist lake, wood and meadow views done around 1900, his
'soul-scapes'. His early work, highly wrought academicism of the
1880s and 1890s, is less desirable.

LÉGER, *Fernand* (1881–1955) Another artist whose
pre-First World War Cubism marks a price high point. Not
surprisingly, the most expensive work by him is a Cubist study
for *La Femme en Bleu* done in 1913. His post-Great War work
is uneven and often dull. There is only so much redeployment
of life in terms of cylinders and cones that people can take. His
post-Second World War paintings on a large scale – workers on
scaffolding, for instance – carries a decorative appeal.

MACKE, *August* (1887–1914) Excitingly short-lived Ger-
man Expressionist painter. The paintings he made in Tunisia in
1914 are particularly colourful and sought after; the brevity of
his life is an object lesson to the other German Expressionists,
none of whom did much worthwhile work after 1918; also to
the Fauves in Paris, who lost momentum after the same war [see
War below].

MAGRITTE, *René* (1898–1967) The darling of Surrealism, and a famous Belgian, in itself something of a Surrealist paradox. It is difficult to impose a price hierarchy on his subject matter, but some themes are particularly desirable: bowler hats, pipes, and the L'Empire de la lumière series. His belief that bad painting could constitute good art took him through a self-mocking Renoiresque phase in the 1940s, which is not so sought after.

MALEVICH, *Kazimir* (1878–1935) The ideal Malevich is painted as soon after his invention of Suprematism (1915) as possible. Suprematism is a pure and abstract Cubism, so the ideal Malevich is also simple, geometric and colourful. Subject matter is reduced to squares, rectangles and circles, though just occasionally a cross is introduced, which is well worth looking out for.

MANET, *Édouard* (1832–83) The work of the father of Impressionism doesn't come up very often, and when it does it can look a trifle old-fashioned. The market wants high colour and familiar Impressionist themes [see **I**mpressionism above]. Examples that fail to deliver on either count are less in demand.

MARC, *Franz* (1880–1916) Rare and in demand, because of his early death in the Great War. What might have been is always more alluring than what was. A prominent figure in Der Blaue Reiter (The Blue Rider) Expressionist Movement, Marc's horses are his ideal subject matter, expressive of all the dynamism that he stood for. Compositions featuring cows and pigs are less exciting to the market.

MATISSE, *Henri* (1869–1954) Matisse's greatest period is still reckoned to be his Fauve years; it's just that major works from that time never come up. What would *The Dance* (1909)

be worth? [see Part V, **M**oney]. Meanwhile his Odalisques –
sinuous female nudes set in colourful interiors – and still-life
subjects are highly prized; likewise the cut-outs, collages of
coloured shapes that he put together later in his career; less
desirable are some of his post-Fauve landscapes when drained of
colour, and interiors with faceless or miserable-looking women.
What a difference a smile makes [see **A**nger and Angst above].

MIRÓ, *Joan* (1893–1983) In terms of financial value per
square centimetre, it is hard to beat the series of Constella-
tions that Miró painted in the 1940s: tiny jewelled watercolours
packed with spidery signs and symbols. Look out for blue, too:
the artist felt that blue was the colour of his dreams, and the
earlier Surrealist compositions are more highly prized if blue
rather than, say, brown. Later in life Miró was like Picasso,
revisiting old favourites and regurgitating them simply. The
uncomplicated late compositions with lots of colour (ideally
the colours of the Spanish flag) are easily absorbed and good for
nervous beginners.

MODIGLIANI, *Amedeo* (1884–1920) Top of the
Modigliani subject hierarchy are unquestionably his female
nudes; it's a moot point whether they are more desirable to the
market horizontal or vertical. Certainly his clothed portraits are
preferable vertical, the more sinuous and long-necked the better.
Less in demand are the scratchier, earlier portraits. But an early
Caryatid is always good news. His sculpture, too, is highly desir-
able in as much as it echoes primitive cultures, but beware of
myriad fakes. On the whole the market is grateful for his early
suicide. He could have become weak and repetitive had he lived
longer.

MONDRIAN, *Piet* (1872–1944) Although his earlier,
representational landscapes are collected, with Mondrian it

has to be his abstract grids. Rarely has an artist been so clearly branded. What is interesting is which colours work best commercially. Yes, you need combinations of the three primary colours, but you cannot imagine the most expensive excluding an element of red [see Part III, **C***olour*].

MONET, *Claude* (1840–1926) The classic, enduring, ever-popular Impressionist, who never forgot that the appeal of the Impressionist picture is the simple formula of light and colour. His earlier works – summer meadows, beach scenes, sunlit snowy landscapes – are perennially in demand. But the late series-pictures are even more expensive now, and in this general order: 1. water lilies, gloriously proto-abstract; 2. Rouen Cathedral, the sunnier the better; 3. poplars; 4. haystacks, as formless and light-filled as possible. Generally speaking not prized for his figures, unless in a minor role subsidiary to their landscape, ideally wielding a parasol.

MOORE, *Henry* (1898–1986) One of the few British artists to feature in the top fifty modernists; a glorious exception to Byron's theory that 'a British sculptor is no more likely than an Egyptian ice skater'. What is prized in Moore is monumentality, recumbent shapes, the mute expressiveness of his figures, holes that connect the two sides of the sculpture (as he put it), and his early unique 'direct carvings' of the 1920s and 1930s. Works featuring wires and string are also desirable. His sheep excite the market less.

MUNCH, *Edvard* (1863–1944) Munch produced one image of such fame and familiarity – *The Scream* (see Part I, **I***mages (Famous)*) – that all else is in its shade, commercially at least. The works of the particularly angst-ridden 1890s are generally his most expensive, particularly those that focus on his anguished relationship with women – *Melancholy, Jealousy,*

Vampire are all good news. His twentieth-century works, often landscapes, are blander and less expensive.

NOLDE, *Emil* (1867–1956) What you want from Nolde is colour ladled on with thick impasto in a primitivist technique. His subject matter – woods, flowers, seascapes – and his style changes little over his career; thus a work of the 1950s can be almost as valuable as one of the period 1908–14, a rarity among the Expressionists, most of whom are felt to have gone off badly after the First World War.

PICASSO, *Pablo* (1881–1973) Our retrospective perception of Picasso is a constantly shifting kaleidoscope, in which first one phase of his life seems pre-eminent and then another. From the strictly commercial standpoint, the different stylistic stages through which he passed can currently be ranked as follows in terms of popular esteem (and therefore price):

1. The Marie-Thérèse period, 1930–35. Collectors respond to the eroticism, the colour and the lyricism. Here the really big trophies are hunted and brought home.

2. The Blue/Pink Periods, 1902–8. Images of great beauty and pathos of young children and acrobats.

3. The Dora Maar period, late 1930s and early 1940s. Passionate, tough images. His women weep a lot, as well they might.

4. Neo-Classicism of the earlier 1920s. The reversion to the inspiration of antiquity produces pure draughtsmanship and timeless images.

5. Cubism, 1908–14. Art historically incredibly important; he and Braque are 'two mountaineers roped together'. But very earthy colours and high intellectual content limit the commercial appeal.

6. The randy old goat years, 1960–73. In the last years of his life he was animated by a sort of senile priapism, which produced some very lazy paintings indeed, and the occasional masterpiece. This phase is adulated by contemporary art collectors responding to the bigness, the irreverence, the freedom.

7. The late 1940s and decade of the 1950s. A less interesting phase, with the exception of the one outstanding masterpiece series, *Femmes d'Alger*.

8. Surrealism, late 1920s. Picasso half-heartedly embraced Surrealism, and it was a relatively anaemic phase until his art was invigorated by his passion for Marie-Thérèse.

But five years hence this list may be very different. Even after his death, the perception of Picasso is as vibrant and changeable as it was when he was alive.

PISSARRO, *Camille* (1830–1903) The most expensive Pissarros are his panoramic Parisian street scenes taken from high vantage points done in the last years of his life. There must be roads and traffic and figures. His fully pointillist landscapes are also prized, as are the rustic scenes that include peasants harvesting. Least sought after are his slightly unfortunate nude bathers in landscapes.

RENOIR, *Pierre-Auguste* (1841–1919) Renoir painted around 6,000 pictures. Not all of them are good, particularly not the late works done when he suffered cruelly from arthritis. The classic Impressionist works of the 1870s and 1880s are still the most sought after: he is the reverse of Monet in that his early works are the most desirable and his figure subjects will generally be more valuable than his landscapes.

RODIN, *Auguste* (1840–1917) A definite hierarchy of subject matter exists: 1. *The Thinker* or *The Kiss*; 2. *Eve* and *The Age of Iron*; 3. any female form in attractive mythological or allegorical nudity, for example *The Eternal Spring*; 4. monumental works such as *The Burghers of Calais*, *Balzac* or *The Gates of Hell*.

SCHIELE, *Egon* (1890–1918) Schiele caught a fatal dose of the Spanish flu in 1918 aged twenty-seven. From a market point of view, it may have been for the best that he left behind only a relatively small oeuvre of very intense quality. There are two varieties: Schiele-Strong and Schiele-Lite. Schiele-Strong is tough, challenging, sexually explicit. Schiele-Lite is prettier. His best landscapes are highly sought after, possibly because they combine a bit of both.

SEURAT, *Georges* (1859–91) The leading artist of neo-Impressionism, or Pointillism, died young, which makes his work simple to quantify commercially: the later the work, and the more purely Pointillist, the better. His early, straight Impressionist work is a less valuable curiosity. Also very highly prized as a draughtsman.

SEVERINI, *Gino* (1883–1966) As with all the Futurists who survived the Great War, he is only really valuable in the few years from 1909 to 1915, at the Futurist apogee. Thereafter there was a descent into the decorative.

SIGNAC, *Paul* (1863–1935) Neo-Impressionist operating in the slipstream of Seurat; like Seurat he is most prized for his pure Pointillist works of 1888–90. Unlike Seurat he went on long into the twentieth century, and his late works are repetitive and less expensive. They are bought for their colour, and for their locations, as he had the foresight to paint places in which today's rich local collectors reside, for instance Istanbul.

SISLEY, *Alfred* (1839–99) The ideal Impressionist land-scape by Sisley is easily prescribed. It should feature: 1. blue skies; 2. water in which the blue sky is reflected; 3. foliage through which plays dappled light; and 4. it should measure at least 60 × 73 cm. The absence of any one of these elements will reduce the value.

SOUTINE, *Chaim* (1893–1943) Soutine is tough, in subject matter and technique, and is explicitly valued as such. You want thick impasto with Soutine, evidence of plenty of paint liberally applied. And his most expensive subjects include challenging works such as his slaughterhouse pieces, great slabs of meat painted in bold Expressionist brushstrokes.

TOULOUSE-LAUTREC, *Henri de* (1864–1901) Early on Lautrec painted horse pictures, and then rather depressing servant girls in a heavy realist style. These are less desir-able to the market than what he produced after 1890 when he blossomed into a painter of cafés, circuses, brothels, dance halls, treated in large areas with flat poster-like colour. He is the origin-ator of a visual brand, that of stylish, raunchy belle-époque Paris.

VAN DONGEN, *Kees* (1877–1968) Van Dongen is another Fauve painter whose most desirable works were produced in the vintage years of 1906–14. He specialized in attractive women painted in very highly charged colours, both literally and cosmetically. After the First World War he kept going on the same themes, but date is important and he is less highly valued in these later works.

VAN GOGH, *Vincent* (1853–90) The financial value of paintings by Van Gogh are very clearly defined by his chrono-logical development as a painter and colourist. First comes the Dutch phase (1880–85) when he struggles mired in the earth

colours of the lowland palette; then comes the Paris phase (1885–7) when he is awakened to modern art and his palette lightens somewhat, which is reflected in a markedly higher level of prices in today's market. Finally there is the full flowering in the light of Provence (1888–90) when Expressionism is invented, ears are mangled, asylums are entered, and all price records are broken.

VLAMINCK, *Maurice de* (1876–1958) Another example of a French Fauve artist who was marvellous early on but declined disastrously later. The landscapes he painted around 1905 under the influence of Van Gogh are as good as anything that the Fauve Movement produced and are recognized as such by the market. But his view of nature became darker and more repetitive later, which is reflected in his prices.

VUILLARD, *Édouard* (1868–1940) Like Bonnard, Vuillard's early Nabi works are prized by the market, as are his closely observed self-portraits. His intimist interiors are also sought after, unless (as happens in the 1920s and 1930s) they become too heavily weighted with bourgeois fittings, making them dated and less saleable.

Innovation

Just before the First World War, the London art world was subjected to two shocking experiences: in 1910 and 1912 the critic Roger Fry put on exhibitions of Post-Impressionist art in the Grafton Gallery that were devastating in their newness. Works by French Fauves and Cubists were revealed to the British public

Paulus Bor (*c.* 1601–69), *Seated nude bathing by a stove*: an old
master given extra appeal by its appearance of modernity

for the first time, to astonishment and outrage. Lytton Stra-
chey observed in awe in December 1912: 'I must say I should be
pleased with myself, if I were Matisse or Picasso – to be able, a
humble Frenchman, to perform by means of a canvas and a lit-
tle paint, the extraordinary feat of making some dozen country
gentlemen in England, every day for two months, grow purple
in the face.' More to the point, even among the cognoscenti
barely anything found buyers.

Today newness sells. That is the biggest change in art over the

past century. One hundred years ago new art, what the avant-garde produced, was shocking to people, and took time to be assimilated. Now, unless art is new, it is felt to lack something. This is reflected in the market for contemporary art, where the new gets its first commercial exposure and validation. As a category of sales at the international auction houses, Contemporary Art now sells more than any other, a turnover markedly greater than the Old Master Department, and larger even than the Impressionist and Modern departments. There has never been a time in history when contemporary art has been as important as it is today.

In fact, contemporary art stands in a changing relationship to older art. In order to build up the perceived importance – and therefore value – of a work of contemporary art being offered for sale, the catalogues of Sotheby's and Christie's often illustrate comparable paintings or sculptures of earlier eras. Sometimes the connections are a trifle tenuous; but hauling, say, Botticelli's *Primavera* into the catalogue note on a Jeff Koons acts as a reassurance that the Koons is anchored in a great tradition of western art. The comparison with the old validates the new, gives it gravitas. But the process is beginning to go the other way, too. When Damien Hirst showed his new paintings in the venerable surroundings of the Wallace Collection in 2009, there was a sense in which the Wallace Collection was being honoured by the irruption of Hirst in its midst rather than the other way round. Contemporary artists such as Leon Kossoff have in recent years been given official rein to prowl the National Gallery, London, to make copies of great works of the past; those copies have then been exhibited by the National Gallery with considerable fanfare alongside the originals. It is hard to resist the conclusion that contemporary artists – whose sex appeal to the public is of rock-star proportions – are now being let loose in museums of

old masters in order to validate the older art. And, in brutal market terms, old masters are in some need of that validation.

Interiors

Paintings of interiors are fashionable and sought after. There is something finite and resolved about an interior as a subject; the sense of enclosure is pleasing to both artist and viewer.

Vilhelm Hammershøi: a desirably silent, unpopulated Danish interior, oil on canvas, c. 1900

Sometimes a carefully contrived view out of the interior through a window can add piquancy. Particularly good news as subjects are:

1. Grand drawing rooms

2. Bathrooms (if by Bonnard)

3. Hotel rooms in Nice by Matisse

4. Deserted Danish rooms with a single chair

5. Artists' studios, *c.* 1820, with open windows and distant views of Rome

6. Garrets, also with open windows, and Parisian rooftops glimpsed beyond

Church interiors are less in demand.

Landscapes

Identifying the location of landscapes can make an enormous difference to how much people are prepared to pay for them. An anonymous nineteenth-century hilly landscape is worth a lot less than that same landscape pinned down topographically as showing Sydney, Australia, or as an early view of Rio de Janeiro. But one can come to grief this way. I once found a pencil inscription on the back of a nineteenth-century watercolour entitling it *Mount Nog*. This sounded like New Zealand, and I duly entered it into the Australasian section of a sale of pictures

of topographical interest. The day before the auction it was pointed out that the inscription was in fact a framer's instruction, and read 'Mount no. 9'.

An English eighteenth-century landscape with, say, a cricket match going on in the middle distance is in Britain worth a lot more than the same landscape without the cricketers. Even a hot-air balloon floating in the sky can add value. But beware: the temptation to get their restorers to insert cricketers, or hot-air balloons, into otherwise run-of-the-mill eighteenth-century landscapes was too great for some unscrupulous picture dealers of the earlier twentieth century.

Much the same rules apply to seascapes as to landscapes. Calm seas are the most desirable. The choppier the waters the less saleable the work. This presumably reflects the normal reservations about bad weather, coupled with a residual fear of seasickness. And be careful to look at the date on anything signed by Thomas Luny: this minor English marine artist of the early nineteenth century had the misfortune to suffer arthritis in his hands even worse than Renoir. He took drastic measures to continue painting. Late Lunys are noticeably coarse, and rumoured in the art market to have been painted with his toes.

Views of towns and cities are almost always more valuable once identified. Some locations are definitely more sought after than others. Venice is certainly very near the top, as are Rome, Florence and Paris. In the hands of the Impressionists, Rouen Cathedral is worth a lot more than a view of the industrial quarter of the town. Factory chimneys tend to be a problem. The emergence of rich Russian oligarchs in recent years has seen an increase in the desirability of views of Moscow and St Petersburg; similarly moneyed Turkish collectors have pushed up the value of townscapes of Istanbul.

Narrative Art

The great narrative pictures that so delighted our Victorian ancestors are out of fashion, but I have to confess to a weakness for them. They had their roots in the illustration of scenes from literature, which began to be painted in the late eighteenth century: Shakespeare, Walter Scott and Oliver Goldsmith inspired a wide range of artists, from Hogarth to Delacroix. By the second half of the nineteenth century, the genre had broken away from the moorings of literary pretext, and began telling stories invented by the artist himself. These subject or problem pictures gripped the Victorian and Edwardian gallery-going public, offering narrative clues which their audience became adept at reading, so as to interpret pictorial dramas almost as nuanced and intricate as a novel.

Alfred Rankley's *Old Schoolfellows* is an excellent example of Victorian narrative art. A man in his sickbed is comforted by a well-dressed male visitor who sits on the edge of the bed, clasping his hand. To the left stands a concerned young woman. We presume that she is the invalid's wife from the way her hand grasps the patient's arm. This would be forward in a nurse, but it's not impossible that she could be the sister of the patient. As ever, the drama is propelled by the title: *Old Schoolfellows*. So these two men were at school together. Since then their paths have diverged. The visitor is clearly prosperous, whereas the ailing man is holed up in what is little more than a garret, as one can tell from the view of rooftops visible through the window. A desk with an ink pot and pen is also positioned in the window, suggesting that the sick man has been trying to make a living as

Alfred Rankley, *Old Schoolfellows*, oil on canvas, 1854: all the
ingredients of a good novel

a writer, a precarious calling at the best of times but disastrous now that illness means he cannot work. More narrative clues: the half-empty medicine bottle on the table confirms his status as a patient receiving treatment. The bird in the cage in the top right is a symbol of entrapment, possibly that of the aspirant writer or possibly that of his young wife. A folded banknote of a reasonably high denomination is clutched in the hand of the prosperous visitor, to be discreetly handed to the woman as he leaves (to tide her and her husband over their present difficulties). The most telling detail is the book lying on the floor. It is Cicero's *De Amicitia (On Friendship)*, which emphasizes the ultimate point of the painting, its moral if you like, that suffering can be redeemed by friendship. The visitor to the 1868 Royal Academy who spent time studying this painting would have walked away moved, charmed and edified.

Titles were always important. Possibly the most famous Victorian narrative picture is entitled *And When Did You Last See Your Father?* In W. F. Yeames's famous composition a young boy, obviously the son of a particularly dashing cavalier on the run from Cromwell's men, is being grilled by a group of fierce-looking Roundheads. Will he give his father away? Surely not, he's obviously a plucky little fellow. But there is always the possibility that these grim-faced Puritan brutes will trick the information out of him. It doesn't bear thinking about.

The French didn't understand this British obsession with telling stories and pointing morals in paint. 'As a general rule it is safe to say that any picture that produces a moral impression is a bad picture,' wrote the Goncourts severely in 1860. Hippolyte Taine visiting London in the same decade complained that English painting's focus on anecdote meant that 'the pleasure of the eye, harmony, beauty of line and colour are all relegated to secondary roles'.

The wind was blowing with the French view. As modernist theory moved inexorably in the direction of Pure Form and aesthetic values, narrative content in painting became something so unspeakable that no one with an eye to their own credibility could afford to have anything to do with it. But later in the twentieth century it made a comeback, in Pop Art and the New Realism of the 1960s. It's no longer unacceptable to contemporary art buyers. Modern narrative art ranges from Bruce Charlesworth's 'who done it' installations to Richard Prince's Nurse series; and of course the ultimate narrative paintings are the quite lengthy jokes or stories that Prince and others create as sampler-like designs [see **B**anality above].

Nudes

Nudes will always sell, provided the models are good-looking human beings; not just females, but males too, although this is more of a niche market. Nudes catch the eye. They can be high-minded, allegories of virtues, exuding nobility and aspiring to timelessness; or they can be low-minded and erotic. Sometimes they can be both: surveying the mêlée of accessible-looking Nymphs, Venuses and Graces strung out across the walls of the Paris Salon in the 1860s, the French painter Jean-François Millet exclaimed: 'I have never seen anything that seemed to me a more frank and direct appeal to the passions of bankers and stockbrokers.'

In the nineteenth century artists got away with painting the unclothed human form provided they played to the rules and

Deeply cerebral bathers by Cézanne, oil on canvas, *c.* 1890

confined their nudity to distant settings like antiquity or the Middle East. The bankers and stockbrokers were happy to pay big money for them: nudes offered the opportunity to buy sex cloaked in the respectability of art. The trouble began, however, when the setting became contemporary. The brazen way that Manet's 'Modern Olympia' stares out of the picture at the spectator marks her out as a successful professional prostitute who makes no bones about her job in the Paris of the 1860s. Courbet's realism applied to the nude was similarly unacceptable. Napoleon III, having admired the simpering Venuses and odalisques at the Salon Exhibition of 1853, was then confronted with Courbet's uncompromising, unidealized *Bathing Women*. He actually struck out at the canvas with his riding whip in a gesture of fury. It wasn't so much the affront to morality that upset him as the hint it offered him of his own hypocrisy.

I used to wonder whether Scandinavian nineteenth-century

The gloriously accessible *La Belle Romaine* by Modigliani, oil on canvas, 1917

painting was an exception to all this nudity. Up until the 1880s official exhibitions in Stockholm, Oslo and Copenhagen seem to have contained far fewer nudes than further south in Europe. Only with painters such as the Swede Anders Zorn at the end of the century do nudes become more frequent. Were artists up until this point in the grip of a Calvinistic stranglehold, restrained by a grim Nordic puritanism? Then I realized that a more pertinent factor might have been the invention of central heating. Certainly this was a factor for Pauline Borghese, modelling daringly nude for the Italian sculptor Canova. Asked if she had not felt a little uncomfortable shedding her clothes in front of the artist, she answered, 'No, there was a fire in the room.'

The nudes of Modernism are similarly divided between the ideal and the erotic. One only has to compare the cerebral investigation of form that characterizes a Cézanne bather with the sexual allure of a Modigliani odalisque. But here one further feature of the modern art market has to be taken into account, the reassertion of Victorian morality represented by Middle Eastern buying. You might just sell the Cézanne to a middle eastern collector; the Modigliani would be a step too far for the new museum of an Islamic state.

Portraits

Portraits should be, in order of commercial preference: 1. of beautiful women; 2. of someone famous; or 3. psychologically penetrating. The reality is that pretty women by Sir Joshua Reynolds sell better than gloomy old men by the same artist, by

a factor of about ten. It doesn't matter how well the gloomy old man is painted. His price will never rival that of a pretty girl, even though she's much less well executed. It is quite extraordinary how otherwise discerning critics will declare a portrait to be beautiful when all they mean is that the sitter is beautiful. A good test, I find, of whether a portrait has commercial potential is whether you would want to find yourself next to the sitter at dinner.

Specific identification of the sitter is of variable desirability from a price point of view. If he or she is someone historically interesting, then it is clearly advantageous that they should be identified – e.g., Lady Hamilton. On the other hand, *Portrait of Mrs Tomkins* is sometimes less seductive than the more generic *Portrait of a Lady*. Paul Durand-Ruel, the Impressionists' dealer, once had to take back a Renoir portrait of a lady that her husband had commissioned then rejected as unsatisfactory. Durand-Ruel rechristened it simply *In the Roses*, shipped it out to America, and sold it for appreciably more than its asking price as a specific portrait.

But beware of faulty research. An eager and socially optimistic young specialist at Christie's once catalogued a painting of a lady as 'Portrait of the Marchioness of Reading'. When his identification was challenged, he pointed to the title on the back. 'There,' he said, 'look: it says "Lady Reading".' What he'd failed to observe was that she had a book in her hand. One other factor is the format of the portrait: I have noticed that there is often a premium on women depicted horizontally rather than vertically, but only if they are young and pretty. If they are dead, that premium instantly evaporates. Accoutrements can be important, too: if a portrait of an eighteenth-century young man can feature him holding a cricket bat, then that is much more commercially exciting than, say, a sword.

Of course some sitters who are otherwise unremarkable

human beings achieve immortality through being painted by a great portraitist. Why would anyone today be talking about Mr and Mrs Andrews if that upstanding but dull provincial squire hadn't had the good sense to choose Gainsborough to paint him and his wife? Conversely, some artists' names have been preserved only because they happened to paint an extremely famous sitter. Pepys commissioned a portrait of himself and one of his wife in November 1661 from an otherwise unknown artist named Savill. The picture of his wife that was delivered on 24 January 1662 did not please Pepys and he sent it back to be 'mended'. 'The painter, though a very honest man, I find to be very silly as to matter of skill in shadowes – for we were long in discourse, till I was almost angry to hear him talk so simply.' Poor Savill; but such exchanges with sitters and their husbands are an occupational hazard for portraitists.

The question of how much to flatter your subject is an important one for the artist. The fashionable British painter John Hoppner (1758–1810) was shamelessly pragmatic about it. He 'used to make as beautiful a face as he could, then give it a likeness to the sitter, working down from this beautiful state until the bystanders should cry out, "Oh! I see a likeness coming!" whereupon he stopped, and never ventured to make it more like.' The bystanders in Hoppner's studio, charged with the delicate judgement of precisely when to cry out, were making both an aesthetic and a commercial call.

There have been various golden ages of portraiture, and works from those periods have a price premium today, not least because they conjure a look of opulence that was satisfying to the original sitter and flattering to the present-day buyer's sense of his own status and worth. In Britain the fifty years either side of 1800 offered you Gainsborough and Reynolds, Lawrence, Hoppner, Romney and Raeburn. Another golden age ensued

'Oh! I see a likeness coming!': *Portrait of a Lady* by John Hoppner, oil on canvas, 1789

in western Europe in the belle époque, the years either side of 1900. An international style of portraiture emerged, taking the earlier 'swagger' look that could be traced back to the grand full-lengths of Van Dyck and sexing it up with a virtuoso display of Impressionistic brushwork. It was a look that spoke of money: only the rich could afford to commission it. You got it from Sargent in London, from Giovanni Boldini or Paul Helleu in Paris, from Anders Zorn in Stockholm or from Joaquim Sorolla in Madrid. But you had to be careful if you engaged Boldini to paint your wife. He was a notorious seducer, and sittings would be enlivened by the occasional chase round the studio.

The portraits painted by modernist artists are less concerned with flattery and creating a moneyed look than with formal experimentation and psychological penetration. And there is one category of portraiture where psychological penetration has always been most prized: that is the artist's self-portrait. The market values particularly highly the self-analysis and revelation that goes into an artist's painted reportage of himself. This is the painter stripped down to his own essentials. This is his self-memorial. The commercial assumption, generally justified, is that the artist is his own most demanding sitter.

Railways

I have a theory that railways are good news in paintings. People like trains. They respond to them as documents of a mechanical progress that is now part of history, nostalgic but still exciting. Railway lines in the city are symbols of efficient urban life; in

Giovanni Boldini, *Portrait of a Lady*, oil on canvas, 1913: probably executed in the intervals between the artist's amorous pursuit of the sitter around the studio

the country they have become absorbed into nature, cutting across the landscape with a satisfyingly geometric exactitude. They can be relied upon to take you where you want to go because they are fixed: as a metaphor for the future they are reassuring. But it wasn't always so. When first invented, they upset Delacroix, as he wrote in 1856:

Soon we shall be unable to go five miles without coming across those fiendish contraptions, railway trains. Fields and mountains will be ploughed up by their tracks: we shall pass one another like birds as they fly through the air. We shall no longer travel for the sake of sight-seeing, but arrive at one place only as a means of going somewhere else. People will journey backwards and forwards from the Bourse in Paris to the Stock Exchange in St Petersburg, for business will have its claims on everyone when the harvest no longer has to be reaped by hand or the land watched over and enriched by careful attention. This thirst for riches, which brings so little happiness, will turn us into a world of stockbrokers.

The mid-nineteenth-century railway revolution was a momentous one. Journey times between places were reduced dramatically, shrinking the world. Landscapes were redefined by the cuttings and tunnels and bridges that carried the rails remorselessly across the country. But such stupendous new technology inevitably increased the pressure on human beings. Delacroix articulates a contemporary anxiety about railways. His predictions about the impact that the sheer speed of this new mode of travel will have environmentally, socially and economically are perceptive. There will be no going back to the innocent age when all men did was till the land: he has seen the future with its increased opportunities for mindlessly efficient travel, and it's a world of stockbrokers. What he does not fully comprehend – how could he? – is the varied impact railways would have on art.

One of the earliest and most memorable artistic responses to the new phenomenon of steam-train travel was the painting Turner exhibited at the Royal Academy in 1844, *Rain, Steam and Speed – The Great Western Railway*. To describe it as a train crossing Maidenhead Bridge in a rainstorm is to do no justice to the wonderfully elemental evocation of steam power triumphing over geography and weather that Turner has achieved. The Impressionists, for whom the railways represented a subject matter totally in line with their determination to paint contemporary life, never achieved such a successful amalgam of atmosphere and movement. Monet's greatest train pictures are set in the Gare St-Lazare where for the most part the trains are stationary and he is able to concentrate on the almost abstract effects of steam billowing across the composition. Pissarro and Van Gogh paint landscapes in which trains meander across the composition, but they do so as adjuncts to contemporary life rather than as the main focus of its thrust.

Where the nineteenth-century railway came into its own was as an exciting new setting for the dramas of its genre and narrative painters. Julian Treuherz identifies two types of railway subject, those unfolding in the station and those in the coach compartment. The station is the place of farewell: where emigrants set off on the journey to Liverpool and on to America; where sad governesses bid tearful farewells to their indigent families; where young boys are dispatched by stiff-upper-lipped parents for their first term at boarding school. William Powell Frith's *The Railway Station* (1862) is the archetype here: all sorts of human dramas are played out on the platform in the moments before the train departs from Paddington: a foreign gentleman negotiates the fare with an exploitative cabby, a bride exchanges last-minute confidences with her bridesmaids, detectives arrest a criminal trying to board the train, tears are shed,

embraces exchanged. All human life is here. No wonder *The Railway Station* proved one of the most successful and popular paintings of the nineteenth century, viewed in the original by countless visitors to its exhibition in London and across Britain, followed by even more people who bought the print.

The train compartment, on the other hand, was a more intimate stage for human relations. It was a vehicle for investigations of class (literally, in that the pictorial dramas enacted in first class were markedly different from those in third). In first class, flirtations were conducted while chaperones fell asleep against a background of fur coats, rich upholstery and opulent travelling rugs; in third class there were fewer laughs: separation and suffering were often the themes of the lower classes against a background of bare wooden seats and windows open to the rain and wind.

The nineteenth-century railway boom had social consequences that also affected art and artists in less direct ways. The huge fortunes made in setting up railways gave huge amounts of new money to people, some of whom spent it on art for the first time. This encouraged artists to paint more pictures to appeal to bourgeois mercantile taste. But there was also a synergy between railway millionaires in America and Impressionist painting. New money liked the new French art. Marie Cassatt's family, for instance, had made its money in railways, and she encouraged her relations to invest in the work of her Impressionist colleagues in Paris. I also think that the railways had an effect on landscape painting by opening up areas of countryside to urban artists for whom they became accessible from London or Paris on day trips. Painters could set out for Argenteuil and other beauty spots along the Seine in the morning and be back in the city the same evening. In England, Surrey became a popular setting for landscapes exhibited at the Royal Academy for a similar

Railway platform drama: the sad governess sets off for her first job
(Frank Holl, *The Wide Wide World*, oil on canvas, 1873)

reason: its accessibility from London on a day return. Could the train timetables also have encouraged landscape painters to paint quicker, hence the spread of Impressionism as a technique?

The positive aesthetic impact of railways themselves on the landscape was appreciated surprisingly early, for instance by the French critic Champfleury, writing in 1859:

Nubile women juxtaposed with rolling stock (Paul Delvaux,
Le Train bleu, oil on board, 1946)

Leaning on a bridge, I contemplate with pleasure those grand iron
tracks, which can be charming in the absence of steam engines.
Bevelled slopes cut through green fields showing great sandy yellow
trenches, a blue sky, rail crossings and gentle curves, are these not
paintings just waiting for a new landscape painter? Industry mixed with
nature has its poetic side: the point is to see it and be inspired.

In the early years of the twentieth century, trains themselves take on a more highly charged artistic significance, particularly to the avant-garde. Artists start looking at them as emblems of the machine age and symbols of modernity. As such, the train as a motif is a positive element in the saleability of a work of classic modern art. The dynamism and velocity of trains was of particular excitement to the Italian Futurists. Marinetti, who could always be relied upon for a good quote, called on artists to celebrate 'the gluttonous railway stations devouring serpents . . . great-breasted locomotives, puffing on the rails like enormous steel horses'.

To the tormented modernist spirit of the early twentieth century the ineluctability of the railway line, which I find rather reassuring, took on disturbing intimations of predestination. The fact that once you got on a train there was no gainsaying your progress along a fixed route to a fixed point became a source of anxiety rather than comfort. The human separation implied by the railway station also induced unease. One of de Chirico's greatest metaphysical works, painted in 1914, is entitled *Gare Montparnasse (The Melancholy of Departure)*. De Chirico provides a link to Surrealism, in which the railway also features as a recurrent motif. Magritte makes use of the occasional train in his work, but they figure most prominently in the art of Delvaux, who was obsessively interested in them and himself collected railway memorabilia. Delvaux had one other area of obsessive interest, with the result that his paintings often comprise startling juxtapositions of erotic female nudes and railway engines.

Without his trains, Delvaux would be a less interesting artist. I don't want to labour the point, but pictorially railways sell. Perhaps most of us are train-spotters at heart.

Rain

Weather is an important factor in the saleability of a landscape. Sunny skies are predictably more desirable than rainy or stormy ones [see **I**mpressionism above]. Floods upset people too. But it's not true to say that bad weather is always bad news: snow can be very commercial in the hands of Monet or Sisley; Dutch seventeenth-century landscapes with skaters on frozen lakes – in fact anything that could be reproduced as a Christmas card – always sell well; and it was part of the Romantic Movement's credo to marvel at the dramatic, occasionally apocalyptic qualities of a rainstorm, presenting it as a thrilling manifestation of the power of nature. In the hands of Turner or Caspar David Friedrich rain can become very saleable indeed.

There was a time in the later nineteenth century when painters were oddly intrigued by rain. A fashion emerged for painting landscapes in which rain has either just fallen, is falling or is about to fall, often in large quantities. Cart tracks overflow with muddy water, skies glower, human beings struggle with umbrellas in the storm; in Cornwall the rain breaks over Penzance promenade; in Brittany the heavens darken; in the Dutch dunes fisherwomen cast fearful eyes at the watery skies, anxious about their menfolk on the tossing seas. From the Baltic Coast to the Dachau Moors, German landscape painters lurked indoors until the weather forecast suggested rain. Only then would they venture out with easels and umbrellas in order to capture the fashionable 'effect' of nature.

'Your work cannot really be good unless you have caught a cold doing it,' declared Norman Garstin in the 1890s. Garstin

was a painter of the Newlyn School, the group of English real-
ists at work on the Cornish coast at the end of the century.
What could be truer to nature than rain? The realists dwelled
on the less appealing side of nature to lend authenticity to their
vision, a reaction against the tendency of academic artists to
prettify, classicize and generally tidy up what they saw. It was
a sort of kitchen-sink school of landscape painting; banality
applied to weather. And there was a heroism to your endurance,
confronting nature even when it was wet and miserable outside.
'Where the cultured catch an effect,' said Oscar Wilde in 1891,
'the uncultured catch cold.'

Despite the heroic efforts of these nineteenth-century land-
scape painters – one might christen them the Pluvialists – rain
remains a commercial liability in today's market. But there are
mitigating factors. One is the compensation of the umbrella.
Painters had become aware of the decorative potential of a
parasol in a sunny landscape: now they introduced umbrellas to
rainy landscapes for similar reasons. Caillebotte's rainy Paris-
ian street scene, dominated by umbrellas, may be on one level
a comment on the alienation of urban life and the isolation
produced by walking in the rain, but on another it introduces
into the composition thrillingly decorative geometric motifs.
Renoir also occasionally succumbed to this temptation. Gener-
ally umbrellas help a picture commercially.

There is one other positive aspect of rain, which can appeal
to that section of today's picture-buyers who want nature made
cosy. There is a pleasure in contemplating bad weather from
the security and warmth of indoors. The very popular Victor-
ian Benjamin Williams Leader – a landscape painter of the old
school who believed in presenting nature through gently sac-
charine spectacles – caught no cold painting his famous _Febru-
ary Fill Dyke_. It is an evocation of winter rain painted entirely

in the studio, a landscape constructed from component parts rather than grown organically on the spot. My colleague Ian Kennedy has described it as 'a solid example of middlebrow academic romanticism'. He goes on:

A rain-sodden track in terrible repair runs by a damp and squalid-looking village. One is inclined to peer about in the mud for stray boots sucked off the feet of passing rustics by the quagmire. Part of the enjoyment of the picture is that it represents a place best appreciated from indoors, a place nobody wants to be. It offers a pleasure analogous to standing at a window watching the rain bucketing down outside.

The reservations of picture-buyers about rain are expressed in an apocryphal story told of George VI visiting an exhibition of the work of John Piper. The show included a series of atmospheric and evocative English landscapes, many of them featuring glowering skies and heavy downpours. At a loss how best to express intelligent interest, the King remarked sadly, 'You seem to have been most unlucky with your weather, Mr Piper.'

S_port_

In the nethermost recesses of the English psyche lurks a residual conviction that the only respectable art is sporting art. Paintings that depict the solid, emotionless facts of the traditional country pursuits of hunting, fishing, shooting and horse racing are safer than those that stray into the riskier territory of human sentiment and passion. Better to spend money on getting an artist to make a pictorial record of your favourite hunter than to paint

your wife or mistress. Hence there is a definite hierarchy in the value of horse painting, which persists today: the most desirable subjects are racehorses, then hunters, and below them the working carthorses and plough-horses of the farm. Colouring is relevant: greys tend to be less sought after than chestnuts or bays. Arab stallions are particularly desirable, not least because of their appeal to the powerful Middle Eastern market.

A resolutely literal depiction of a sporting event: *Kent v Lancashire at Canterbury Cricket Week* by Albert Chevallier Tayler, oil on canvas, 1906

Similarly there is an enduring fondness for paintings of stags, boar, foxes, ptarmigan, pheasants, snipe, partridge, duck, grouse and woodcock, all lovingly delineated with the care and attention to detail of an ornithologist or zoologist. It was an early form of trophy art, literally the depiction of the sporting trophy: painting what you kill. Was Brâncuşi's almost abstract *Bird in Space* sculpture classifiable as a work of art? This was the point

at issue in the famous 1928 court case [see Part V, **T**_axation_]. The American judge was dubious: 'If you saw it in the forest, you would not take a shot at it,' he suggested, as if that all but settled the matter.

As the nineteenth century progressed the range of sports that artists were asked to depict began to expand. Cricketers had been an element in English landscape since the previous century. Boxing, too, was a subject for which there was an enduring demand: prizefighting was popular – betting on the outcome of fights rivalled betting on horse racing – and the prizefighters themselves, men of well-developed physiques, were in demand as models for leading artists at the beginning of that century. Tennis as a subject was treated as a piece of upper-middle-class domesticity. Endless sets are played out on the vicarage lawn in Victorian genre scenes. But the first meaningful collision between tennis and art had taken place rather earlier: of the many artists who have played the game as a break from their efforts in the studio, the most notorious was the famously incendiary Caravaggio. During a game in Rome in 1606 he quarrelled with his opponent and stabbed him on court, as a result of which he had to flee to Naples, with lasting effects on the history of art.

In the second half of the nineteenth century artists turned their attention to golf as the game grew in popularity. But they didn't produce enough pictures. For art dealers today it's frustrating that there aren't more paintings of golf because the popularity of the sport in moneyed circles means that there is no shortage of people to buy them. It has not been unknown for less scrupulous members of the art trade to retouch the faggots on a peasant's back in the classic Victorian landscape into a bunch of golf clubs and recast him as an early caddy.

Nineteenth-century treatments of football and rugby remained resolutely literal and a little wooden. But gradually

KID LEWIS.
v.
JIM BERRY
AT THE
PREMIERLAND.

William
Roberts

Sporting modernism: *Boxers* by William Roberts, pencil, pen and ink, 1914

the art of sport was touched by modernism. The Futurists, with their interest in the movement and dynamism of modern society, were sometimes drawn to the subject. Boccioni, for instance, painted a memorable *Football Player* in 1913 (now in the Museum of Modern Art in New York). George Bellows's drawings and paintings of boxers are among the most impressive

sporting images of the twentieth century. These are the works with enormous commercial premium. But given the importance of sport in modern life, it has inspired surprisingly few great works of art. There are plenty of depictions of sporting encounters that exist as commemorative records, but few that are artistically transcendent. This is one of those categories in which it is easier to note the masterpieces that weren't created rather than those that were: *Cricketers* by Wyndham Lewis; Henry Moore's *Goalkeeper*; Giacometti's *L'Homme qui marque un but*.

S*till Life*

There is a price hierarchy in the component parts of traditional still lifes. Flowers are fine, and fruit is generally more desirable than vegetables; dead game is almost always bad news, particularly if there is any evidence of blood. When I worked in the Old Master Department at Christie's I once optimistically catalogued a larder still life as 'Vegetables on a ledge with a sleeping rabbit'; but no one was fooled: the rabbit was palpably dead and the painting failed to reach its reserve. So-called *vanitas* still lifes, intended to remind the viewer of his own mortality, are best avoided if they feature skulls too prominently.

The great Dutch floral still-life paintings of the seventeenth and eighteenth centuries have an unflagging appeal to the market, while offering challenges to the hapless cataloguer struggling to identify the different blooms depicted. As long as you pinpointed one correctly you could just about get away with it: 'Roses and other flowers in a vase' was a frequent standby. Mod-

ernism has shifted the focus. Sunflowers, ever since Van Gogh
came to grips with them, have become good news commercially.
Their inclusion in any floral still life painted since strikes a note
of modernist seriousness, tinged with the residual optimism
of the flower itself. Even thistles have their attractions, in the
appropriately angst-ridden hands (I mean Egon Schiele's).

Other desirable components in still lifes include musical
instruments and books. I particularly like those evocative por-
traits in which the sitter is absent, and their place taken by a still
life of their favourite things – a violin, perhaps, or a volume of
Keats. Even their boots, in the case of a poignant study by Van
Gogh, which could also be read as a self-portrait. There is more
to people than their faces.

Vincent Van Gogh's eloquent boots (oil on canvas, 1886–7)

Surrealism

Surrealism is mysticism for materialists. It has an enduring fashionability, appealing to people who are stimulated by the psychedelic hinterland of its dream culture, and by the apparently daring but ultimately unthreatening anarchy that its subversion of logic creates. At its most basic level the Surrealist painting thus reduces itself to the simple image of Magritte's smoker's pipe with the inscription 'Ceci n'est pas une pipe'. Or its sequel, a depiction of the same pipe inscribed 'Ceci continue de ne pas être une pipe'. The ultimate Surrealist paradox would be a painting by Magritte consisting of the words 'Ceci n'est pas un oeuvre authentique de Magritte', with an attestation of its authenticity in the artist's hand on the reverse. But to my knowledge he never thought of it.

The twentieth century is the century of dreams, starting with Freud's investigations into the subconscious, and flowering in the LSD-inspired fantasies of the 1960s and 1970s. The Surrealists provide a link between the psychiatrist and the hippy, positing the dream as an alternative, just as valid, reality. 'I believe in the future resolution of these two states, dream and reality, which are seemingly so contradictory, into a kind of absolute reality, a *surreality*,' explained André Breton in his *Manifesto of Surrealism*. It is a recipe that continues to enchant (and enhance prices) into the twenty-first century as a generation that fondly remembers its hippy youth reaches late-middle age and maximum spending power.

For those in search of the roots of the Surrealist spirit, there is an interesting early manifestation in Isidore Ducasse's *Les Chants*

René Magritte, *Ceci continue de ne pas être une pipe*, pen and ink,
1952

de Maldoror, written under the pseudonym of the Comte de
Lautréamont in 1869. Here a young boy is described as being
'as beautiful as the chance meeting of an umbrella and a sewing
machine upon a dissecting table'. In the face of the technologic-
al advances of the second half of the century, there was an
imaginative need to subvert the machinery of science in order to
assert the essential unpredictability and the natural freedom of
the human spirit. In its defiance of reason and logic, the proto-
Surrealism of Ducasse overlaps with the fantasy of Lewis Carroll
and the nonsense limericks of Edward Lear. We have been here
before. The lobster that performs a quadrille in Lewis Carroll's
Alice in Wonderland is grandfather to the lobster that Dalí trans-
forms into a telephone receiver. Surrealist collectors today are
responding to the same need to be reassured that the free play of
the imagination still has the power to undermine the certainties
of technology.

As far as the market is concerned, there is a premier division of Surrealists comprising Magritte, Dalí and perhaps Max Ernst, plus two other great artists who went through Surrealist phases, Picasso and Miró. Just below them comes a grouping of names such as Yves Tanguy, Delvaux, Man Ray, Victor Brauner, and a ladies' section including Leonora Carrington and Dorothea Tanning. There is a golden age of Surrealism, which is the decade of the 1930s. Works from that period generally command the highest prices. A Surrealist vocabulary of subject matter that has particular commercial appeal would include pipes and lobsters, of course, as well as bowler hats, melting watches, masked apples, night scenes set in daylight, and roses and combs that suddenly expand in size to fill whole rooms.

The antennae of the auction houses are particularly sensitive to positive commercial brandings of modern art movements. As a result, Surrealism is now regularly presented as a separate auction category, with its own growing constituency of specialist collectors. Would prices for Magritte, say, be quite so high without this step having been taken? Are we witnessing Christie's and Sotheby's merely reflecting taste, or actually directing it? Auction-house insiders officially claim the former, but sometimes nurture secret dreams of the latter. The truth lies somewhere in between. For auction houses it's a process of identifying an incipient flame with the potential to be fanned into a conflagration. Sotheby's and Christie's are good at the fanning process; but they can't create the initial fire. That must already have been lit in the collective consciousnesses of collectors, dealers, museum curators, art critics, not to mention cartoonists, marketing men and advertising agencies. And with Surrealism it emphatically had.

War *(1914–18)*

War artists are more exciting to the market than military paint-
ers. The distinction became manifest from the First World
War onwards. Up until that point military painters had treated
armed combat as a self-contained, almost picturesque activity,
a spectacle whose ill effects were largely confined to the heroic
soldier and could therefore be enjoyed by civilians at a safe
distance. The nineteenth century was a golden age of national-
ism and colonial expansion, and a good deal of sabre rattling,
easily translated into military paintings that stimulated a pleas-
ant armchair patriotism. Warfare is depicted by the Victorians
in terms of a boisterous point-to-point, with heroic winners and
plucky losers.

This mixture of fantasy and exuberance came to an end in
1914, when it was superseded by a new sort of battle picture, one
in which colour and spectacle was replaced by khaki and mud.
And for the first time war artists emerged; painters operating on
the front line. Such was the reach of conscription that they were
often serving soldiers, who transmuted their experience into
pictures that have a direct and harrowing impact.

The artists ostensibly more attuned to the glories of warfare
in the machine age were the Italian Futurists, and initially they
welcomed the conflict. Marinetti declared: 'We wish to glorify
war – the sole cleanser of the world – militarism, patriotism,
the destructive act of the libertarian, beautiful ideas worth
dying for, and scorn for women.' (The misogynistic addendum
seems a trifle gratuitous.) But their enthusiasm waned as the
fighting dragged on. Boccioni was the only Futurist artist to be

killed on active service in the First World War, and his wasn't a very Futurist death: he died from injuries sustained when his horse shied at a motor car. The most memorable modernist images of the war evoke the endless grind of trench warfare in terms of its grim and implacable machinery. Fernand Léger's *Card Players* shows soldiers as pieces of military hardware whose relaxation is also mechanical and soulless. Christopher Nevinson's *La Mitrailleuse* is an extraordinarily powerful, pared-down image of men barely distinguishable from the killing machines that they operate.

The Great War produced images that are more highly prized than those of any other conflict. But in another way its destructive power had a cruel effect, as a blight on the careers of a large number of supremely talented artists. Of the generation of artists that came to prominence in those extraordinarily fertile and exciting few years leading up to the First World War, almost no one went on to do work of a comparable quality after 1918. Perhaps the only exceptions are Picasso and Matisse. The cruel retrospective verdict of today's art market is that most of these artists would have left more satisfactory imprints on the sands of artistic time had they died in the First World War than they did by surviving. To be callous about it, perhaps more of them should have been deployed in the front line of the trenches, literally an avant-garde. On the German side, two great Expressionists, August Macke and Franz Marc, were killed in action. Sad, of course, but in terms of ensuring a strong market for their consequently rare work, these last two may have got it right. In general, the younger an artist dies the better.

Here is a list of major painters who survived the First World War but thereafter went into decline. I have preceded the name of each artist with the date of execution of the work by him that

Christopher Nevinson, *La Mitrailleuse*, pen and ink, 1916

has raised the highest price at auction in modern times. In no case is the record held by a post-First World War painting, even though many of the artists on this list had fifty years more of working life after the conflict.

1908 Giacomo Balla (d. 1958)

1918 Giorgio de Chirico (d. 1978)

1905 André Derain (d. 1954)

1913 Juan Gris (d. 1927)

1910 Eric Heckel (d. 1970)

1910 Alexej von Jawlensky (d. 1941)

1913–14 Ernst Ludwig Kirchner (d. 1938)

1912 Fernand Léger (d. 1955)

1910 Max Pechstein (d. 1955)

1913 Karl Schmidt-Rottluff (d. 1976)

1915 Gino Severini (d. 1966)

1910–11 Kees Van Dongen (d. 1968)

1905 Maurice de Vlaminck (d. 1958)

Wall-Power

Authenticity

Colour

Emotional Impact

Fakes

Finish

Framing

Genius

Nature *(Truth to)*

Off-Days

Restoration

Size

Authenticity

How do you establish that a specific artist painted the picture in front of you? A signature helps, of course; and if the painting is signed, and you can read the name, the next step is to assess whether the work is stylistically plausible and of sufficient quality to be by the artist. If the painter is of the stature to command his own catalogue raisonné (the definitive published list of all known works by the artist), then checking that the painting is included in it is generally conclusive. (It's as well to be sure that it's not recorded as being in a major museum, which will mean yours is either stolen or fake.)

It is important to look at the back of the painting. Some art experts are so obsessed with this mantra that they do it before looking at the front, and sometimes give the impression they have forgotten to take the second step at all. It's certainly true that the back can tell you a lot. There you can find old exhibition labels or dealers' labels or auctioneers' stock numbers, all of which can be checked against the relevant literature and archives. You may even discover an inscription or title written in the artist's handwriting. But don't in your enthusiasm do what I once did, entitle a painting *Right of Passage* when what I had transcribed was an early owner's aide-memoire as to where it was to hang.

What do you do if the painting is not conclusively pinned down by the literature or archives on the artist? How do you decide whether what you are looking at is a good imitation, or a work by a good artist on an off-day [see **O**ff-*Days* below]? If the painter to whom the work is attributed is important, there

will be an acknowledged expert to consult, often an academic. Sometimes there is even a committee of experts on a particular artist, who meet at intervals to view newly discovered works hopeful of acceptance as genuine. You arrange for the picture to be viewed. The best outcome is a positive verdict, accompanied by a certificate and a statement of intent that the work will be included in the expert's forthcoming addendum to his catalogue raisonné. (The statement of intent is enough. It has to be. Publishers, who find they've already lost money on producing the expensive catalogue raisonné, are chary about producing further volumes and the addendum never quite emerges in the bookshops.)

With some old master painters there are two separate experts, occasionally mutually hostile. Both authorities have to be consulted. In the event of disagreement, the last resort of the auction house is to put the work in the sale, but publish in the catalogue both views of its status. The verdict then depends on a judgement of the stylistic quality of the work itself, and the art-buying public makes up its mind, which it is impressively decisive about doing.

The worst outcome is rejection by the expert or expert committee. With an out-and-out fake, justice is seen to be done. But when a work of good quality and possible authenticity is given a negative verdict the expert's decision catastrophically reduces its value, in some cases from potential millions to just a few hundred. All you can do then is wait a decade or two and hope that a new generation of scholarship emerges which takes a more positive view. And meanwhile hang it on your wall and enjoy it. After all, it remains the same painting as it was before the experts got at it.

The ultimate statement of aesthetic purism is to form a collection of high-quality unattributed paintings. 'Look,' say such

high-minded owners, 'this is collecting at the opposite pole from those who simply buy signatures. I appreciate a painting because it is beautiful, and it remains beautiful whoever painted it. The identity of the artist is a secondary issue.' It's a line often taken in their own collecting by penurious art-world professionals, who are drawn to unattributed works with potential (generally never quite realized). The truth is that authorless paintings are cheaper because they lack that crucial dimension of artistic personality. Knowing who did them is a key component in their desirability. The awareness that Rembrandt actually touched with his own hand the canvas that you are holding in your own is incomparably exciting.

C*olour*

Colour sells. The art dealer who bases his business on this simple truth will be among the last to collapse into bankruptcy. Colour is what makes the immediate and direct appeal to the eye; it is the most sensual element in art. Collectors from the emerging markets buying modern western art for the first time are particularly responsive to bold colours. That's why they tend to fall in love first with the Impressionists, whose revolution was all about colour and led to the formation of rules about complements. The primary colours – red, yellow and blue – each had a complementary colour formed by the mixture of the other two. Thus a red object casts a shadow that contains green, a yellow object's shadow contains purple, and a blue object's shadow contains orange. The result is painting in an unprecedentedly high key.

But the new rich in Asia and Russia are even more devoted to those early-twentieth-century modernist art movements which took colour further, employing it in large, intense, unmediated expanses. So it is the Fauves in Paris and the German Expressionists whose prices have grown most steeply in the twenty-first century. The heroes of these new collectors are Derain, Vlaminck and Matisse, Jawlensky, Franz Marc and Kandinsky. It is the colour that does the trick.

Red and blue are the most important colours in modernist art. In the sort of abstract painting that consists of geometric simplification, the significance of colour is intensified. Mondrian's compositions are essentially grids demarcated by black lines on white backgrounds. What gives them their individuality is the disposition and colours of the rectangles within the geometric scheme. Ideally you have a little red, yellow and blue. You can do without the yellow, or even the blue. But a Mondrian without a touch of red is going to struggle to be a top seller. A Miró or a Chagall needs a preponderance of blue. 'Blue,' said Miró, 'is the colour of my dreams.' And the cry of buyers goes up, from Los Angeles to Moscow, from Seoul to Stockholm: 'Find me a blue Chagall!' Picasso is at his most appealing to the market when he is at his most colourful, in the 1930s. Again it is hard to imagine a Picasso top seller from that period that does not primarily feature red and blue, helped out by a bit of yellow and green.

In fact the power of red is quite extraordinary. A judicious touch of it at an appropriate point in the composition can give a painting a huge extra piquancy and impact. I remember standing in front of a magnificent Guardi of the Grand Canal in Venice that Sotheby's sold in 2009. In the left centre was a tiny fleck of red, barely to be noticed at first sight in the panorama of buildings and water and gondolas that was predominantly

painted in greens, blues and yellows. But if you inspected the picture with your hand held over that tiny fleck, the loss of power and interest to the whole was disproportionate. The painting realized £20 million. How much did that single brush-stroke contribute?

As a general rule, British painters are not colourists. Even when their colours were at their boldest, with the Pre-Raphaelites, there is a certain strangeness and awkwardness to the effects produced. It was commented on by bemused French visitors such as Hippolyte Taine in 1862: 'There can be no doubt there is something peculiar in the state of the English retina,' he declared. It was the lack of taste that he couldn't understand. He rued it in English fashion, comparing the Englishwoman to 'a fenced field in which enemy colours meet and wage war on each other'.

A natural instinct to muddiness afflicts the British palette, a fondness for earth colours. It may be a reflection of the British weather, or an embarrassment at the sensuality of colour, but it is noticeable that when you walk into an exhibition of twentieth-century British painting the overall impression is noticeably less vivid by comparison with an exhibition of equivalent continental art. The chromatic temperature is lower. The Scottish colourists – John Duncan Fergusson, Samuel John Peploe and Francis Cadell – had to go to Paris for the liberation of their palettes. That liberation has been reflected in a big surge in their prices over the past generation.

Sometimes the buyer of a painting is acquiring nothing more than a colour, literally. I remember a financier who had his eye on a colourful Matisse interior that was coming up at auction. He flew over to London in his private jet to check it out. It transpired that the painting contained a particular shade of blue that his wife had fallen in love with and wanted to use on the walls

of a room she was decorating. He bought it, and flew it home in triumph. A year later, I noticed it coming up for sale again in New York. 'We didn't need it any more,' he explained. 'We got the colour for the room.'

Emotional Impact

One of the tests of the quality of a painting is that it should produce emotion in the spectator. But the emotion must be genuine. In May 1887 Camille Pissarro took his daughter to an exhibition of the works of Jean-François Millet in Paris. There was a dense crowd, he reported, and he ran into an acquaintance called Hyacinthe Pozier. Perhaps he should have been on his guard with a man named Hyacinthe. Anyway, in Pissarro's words, Pozier

greeted me with the announcement that he had just received a great shock, he was all in tears, we thought someone in his family had just died. – Not at all, it was *The Angelus*, Millet's painting which had provoked his emotion. This canvas, one of the painter's poorest, a canvas for which in these times 500,000 francs was refused, has just this moral effect on the vulgarians who crowd around it: they trample one another before it!

Pissarro identifies two concerns here: the unthinking mass appeal of a familiar image; and the genuineness of the emotion that viewing it produces. Was a lot of money offered for it because it made people so emotional? Or was the emotion triggered by the amount of money offered for it?

In the hierarchy of the arts, paintings come fairly low down the list in their capacity to reduce the consumer to tears. People are probably most emotionally susceptible to music; it's not uncommon to see members of the audience at a concert wiping a discreet tear from their eye. Literature, when you are swept up emotionally by harrowing events in a novel or play, has a similar power to make you weep. But if you come across a visitor to an art gallery in tears you would be more likely to assume – as Pissarro did – that they've just had a message announcing a death in the family than that the art is responsible.

Not that it's impossible. 'Since the primary object of poetry and painting is to play on the emotions,' wrote the Abbé du Bos in the eighteenth century, 'poems and pictures are only good if they move and involve us. A work which moves us a great deal must be excellent from every point of view.' Diderot backed him up: he exhorted painters to 'Move me, astonish me, unnerve me, make me tremble, weep, shudder, rage, then delight my eyes afterwards if you care to.' Stendhal was notoriously susceptible. He likened himself to the sounding board of a violin echoing and responding to the emotional vibrations of the work of art he was encountering. He describes a day in Florence:

The Sibyls of Volterrano gave me the most precious delight I have ever derived from painting . . . I was worn out with swollen feet, aching in narrow shoes – but in front of this picture I totally forgot it. My heavens, how beautiful it is! I got into the state of emotion where the *celestial sensations* of the fine arts encounter impassioned sentiments. When I left Santa Croce I had palpitations of the heart, felt beside myself and feared to fall down.

This is a condition now given a medical name – Stendhal syndrome. It describes extreme emotional reaction to a work of art. What is prized is the sincerity of the response, its spontaneity.

Arthur Hughes, *Home from Sea*, oil on canvas, 1862: a potential
tear-jerker

Rothko said in 1956:

I'm interested only in expressing basic human emotions – tragedy, ecstasy, doom and so on – and the fact that lots of people break down and cry when confronted with my pictures shows that I *communicate* those basic human emotions. The people who weep before my pictures are having the same religious experience I had when I painted them.

People who look at works by Rothko are, it seems, often moved to tears. They are at the opposite pole from the spectators in the saleroom who break out into spontaneous applause when a Rothko sells for $78 million. Or are they? Perhaps it is gratifying to find your emotion priced so high.

But things aren't always what they seem. Once, in the Hermitage Museum in St Petersburg, I watched a very beautiful young woman looking very intently at a Rembrandt. She was deeply involved in what she saw, and I was moved by how much she appeared to be moved. I fancied I saw a tear in her eye, even though she seemed to be trying to hide it by discreet motions of her hand. I went closer. Then it dawned on me: the painting was glazed and she was using it as a mirror to adjust her mascara.

I have to confess that I have rarely if ever shed tears in front of a painting. But then I am English, and had a conventional upbringing. Paintings that move me strongly tend to be those which impress me as literature does, which arouse my sympathies like a novel. I have to have a handkerchief ready – just in case – whenever I go into the Ashmolean Museum in Oxford. There is a painting by the Pre-Raphaelite artist Arthur Hughes called *Home from Sea*. It shows a young sailor boy lying in the grass weeping at the grave of his mother. She has died while he has been away on his first voyage, and his older sister kneels mournfully beside him. The setting is an idyllic English churchyard, with sun dappling the ancient church walls beyond. I don't

want to go too deeply into it because it is too upsetting. But the face of the boy in profile as he buries his head in his hands, and the detail of the damp hair matted by tears to the side of his cheek, are almost unspeakably sad.

Fakes

Fakes work best when there is a receptive audience for them, when there is some compelling reason why the victim of the fraud wants them to be genuine. In the eighteenth century the German writer and classicist Johann Winckelmann, never having visited Greece but dreaming of an image of the ancient world that was informed by pretty boys, was sold a very lovely drawing of Ganymede as the authentic work of an artist of classical antiquity. When the contemporary German painter Raphael Mengs confessed he had knocked it up as a joke, Winckelmann refused to believe it. You suspect that Göring would have had the same reaction had he been told that his Vermeer was painted by the modern Dutch faker Van Meegeren (which it turned out to be).

That's the characteristic of fakes: they may deceive the generation in which they were created, but unlike the real thing they date. Looking at a Van Meegeren now, it is hard to understand how the pastiches that he produced took in quite reputable experts in the 1930s. Our image of the past changes. The Dutch seventeenth century viewed through the eyes of the early twentieth century looked different from the same period seen by the eyes of the early twenty-first.

There are degrees of fakery: an early-nineteenth-century landscape attributed to Constable but actually by a lesser, unidentified hand, is not a fake; it is merely wrongly attributed. The same picture with a Constable signature added to it is not 100 per cent fake. It is simply not by Constable, and would be a perfectly legitimate painting once the spurious signature was removed from it. On the other hand, a modern painting in the style of Constable which has been oven-baked in order to produce an apparent early-nineteenth-century craquelure in the paint surface and then claimed as a genuine Constable is an out-and-out fake, manufactured to deceive. Scientific analysis will help here. A fake Van Gogh, for instance, was exposed by pigment tests showing it to have been painted with a kind of white paint not manufactured until thirty years after the artist's death.

Signatures are the crucial element. To try to pass off a painting as being by an artist when it isn't becomes an act of criminal fraud once a spurious signature is knowingly added to it. But beware: the little letter 'n' or the combination 'd'ap' in front of the signature, perhaps to be misread by the hapless expert as a malformed tuft of grass, is the faker's get-out. The 'n' stands for 'nach' in German and the 'd'ap' for 'd'après' in French, acknowledgements by the painters of the pictures that these are merely copies after better-known, more skilful masters.

Any painting that has been acquired in good faith and turns out not to be by the artist to whom it is attributed involves a disappointment to its owner. Sometimes, when a painting has been in a family for generations, the disappointment takes on tragic dimensions. The sweet old lady who one day brought her Rembrandt into Christie's confessed to me that it would be a wrench to sell it, but she knew from her father that it was very valuable and the moment had now come because without the money she was facing pensionless penury. Breaking it to her

An early device for artificially ageing copies of old masters
(*Art Journal*, 1852)

that the painting was just a nineteenth-century copy and as such worth under £100 was not an easy thing to do.

The most successful fakes are of modern works. Not only is there less need for artificial ageing processes, but a crucial distinction between modern art and older art works in favour of the faker of modern art. Old master paintings generally aim for the accurate and convincing rendering of reality, and their quality can be judged reasonably clearly by the adroitness with which they achieve that aim; with modern art, whose aim is no longer simply an accurate rendering of nature, that criterion is lost. What you do have with modern art is a more clear-cut

distinction of style. Thus it becomes easier to identify who the artist is by style, but, because the criterion of accurate rendering of the visible world is lost, more difficult to detect whether the work is good enough actually to be by him. In this respect, modern art is the faker's period of choice. Style is easily imitable. But as a counterbalance to that, more extensive archives exist for modern art, certainly for the more important painters. Catalogues raisonnés – lists of the entire production of an artist compiled by later experts – are more comprehensive and watertight because the original dealers who first handled major modern masters' work kept more comprehensive records. So the most telling way to judge whether a modern work is a fake is the simple question, is it recorded in the catalogue raisonné? If it's not, don't trust it.

Modigliani is more problematic. His work is less reliably recorded, owing to the vagaries of his production and the vagaries of his dealer, and the incurable romanticism of Italians, which makes them notorious fakers. A number of catalogues raisonnés of Modigliani's work have been produced over the past fifty years, only one of which – assembled by Enrico Ceroni – is accepted as largely reliable. But even the name Ceroni is not a total guarantee. His wife, perhaps in need of an income stream in her widowhood, took to issuing optimistic certificates of authenticity bearing the Ceroni name after his death.

Even the archives can't totally be relied upon. The cleverest fakers of modern times have found means of embedding their fakes into them. One way of doing this is to identify a work recorded but lost and to fake something to that specification, complete with spurious labelling tying it to old exhibitions at which the original is recorded as having been shown. A disturbing variant is the scam worked some years ago by an unscrupulous Far Eastern operator. Step one for him was to buy

a genuine work of modern art for several hundred thousand dollars, usually at auction so that the item would be readily accessible on Internet art-price sites. He would then produce a faked replica of the genuine work and sell that on privately, presenting it as the work he was recorded as having bought at auction. Some time later he would re-enter the original work at auction and cash in on that too. The net result, of course, was that two versions of the same work would be at large. But the duplicity often did not come to light for several years, long enough for him to have banked both cheques.

Dealers, auction houses and museums are constantly vigilant against such things. There are mechanisms for compensation in the very rare occasions when mistakes are made. But fakes remain an expert's nightmare. I was once deceived by some watercolours brought on to the *Antiques Roadshow*. They were very poor-quality landscapes in a vaguely Dutch style. 'When were they done, mate?' enquired the owner cheerily. 'In the early part of the twentieth century,' I hazarded. 'Wrong!' he declared in triumph. 'I knocked them up myself last week. Look,' he went on, pulling another example from his carrier bag. 'This one's even signed. It's by Hertz van Rental!' The late Kenneth Clark never had to put up with such challenges.

Finishing a Painting

For a nineteenth-century painter, the idea of 'finishing' a picture was different from what more recent modernist artists would understand by the term. It is a point of regret to Delacroix that

Finished or unfinished? Paul Cézanne, *Fleurs dans un vase rouge*, oil
and pencil on canvas, 1880–81

some of the spontaneity of the immediate execution of a paint-
ing must be sacrificed in order to give it the degree of finish
that was demanded by his contemporary audience. He writes in
April 1853: 'One always has to spoil a picture a little in order to
finish it. The last touches, which are given to bring the differ-
ent parts into harmony, take away from the freshness. It has to
appear in public shorn of all those happy negligences which an
artist delights in.'

In the twentieth century, artists are no longer straitjacketed
by the necessity of giving a painting conventional finish. But
other concerns emerge. In April 1944 Keith Vaughan records
in his diary a fascinating discussion that he has with Graham
Sutherland on the subject of how a picture reaches the point
beyond which it cannot go without falling apart, or at least

transmuting into something different. A purchaser brought a painting back to Sutherland, asking him if he could do anything about a small area in the right-hand bottom corner, which somehow the client found unsatisfactory. Sutherland agreed to take the painting back and do what he could because he knew himself that this was the one point in the picture that was not quite resolved.

This leads Vaughan and Sutherland on to discuss whether there is in all great paintings always one such point, a flaw if you like, which has not been completely resolved, and which is in fact essential to the strength and beauty of the whole work. The flaw cannot be repaired without the whole painting being damaged. It is as if a painting is trying to approach a complete equilibrium but can never quite reach it; if it did it would disintegrate, the tension would snap. Vaughan and Sutherland decide that whether or not a person is sensitive to this particular quality can be tested by asking him which he prefers: Bellini's *Agony in the Garden*, or Mantegna's version. 'The Mantegna is obviously the more perfect,' writes Vaughan.

The articulation of the whole picture space is flawless; the transition from body to limb from limb to hand and hand to fingers is effortless and consummate. Bellini's is altogether different. There is a tremendous sense of strain in bringing the objects into relationship. A feeling of anxiety that it may at any moment not quite succeed, and the whole picture fail. This feeling permeates the whole picture, it gives a vibrant tension to every relationship. The Bellini is the greater picture. The Mantegna is the more perfect.

Auerbach gives a more straightforward account of the point at which he finds his picture complete: 'When the forms evoked by the marks seem coherent and alive and surprising,' he says, 'and when there are no dead areas, I think the painting might

be finished.' And in March 2004 Lucien Freud talks about the same question with Martin Gayford, whose portrait he was painting. 'Finishing well in a picture is of course the most important thing of all,' says Freud, and went on to explain, in words that are elusive but ultimately persuasive, 'I begin to think a picture finished when I have the sensation I am painting someone else's picture.' Rothko uses a different analogy. It took him many hours to get the proportions and colours just right, he said. It is only finished when everything 'locks together'. He concludes, 'I guess I'm pretty much of a plumber at heart.'

While the modern audience for painting no longer demands the standards of finish that Delacroix was subject to, the categorizing of a work as specifically 'unfinished' still makes the market anxious. Why didn't the artist finish it? Was it abandoned as unsatisfactory? The title of an exhibition mounted in 2000 in Vienna and Zurich was deeply disturbing. It was called 'Finished/Unfinished', and focused on various works by Cézanne, trying to assess in which category they belonged. The organizers were perplexed by a distinct reluctance from private owners to lend to this show, scholarly and interesting though it turned out to be. The reason was no one wanted to risk their work being blighted as 'unfinished'. Commercially this would have been a disaster.

Framing

How a painting is framed makes an enormous difference to our perception of it and to the price it sells for. The wrong frame on a work will drastically diminish its impact. Reframing it more

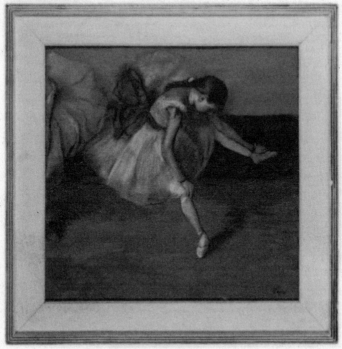

How Degas framed his own work

sympathetically can transform it. How you do this depends on the value of the painting: with a $10 million Canaletto, it makes absolute sense to spend $75,000 on a fine eighteenth-century frame that does it justice. It could even turn it into a $12 million Canaletto. But spending $75,000 on the same frame for a $25,000 eighteenth-century landscape, while it may improve it visually, won't be justified by any significant increase in its value. Conversely, in routine old master sales you used occasionally to get unexpectedly high prices realized for very ordinary copies or school pictures. This was because we cataloguers only looked at the paintings and correctly identified them as copies, but failed to notice that they had been set in the magnificent period

carved-wood frames that had held the originals. Observant punters in these cases recognized that the frames were worth many times the value of the paintings.

With old master paintings a strict discipline has traditionally been observed about only using frames that are of the style, period and nationality of the painting itself. And certainly an appreciation of a painting in its original frame (i.e., put on it by the artist, or at least in his time) adds to its value. This extends to modern art as well: for instance the simple dark wooden frames of the German Expressionists, if contemporary with the painting, are much prized. But with the coming of modernism, greater stylistic flexibility has ensued. Today one often sees Picasso or Miró in black-and-gold Italian seventeenth-century frames. To a modern eye, they work rather well. It started with the fashion, much appreciated in America, of putting Impressionist paintings in French eighteenth-century frames. Once I removed from a fine Degas pastel of a ballet dancer its original white frame, constructed by the artist, and offered the painting at auction in a French eighteenth-century gilt frame in order not to deter late-twentieth-century American buyers. It made a world-record price, but it was not one of my proudest moments. At least we gave the buyer the option to return it to its original frame.

Genius

Sometimes you look at a painting and its sheer, surpassing quality is manifest. You know immediately that it's there. But how to define what constitutes that quality? It is easier to describe its impact than to identify its components. Jean Cocteau records his reaction to seeing great works by Velázquez and Goya in the Prado:

I remark the disconcerting simplicity of genius. Velázquez and Goya seem to paint at top speed with an incredible 'luck' in each touch. No matter how close one comes, inspects, analyses, one fails to understand how what has been done was done. And the boldness. The bolero of the *Maja*: the brush dashes down a bit of yellow paste, and in it there remain the streaks of other colours. Velázquez, the lace of the infant: as if he had let the paint run out of its tube with the caprice of honey flowing over honey.

Adrian Stokes describes Sargent painting:

His hand seemed to move with the same agility as when playing over the keys of a piano. That is a minor matter; what was really marvellous was the rightness of every touch . . . all was rendered, or suggested, with the utmost fidelity. Parts were loaded, parts were painted clear and smooth, every touch was individual and conveyed a quick unerring message from the brain. It was, if you will, a kind of shorthand, but it was magical.

Genius is sometimes seen to reside in that happy initial touch, painting '*au premier coup*' without reworking. '*Posez, laissez,*' said Baron Gros to his pupils, implying a kind of divine

inspiration that guides the hand of the artist as though he is momentarily possessed, becomes a conduit for some external power that it is wrong to tamper with or mediate. Byron likened his creative self to a tiger. 'If I miss my first spring, I go growling back to my jungle. There is no second. I can't correct; I can't, and I won't.' Alternatively there is another sort of genius, which is the taking of pains, the capacity infinitely to return to a work, adding to it, recrafting it, until it attains perfection. This is an unromantic, almost artisan, version of the phenomenon, but it has its place in the anatomy of genius [see **N**ature (Truth to) below].

A disconcerting simplicity – a felicitous initial touch – a magical shorthand – the taking of pains – or luck? But you know it when you see it, and so does the market.

Nature (Truth to)

Throughout art history the illusory ideal of absolute truth to nature has fascinated painters. It became the mantra of the Pre-Raphaelites. George Eliot wrote of John Ruskin in 1856: 'The truth of infinite value that he teaches us is <u>realism</u> – the doctrine that all truth and beauty are to be attained by a humble and faithful study of nature, and not by substituting vague forms, bred by imagination on the mists of feeling, in place of definite, substantial reality.' The Pre-Raphaelites tortured themselves with the challenge of painting in accurate detail each single leaf of the tree.

The hyperrealism that this sort of attitude produces is an

J. W. Inchbold, oil on canvas, c. 1855: the hard-edged
Pre-Raphaelite truth-to-nature that paints every leaf

enduring feature of painting and will always have its adherents. People like to pay money for hard work, for paintings that are clearly the product of a lot of time and effort, and can be judged by the meticulousness with which they reproduce the objective facts of nature. But unchecked this attitude can degenerate into a painful literalism: Philip Ernst, father of Max Ernst, was a keen amateur painter in turn-of-the-century Frankfurt. He once painted a picture of his garden but for compositional reasons omitted a tree. Such was his commitment to 'truth to nature' that when he finished his picture he was overcome by remorse and went out and cut down the tree.

This Teutonic literalism is an echo of the story that Bernini liked to tell about a Spanish nobleman on his way to Naples who fell off his mule, rolled down a steep hillside and ended up at the bottom of a ravine, miraculously unhurt. To commemorate this miracle he decided to order a votive picture. He related his adventure to the painter Filippo Angeli, who made a painting in which he represented to the best of his ability the accident and the place where it had occurred. Bernini takes up the story:

The Spaniard liked it very much but complained that the mishap should have been represented on the other side of the mountain. The artist pointed out that it would then be out of sight, but his patron reiterated that this was falsifying history, and that he must insist on the incident being painted on the other side of the mountain, so that finally Filippo, who was well aware of his stupidity, promised to change it and, having effaced the figure, brought back the painting saying he had placed him on the other side. The Spaniard declared that he was well satisfied and paid the artist a good price.

That there might be another, essentially optical approach that achieved truth to nature was the lesson taught by the Impression-

ists. But the instinctive British preference was for a more literal
and hard-edged technique. Henry James put his finger on it:

When the English realists 'went in', as the phrase is, for hard truth
and stern fact, an irresistible instinct of righteousness caused them
to try and purchase forgiveness for their infidelity to the old more or
less moral proprieties and conventionalities, by an exquisite, patient,
virtuous manipulation – by being above all things laborious. But
the Impressionists, who I think are more consistent, abjure virtue al-
together, and declare that a subject that has been crudely chosen shall
be loosely treated. They send detail to the dogs and concentrate them-
selves on general expression . . . The Englishmen, in a word, were
pedants, and the Frenchmen are cynics.

 James was right: one of the reasons why Impressionism failed to
catch on immediately in England was that the English thought
it was lazy. Why should we give good money for something that
didn't take very long to knock up?

Off-*Days*

Good artists sometimes paint bad pictures. I suppose there
are inevitably mornings when you wake up and start painting
and it doesn't go well. Maybe you've got a hangover, maybe
you're distracted by your rent arrears or the impending visit of
your mother-in-law. But the net result is a poor piece of work.
In many cases all that happens is that the drawing is thrown
away, or the canvas scraped down for reuse another time. But
not always: sometimes the work finds its way into your dealer's

hands, he sells it (perhaps for a lower price than usual, but you pocket your share of the proceeds and move on) and then it's out there, this inferior painting, eternal testament to what you're capable of when you're off your game.

Some artists are more rigorous than others. They make a virtue of their 'quality control', as Monet did with a batch of water lilies that he had painted to be exhibited in New York in 1909. He took a second look at them and refused to let them leave the studio. He felt they weren't good enough. His dealer Durand-Ruel, arch salesman that he was, turned the disappointment of having to cancel the exhibition into something positive by emphasizing this evidence of his artist's uncompromisingly high standards. When you buy a Monet, he reminded his clients, you're buying a good Monet, because the artist doesn't allow bad ones out of his studio.

Such judgements are true, up to a point, during the artist's lifetime. But they don't take into account what happens after the artist is dead. Unless he's destroyed everything that he hasn't allowed out of his studio, there's a remaining detritus left behind. And there are your heirs, anxious to cash in on the inheritance. So it became accepted practice to have a stamp manufactured of the late artist's signature which was then applied to anything unsigned found in his studio, finished or unfinished. Hence the ambiguity of the unsigned work that emerges after the artist's death bearing the studio stamp. It is certainly true that artists sometimes refused to sell in their own lifetime works that were specially dear to their hearts, or prized beyond all others because of their personal significance. Dealers and auctioneers are only too ready to point out that this was probably the case with the 'stamped' rather than 'signed' work that they happen to be selling. But not all 'stamped' works can be compelled into this category. Some were frankly not very good.

Then there are other artists who, in the prolificity of their inspiration, in their belief in their own myth, painted far too much. Late Picasso, for instance. I yield to no one in my admiration for the masterpieces that Picasso unquestionably painted in his eighties and beyond – the power, the invention, the enduring sexual drive are quite remarkable. But in his old age he also produced some real duds. And the tragedy was he didn't destroy them. Nor did his heirs. They were too valuable, even as duds.

Off-days matter less to old master painters. That is because they didn't expect to complete a finished work in a day so there was scope for revision and improvement over longer periods of time, hence the pentimenti, where perceived mistakes were corrected. It is a characteristic of modern art that it is finished more quickly, often in the span of a day, in order to capture the immediate inspiration. This is a conceit of Romanticism: '*Posez, laissez*,' Baron Gros told his pupils. The first touch is the right one, the sincere one. To correct is to corrupt one's sincerity. So if your first touch is a false one, all you can do is go on in hope, a hope that is sometimes misplaced.

R*estoration*

Paintings aren't always what they seem. Under an apparently flawless surface can lurk camouflaged problems of condition which once detected will drag down the price of a painting. If it has repaired tears or retouching by a restorer it will make less than if it is in pristine condition, or '*dans son jus*' as the French say.

'Paintings are like women,' says Jasper, my art-dealing friend. 'As they get older they need restoration.' He sometimes dreams of expanding his premises into a one-stop shop for the very rich. There would be a department supplying private jets, another specializing in luxury yachts. There would of course be a very glorious art gallery; and there would be a department combining restoration of paintings and cosmetic surgery for the paintings' owners.

Delacroix would have taken issue with him. He wrote in 1854:

Many people imagine that they do a great deal for paintings when they have them restored. They appear to think that pictures are like houses that can be repaired and still remain houses, like all those other things, in fact, which time destroys, but which we contrive to preserve for our use by constantly repairing and replastering. Women who know how to make-up can sometimes disguise their wrinkles so as to appear younger than they really are, but a picture is something totally different. Each so-called restoration is an injury far more to be regretted than the ravages of time, for the result is not a restored picture, but a different picture by the hand of the miserable dauber who substitutes himself for the author of the original who has disappeared under his retouching.

There are various sorts of restoration: restoration undertaken to repair a damage, a tear in the canvas or paint flaking off the surface; and restoration that is essentially no more than cleaning, the removal of discoloured varnish and/or layers of accreted soot and nicotine to reveal the original colours of the painting. The former is obviously more drastic than the latter, although both have their perils. Restoration to repair a damaged canvas generally involves relining, a process whereby a backing canvas is attached to the existing canvas to give it extra support. Hot wax or glue is used, and a hot iron. Unless this is done with enormous skill and delicacy it can result in irrevocable damage to

the picture surface, a flattening of the impasto (the relief effect of the brushstrokes applied by the artist in varying thicknesses of paint). There was a fashion among American restorers in the twentieth century to reline all canvases regardless of their condition, presumably in order to achieve future durability. Now that technology has moved on, twenty-first-century dealers and auctioneers expend much time and money on removing these linings from undamaged canvases in order to recapture their pristine state: heroic attempts at the restoration of virginity. Perhaps that service could be added to those available at Jasper's one-stop shop.

With severely damaged paintings, as a restorer you are faced with a choice: to repaint or not to repaint. The purist (and there are very few of those) will simply stabilize paint loss and mend damage to the canvas but not add new pigment. The pragmatist will repaint as much as is necessary to give the impression of pristine condition. A case reached the British courts some years ago concerning a painting by Schiele that had been damaged by fire and then reworked by an imaginative restorer. Was it legitimate, the judge had to decide, still to describe the painting as a work by Schiele when so much of it was the work of another hand? The judge took a strictly mathematical view: if more than 50 per cent of the paint surface comprised the efforts of the restorer, then it was no longer a work by the artist.

Cleaning a painting also has its perils. Varnish was an essential part of traditional oil painting, the final layer on the paint surface applied to add gloss and protection. Varnishing day at the Royal Academy was an important ritual. But varnish discolours over time and distorts the original colours, sometimes seductively. The colours revealed by the removal of old varnish or dirt can be shocking to modern-day sensibilities. And it takes an experienced restorer to clean a painting well. Artists

of the past painted in successive glazes of colour. A clumsy restorer, besides removing the varnish, might mistakenly also remove an upper glaze of the artist's original work. If that glaze also includes the artist's signature – always a possibility – then the restorer is in even more serious trouble. It is not unknown for signatures thus momentarily lost in the hurly-burly of the restorer's studio to be hastily reapplied. But let's not dwell on such moments of crisis.

Then there is the ultraviolet light, much used in the art world. This is an appliance that, if you shine it on the surface of a painting, reveals by florescence areas of paint that are of more recent application than the original. Modern science has developed new sorts of varnish, which come to the aid of unscrupulous restorers. There is a certain type of masking varnish which blocks ultraviolet light, and gives the impression that what you are looking at is a totally pristine, unblemished paint surface. Pity the poor expert, ultra-violet lamp in hand, who has to interpret what he sees (or doesn't see).

Size

It's very unsubtle to be seduced by size, I know, but I have to confess I like large paintings. I like to see a lot of wall covered. Generally the market agrees with me. Say, for the sake of argument, we are dealing with paintings of just about equal aesthetic merit by the same artist (admittedly a hypothetical situation), then the bigger the better. A late Picasso of a Cavalier that measures 150 × 100 cm will be worth appreciably more than

Intense quality on a small scale: Jan van Kessel, oil on panel, 22 × 17 cm, 1669

one of only 60 × 50 cm. A Monet landscape of 70 × 90 cm will be worth more than one measuring 54 × 65 cm. This was the simple criterion by which the early dealers in Impressionism demarcated value. You paid more for a bigger one. Some smaller works are artificially enhanced by being given large frames; but not everyone is deceived.

There is a point, however, at which a painting becomes too big, and therefore compromised commercially. If a painting won't go through a decent-sized front door, its market will be limited. You can praise its 'monumentality', but if it's too big for a modern-day room it simply won't sell unless seriously discounted.

At the other end of the scale there are certain cases when less is more. Where the workmanship is very concentrated and intense – a portrait head by Dürer, a still life by Jan van Kessel, a Cranach, a Surrealist portrait by Salvador Dalí – its small size becomes a virtue. The vocabulary of the dealer in precious stones is then usefully deployed: 'an absolute jewel'; 'a little gem' [see Part V, **G**lossary].

Provenance

Degenerate Art
Missing Pictures
Restitution
Theft

Degenerate Art

The Nazi regime was good at playing on people's prejudices. When it declared that most of the modern art on view in German museums was degenerate, it had immediate popular support, appealing to the public's natural suspicion of what was new or shocking. 'Who wants to take these pictures seriously?' demanded the Nazi press, reviewing an exhibition of the work of the Expressionist Oscar Schlemmer in Stuttgart in March 1933. 'Who respects them? Who wants to defend them as works of art? They are in every way unfinished . . . they might as well be left on the rubbish heap where they could rot away unhindered.'

Gradually the opinion was encouraged that such art had no place in German public collections. The use of the word 'degenerate' could be traced back to a book published in 1892 called *Entartung* (*Degeneration*). The author was Max Nordau, ironically a Jew: he declared all modern art to be pathologically neurotic. Other texts useful to the Nazis included Paul Schultze-Naumberg's *Art and Race*, published in 1928, which mixed photographs of diseased and deformed people taken from medical textbooks with images of modern painting and sculpture. Not only was degenerate art eliminated from museums, but so were those museum curators who admired it. Dealers who specialized in it were closed down. An exhibition of the work of Franz Marc was forbidden on the grounds that it endangered 'Public Safety and Order', an early example of the tentacles of 'Health and Safety' extending into cultural matters.

The authorities went so far as actually to ban 'degenerate' artists from painting. They were not allowed even to buy art

materials. Gestapo agents would make surprise visits to their houses and studios to check up on them. Many, such as Max Beckmann, fled the country. Others, like Kirchner, committed suicide. Critics were brought to heel. In November 1936 Goebbels announced that the practice of art criticism was henceforth forbidden. 'The art critic will be replaced by the art editor,' he declared. 'In future only those art editors who approach the task with an undefiled heart and National Socialist convictions will be allowed to report on art.'

This was not, of course, the first time that state authorities have intervened in dictating what was acceptable art. In the first years of the French Revolution a similar policy was adopted towards devotional or religious works. Artists were banned from creating them, and any works in national collections that might excite religious fanaticism were relegated to storerooms.

What art did the Nazis like? Nordic art, they said, art that invigorated the healthy-folk feeling of Germany. The definition of Nordic art was elastic, and was somehow twisted to include not just German cathedrals, and Dürer, Altdorfer, Holbein and *gemütlich* nineteenth-century romantics such as Carl Spitzweg, but also the finest classical art, so that Greek sculpture and some of the masterpieces of the Italian Renaissance were also embraced. When it came to contemporary art, what was considered acceptable was pretty anodyne. It must be finished to a high degree: a distaste for anything unfinished was what linked the taste of the Kaiser to the Führer. A new museum in Munich was inaugurated in 1937, to display Nazi art. On its walls were bland renditions of well-scrubbed German peasant families rubbing shoulders with paintings of strapping Aryan women in states of idealized nakedness, while heroic war scenes were acted out, sometimes featuring the Führer as a knight in shining armour.

Ernst Ludwig Kirchner, *Albertplatz in Dresden*, oil on canvas, 1911:
deaccessioned as degenerate from the Wallraf-Richartz-Museum,
Cologne, in 1937

Simultaneous with the mounting of the exhibition of Nazi
art, a derisive exhibition of 'Degenerate Art' was opened to the
public in Munich. The works of 113 artists were represented,
which were nonetheless a small fraction of the 16,000 works of
art that Nazi confiscation committees ultimately removed from
German public collections. They were hung as unflatteringly
as possible, some without frames. A catalogue drew attention
to the barbarity of Kirchner, the Marxist propaganda inherent
in the works of Dix and George Grosz, the racial impurity of
Expressionist sculpture, the 'endless supply of Jewish trash',
and the 'total madness' of Cubism and Constructivism.

The confiscation committees had to make some ticklish

decisions. Was Impressionism degenerate? It was dangerously
unfinished, and therefore not to be encouraged; but few works
were actually deaccessioned. Lovis Corinth presented a further
difficulty. His early works were acceptable as healthily German;
but his later ones were deemed decadent. In the end a comprom-
ise was struck. It was noted that he suffered a stroke in 1911, a
convenient turning point. In a linkage of bodily illness to moral
collapse, works executed after that date were deemed by the
committee degenerate, and works before it acceptable.

What to do with the mass of 'degenerate' art that the
authorities had accumulated? The Nazis were realistic enough
to appreciate that some of it had considerable financial value on
the international market, which they exploited by a number of
discreet private sales, and then by a major public auction of 126
works at Fischer of Lucerne in June 1939. Buying at that sale was
a difficult moral decision for the international art collector. You
knew that the money you paid would be swelling the exchequer
of an immoral and repressive regime; but equally if you did not
buy them, the works concerned – masterpieces by Picasso, Mat-
isse, Van Gogh, Gauguin, Modigliani and all the major Expres-
sionists – might well be destroyed. And of course some of those
who bid bought extraordinarily well. Picasso's *Acrobat and Young
Harlequin*, removed from the Wuppertal Museum, was acquired
in the Lucerne sale for the equivalent of a few hundred dollars.
It sold again at Christie's in 1988 for $38 million.

The sales both public and private did not, however, make
much inroad into the sheer volume of degenerate art remain-
ing in the Berlin warehouse where it was stored. More drastic
measures were called for. On 20 March 1939 1,004 paintings and
sculptures and 3,825 works on paper were burned in a nearby
courtyard, at the Headquarters of the Berlin Fire Department,
providing the firefighters with a useful training exercise.

By one of history's ironies, the knowledge that a particular painting was one of those declared degenerate by the Nazis today enhances its value. Works that can be shown to have been ejected from German state collections in the 1930s are prized as particularly choice examples: not simply on the precarious logic that anything disdained by a regime as evil and misguided as the Third Reich must be good, but more because these are paintings originally deemed outstanding enough to have been acquired by major museums, and a major museum provenance is a rarity and an attraction to the market.

Missing Pictures

It's always exciting when a missing picture turns up. I found one in 1980 in – of all places – the storeroom of the National Gallery in Oslo. I had been invited in to look at something else, but I noticed another painting in the distant shadows, a full-length nude, unmistakably Victorian. 'What's that?' I asked. 'It's a painting we've been looking after since the Second World War,' I was told. 'No one has claimed it.' I found it was signed by Sir Lawrence Alma-Tadema. It turned out to be an important work by the great nineteenth-century reanimator of antiquity entitled *The Sculptor's Model* (like various painters in history, Alma-Tadema helpfully kept a *Liber Veritatis*, assigning each of his works an opus number). Research back in London revealed the painting as having belonged to the British Ambassador to Oslo in 1940. He'd had to leave it behind when he fled the German invasion. It wasn't too difficult to locate his son in England,

who took surprised repossession of it. I sometimes wonder if the ambassador might have been quite grateful to 'lose' the painting in 1940. It was cumbersome, and at that point worth very little. Certainly not much effort was made to retrieve it after the war. But by 1980 it had become valuable again, and the family sold it soon after for £121,000.

Pictures go missing for many reasons: some are stolen, some are destroyed, some are mislaid; some simply disappear into family collections where their significance is forgotten in their passage from generation to generation. Major works of art that have been destroyed include Titian's *St Peter Martyr* (in a fire in 1867), and Courbet's *Stonebreakers* (in the Dresden firestorm of February 1945). These paintings, whose tragic demises are fully documented, are known to have existed from old copies, prints or photographs. Similar evidence attests to the existence of other lost works whose fates are less clear.

Where, for instance, is Monet's portrait of Manet sitting in Monet's garden in Argenteuil, probably painted in July 1874 at a crucial point in the development of Impressionism? It was in Manet's possession when he died in 1883 and was inherited by his wife, who sold it to the distinguished German Impressionist Max Liebermann. Liebermann died in 1935, and the painting escaped Nazi Germany into the collection of his heirs in New York, but from there it was stolen before the Second World War. It has not been seen since, but an old photograph tells us what it looked like.

And where are the five missing portraits of madmen painted by Théodore Géricault in 1820? A series of ten was commissioned by a young friend of the artist, the alienist Étienne Georget, possibly after Georget had treated Géricault himself for an episode of madness [see Part I, **G**éricault]. Georget died from consumption in 1828, at which point five of the series were sold

Put to sleep in an Oslo storeroom: Sir Lawrence Alma-Tadema, *A Sculptor's Model*, oil on canvas, 1877

to a medical colleague, Dr Lachèze; these reappeared on the art market in the second half of the nineteenth century and are now all in major museum collections, acknowledged as being among the greatest portraits of the nineteenth century. The other five portraits were sold to a Dr Maréchal, who apparently hung them in his house in Brittany. Where are they now?

In 1636 Claude Lorraine executed a Mediterranean harbour scene, inscribed 'Napoli' and measuring 76 × 98 cm. It's missing. Claude's *Liber Veritatis* is a godsend for detectives of lost pictures, because not only does he list all the pictures he ever painted but he also adds sketches of them. Thus we know first of the existence of this lost harbour scene from the drawing in the *Liber Veritatis*, which is preserved in the British Museum. We also have information about the history of the original oil painting that this drawing records. It initially belonged to the Duke of Richelieu, and found its way into the hands of Archibald McLennan, an important Scottish collector, by 1837. McLennan left his pictures to the Glasgow Museum. In a bizarre transaction some time between 1870 and 1882, the museum sent the picture (with twenty-three others) to the Imperial Museum, Tokyo, in exchange for oriental works. It certainly never came back. The Imperial Museum now exists as the National Museum, but there is no record there today of the Claude. Was it stolen in the chaos that followed the earthquake that devastated Tokyo in 1924? Or could it have been looted by an American in 1945?

A possibly more prosaic fate befell a version of Rossetti's *Proserpine*, a Pre-Raphaelite head modelled on Jane Morris. It was put on a train at Paddington Station bound for Lechlade in Gloucestershire in 1872. But when it came to be unloaded at Lechlade it had gone, and has not been seen since. Could it have languished for a century and a half in a British Rail Lost Property depot?

Then there are the works that are not so much lost as put to
sleep, paintings that become separated from their authorship;
hence the art-world term 'the sleeper', the picture that appears
on the art market under-catalogued, without its full significance
being recognized. Dealers and collectors live in hope of such
discoveries, but they don't happen very often. Rubens's *Massacre
of the Innocents* was bought by the Prince of Liechtenstein from
a leading firm of Antwerp dealers around 1700, and then sold by
his descendants in 1920. Some time in the eighteenth century it
was downgraded, erroneously attributed to Jan van den Hoecke,
a minor Rubens follower. From then on it was effectively put to
sleep. Only in 2002 was it reawakened when it was consigned
to sale at Sotheby's and recognized as a work of Rubens, painted
about 1610 soon after his return from Italy, 'a trumpet blast that
announces the arrival of the Baroque in Flanders'. It turned into
a trumpet blast that announced the strength of the twenty-first-
century old master market, and fetched £46 million.

The element of 'rediscovery' that accompanies the re-emer-
gence of a missing picture is an exciting one to the market. It
implies freshness, the opportunity to lay your hands on some-
thing out of reach for generations. Conversely paintings that
have been on the market several times over a brief period of
years are tarnished, no matter how high their objective qual-
ity. Like people divorced several times, they are less desirable
because available too regularly.

Rubens Reawakened: *Massacre of the Innocents*, oil on panel, 1609–11

Restitution

Looted art is as old as warfare. Ever since man first made works
of art and attached value to them, art has been high on the list
of prized possessions plundered by the conquerors from the con-
quered: to the victor the spoils. Napoleon was a great plunderer
of paintings and sculpture. He ravaged Italy and Spain, bringing
back to Paris a succession of great works. In the Louvre, which
was rechristened the Musée Napoléon, the Emperor established
one of the greatest art collections ever assembled. After Napo-
leon's defeat at Waterloo, a process of restitution was enacted
by the allies. The stolen art was repatriated. Géricault and other
young French artists wept as they watched the masterpieces with
which they had grown up being packed into crates and sent
home.

Looting during the Second World War presented the art
world with a unique set of problems. One was the sheer scale of
the thefts carried out by the Nazis, sometimes from museums
but more often from private collections in occupied countries.
Another was the fact that for half a century afterwards the Cold
War prevented victims gaining access to vital records held in
Eastern Europe. In the west, too, previously restricted sources of
information about Nazi wartime looting such as those held in
the National Archive in Washington were opened to the pub-
lic only in the 1990s. In the same decade the governments of
Germany, Austria and Switzerland all enacted legislation making
it easier for claimants – particularly Jewish claimants – to gain
restitution of property stolen in the war.

All this meant that, in the art world, it was not until two

generations after the end of the Second World War that its final conflicts were played out. Lootings of valuable paintings were belatedly identified, investigated and tortuously resolved. Cases were still being uncovered and disputed in the early years of the twenty-first century. The original owners had long since died, often in concentration camps. For the Jews of Nazi-occupied Europe – among whom were some of the major art collectors of the time – oppression followed a similar pattern. First they lost their rights, then their possessions, and finally their lives. Restituting works of art to their descendants is an inadequate but symbolic gesture of recompense.

The restitution of Max Silberberg's Van Gogh drawing *Les Oliviers* from the Berlin National Gallery to his elderly daughter-in-law in 2002 was an early example of a carefully researched claim with a satisfactory denouement. Silberberg – a Jewish industrialist from Breslau – had sold his collection in 1935 at auction in Berlin, where the National Gallery had acquired the Van Gogh. A few years later Silberberg himself died in a concentration camp. Only in the late 1990s did newly accessible archives reveal that the 1935 sale had been a forced one and therefore illegal. His sole surviving heir was identified as living near Leicester, and she was reunited with her drawing, released immediately by the Berlin National Gallery.

The descendants of various Viennese victims have managed to reclaim several high-profile Klimts and Schieles from Austrian museums, and a great Kirchner was released from a German public collection. Generally museums have proved laudably swift to restitute once the results of what can be extensive research are presented to them. The worst scenario occurs when a painting now in the collection of a private owner who bought it in good faith turns out to have been looted in the war. The child or grandchild of the original victim demands it back.

The drawing restituted from the Berlin National Gallery:
Van Gogh, *Olive Trees*, pen and ink, 1888

The current owner is reluctant to hand over a possession perhaps worth millions of pounds, but is forced into the uncomfortable realization that his picture is an unnegotiable asset so long as there is a legitimate restitution claim hanging over it. These are intractable human problems, crimes with two victims. A fair reconciliation of conflicting rights is very difficult when the huge moral force of the Holocaust is part of the equation. Sometimes agreements are brokered whereby the painting is sold and the proceeds shared, but such agreements often leave both sides feeling aggrieved. There are no easy resolutions.

Restitution is occasionally impossible because there are no claimants. Families were simply wiped out, leaving no descendants. One of the saddest groups of paintings I ever saw was locked away in a picturesque former monastery outside Vienna, where I was taken in 1986. This was the storage depot for hundreds of works of art confiscated by the Nazi authorities from Jewish owners in Austria and since unclaimed. Ultimately these paintings were sold at auction and the proceeds handed over by the Austrian government to Jewish charities. But when I first saw them, stacked up and apparently abandoned, they seemed like orphaned children each with a terrible story to tell. I pulled out one on which the Rubens signature had been amateurishly scratched out and partly overpainted with watercolour. Why? I wondered. Later I understood: the frightened owners must have done it as a last desperate attempt to deflect the Nazi confiscators from their most treasured possession; unsuccessfully, as it turned out. But the final almost unbearable irony was that the painting itself wasn't actually by Rubens. It was just an old copy.

Auction houses had to take radical action to operate in the perilous new era of restitution claims. Departments were set up solely to research the history of ownership of works consigned for sale. Nothing that had been looted in Nazi years could be

offered at auction without a prior resolution of the case. Buyers would not bid on anything the provenance of which in the years 1932–45 was in any way dubious. Wartime transactions in occupied Paris became a particular focus, because this was where a lot of looted art was traded. Like unexploded bombs from sixty years before, unsuspected collaborations with the enemy at high levels in the Parisian art trade were uncovered, with uncomfortable latter-day repercussions for the businesses concerned where they were still in existence.

But wartime expropriation of art was not carried out solely by the Nazis. There were also major German private collections that found their way into the Soviet Union. As the Red Army swept into Germany in 1945, their policy was to take possession of as many valuable works of art as possible. The Soviets viewed these as war reparations against the devastation the Germans had wreaked in Russia. The paintings they carried away were stored in secret chambers in the Pushkin Museum, Moscow, and the Hermitage in St Petersburg (then Leningrad). For fifty years their existence was denied. Then, with the fall of Communism, these chambers were opened up. I was lucky enough to be one of the first people from the west to see the exceptional Impressionist pictures held in the bowels of the Hermitage. One particularly I will never forget. It was a magnificent Degas oil painting of figures promenading in the Place de la Concorde in Paris, a masterpiece, regretfully recorded in books published on the artist between 1945 and 1990 as 'destroyed in the Second World War'. And yet here I was holding it in my hands. It was an extraordinary moment of resurrection from the dead.

The descendants of the original owners of those German collections lobbied for their return. These private German claims carried less weight than those of Jewish victims of Nazi looting, and the government of Russia was implacably opposed. This was

art appropriated by the Russian state and any restitution would have borne an impossible political symbolism. But it is also true that you are much less likely to get back art stolen from you in the war if you didn't end up on the winning side.

Quite apart from moral considerations, various commercial interests are served by restitutions. Multimillion-pound pictures returned to hitherto penurious heirs often find their way almost immediately into the saleroom. Lawyers have grown rich by identifying and pursuing restitution claims on a no-win no-fee basis that rewards them with high proportions of the ultimate proceeds in the event of success. And then there are the grey areas, the cases where there is a gap in the provenance between 1932 and 1945, a gap exploited by unscrupulous agents who suggest the existence of a potential claim. These are often settled by current owners not because they acknowledge the validity of the claim but because it is impossible to prove a negative, and while there is a scintilla of doubt about its provenance a painting becomes unsaleable. The silence of the possible claimant is bought by writing them – or their agents – in for a few percentage points of the proceeds.

Human greed can never be totally excluded from financial transactions, even when they concern attempts to right the suffering and persecution of the past. But the consolation is that overall more good than evil has been achieved by the restitution process. And restituted art tends to sell well, for a variety of reasons: because it is fresh to the market, or has a museum provenance, or simply because there is a groundswell of buyer sympathy for the original dispossessed owner.

Now on to the Elgin Marbles.

Theft

Vincenzo Peruggia was arguably the most successful art thief
in modern history. He was the man who stole the *Mona Lisa*.
On 20/21 August 1911 he managed to hide himself overnight in
a cupboard in the Louvre. He was a carpenter, and had done
work for the museum in the past, so he knew his way about. He
emerged the next morning (a Monday, when the museum was
closed to the public), took the painting off the wall, hid it in the
voluminous tunic that all Louvre workmen wore, and walked
out of the door. Two years later he was arrested in Florence
when he tried to sell the painting to a well-known art dealer. At
his trial he defended himself on patriotic grounds: it was wrong
that France should have possession of this great Italian treasure.
He had merely tried to repatriate it. The court was partially per-
suaded: he got twelve months, reduced to seven on appeal.

The theft of works of art is at first sight a baffling phenom-
enon. Paintings are unique. You steal a famous one, and who's
going to buy it? How are you going to turn your ill-gotten gains
into cash, particularly today when every auction house and
legitimate art dealer is going to be alerted to the theft through
easily accessible international information agencies such as the
Art Loss Register? Yet thefts of valuable paintings continue,
sometimes from major museums and art galleries. Apart from
the *Mona Lisa*, more recent thefts include Munch's *The Scream*.
Are the criminals responsible just incredibly stupid, incapable
of thinking through the consequences of finding themselves in
possession of non-negotiable assets?

Wait a minute, though. There is an explanation. What about

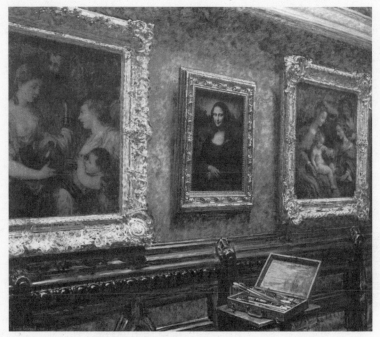

The *Mona Lisa* in place, shortly before its theft (Louis Béroud, *Mona Lisa at the Louvre*, oil on canvas, 1911)

stealing to order? There must be hugely rich, totally unscrupulous art lovers who want to own great art that is denied to them because it belongs to someone else. So they send out their paid hitmen to take possession of the paintings they desire, which are wafted away in the night from museum walls, and never seen again. They end up in the fevered clutches of these mysterious art-loving master criminals, who enjoy them in the seclusion of their secret galleries on private islands in the Caribbean.

Except they don't. There is absolutely no evidence that these people exist. If they did, they would be the purest art lovers of all, because they would be acquiring art drained of financial value, art that there is absolutely no prospect of their ever resell-

ing legitimately. These Mr Bigs are not found outside the realm of fiction.

Very occasionally, however, a total eccentric will emerge who steals works of art on his own account, with no apparent motive beyond keeping them for himself. Stéphane Breitwieser, a French waiter, was arrested in 2003. It transpired that over the course of seven years he had robbed over 100 museums in seven countries. He took small pictures, which could be hidden in his coat, and he concentrated on small museums with limited security arrangements. His method was a simple one. While his girlfriend would keep watch, or flirt with any passing guard, he would take out a knife and remove a painting from its frame before walking off with it. The most valuable work he acquired was a Lucas Cranach portrait of Sybil of Cleves.

He kept his collection in his mother's flat. When he was arrested, she set out to destroy the evidence. She threw 100 works into a local canal, and destroyed sixty oil paintings, including the Cranach – by chopping them into pieces and throwing them out with her kitchen rubbish. This may have been the most valuable rubbish bag in the history of art, even more so than the one mistakenly fed to the crusher in Tate Britain in 2004 [see Part II, **B**anality].

Another interesting case is the Rembrandt portrait of Jacob de Gheyn in the Dulwich Picture Gallery. This small (29 × 24 cm) panel has been stolen on four separate occasions, and each time recovered. It's one of life's mysteries why it should have been taken so often. Conceivably stealing it is on the curriculum for SAS training.

So: why is art stolen? Ultimately it is held for its potential ransom value. Most valuable art is insured. If it's stolen, the insurance company is exposed to a claim for its full value. With a $10-million picture, this is no joke. Offering a reward of, say,

$1 million for 'information leading to its return' makes very good sense for the insurance company. Officially there would be no direct negotiation with the thieves; but if by paying out $1 million they can save themselves $9 million by achieving the return of the picture to its rightful owner, then so be it. Sometimes this 'endgame' negotiation does not take place for a number of years, which means that the insurers will have paid out the full value to the original owner. So when the insurance company pays out the $1m reward and repossesses the painting, it finds itself the legal owner of the work. The insurers could then sell it, and find they get $20m back because the art market has moved on. This leads to unconfined joy among the brokers.

There is some evidence to suggest that the reason why valuable works of art aren't always immediately traded in for ransom is that they have a criminal currency. They are used as collateral in drug and illicit arms deals. They disappear into a murky underworld, where their changes of ownership pass them between very dirty hands indeed, before they re-emerge finally to be traded in for the insurance company's cash. It's a depressing ordeal for a great work of art.

Once I was approached by the police in Devon. They had an odd request. Would I value a Sir Joshua Reynolds that they had just recovered after a local burglar had been apprehended with it? It was clearly not genuine, but by a follower and worth under £1,000. The police were crestfallen. 'Not worth £85,000, then?' 'I'm afraid not.' 'Are you sure?' 'Quite sure.' Convicted of stealing something worth £85,000, the malefactor was liable to a sentence considerably longer than if it was worth £850.

Market Weather

Antiques Roadshow

The most successful and popular programme about art that has ever been made for television is the *Antiques Roadshow*, first screened in 1978 and returning every year since to the BBC schedules in longer and longer episodes. Its formula – a team of art experts descending on a town and valuing the local inhabitants' treasures – is the recipe for enthralling television and has been copied in many other countries. It has everything: works of art, human stories, unexpected discoveries, and the stirring extra dimension of money. The old print mouldering in the attic is dusted down, brought into the programme and turns out to be an early Picasso etching worth £100,000. Millions of viewers thrill to the vicarious pleasure of a win on the lottery. It is important, too, because for most people in Britain it represents their only contact with art and the art world.

I know a little bit about it because I was one of the original experts recruited to appear on the programme. I was a callow young man of twenty-seven, only recently emerged from the twilight of the Christie's Old Master basement, and now led blinking into the TV lights. That I was selected for such glory was owing to a happy chance. Christie's in those days used to send out teams of experts on Saturdays to pre-advertised provincial towns. The local inhabitants were encouraged to bring in their works of art for valuation and sale. It was a productive source of business. But Christie's senior picture experts all had better things to do at weekends – shooting, going to the opera, staying in ducal houses – so it often fell to me to go on these trips. One Saturday the event was covered by the regional

television station, in this case BBC Bristol, and run as an item
of local news. It caught the eye of some inspired executive in
BBC Bristol who decided that the format of art experts touring
the country had the makings of an interesting programme, and
a pilot series was commissioned. Where to turn to for experts?
Initially the BBC looked no further than the team they had
filmed on the original news report.

I only have to look at a recording of one of those early shows
to get an embarrassing vision of myself at that age. You don't
know until you perform in front of the TV camera how you are
going to come across on the screen. I come across as variously
nervous, faintly constipated, awkward and patronizing, some-
times all at the same time. Viewing my early performances again
now, I discover I also spoke as though I had several plums in my
mouth.

'What a charming watercolour,' I would intone insincerely to
its hapless owner on the *Roadshow*, sounding like an electioneer-
ing Conservative politician of the 1950s confronted with a prole-
tarian baby. Then I would throw in the well-worn line intended
to lead seamlessly into my valuation of the wretched object:
'Have you ever thought what it might be worth?' Unfortunately
this didn't always produce the desired response, as the stolid
British owner to whom the question was addressed, suddenly
faced with the embarrassing question of money on national
television, would more often than not blush, stare at his shoes
and mutter mendaciously, 'No,' at which point I would have to
override his reservations and tell him anyway.

My problem was that subconsciously I thought I was Ken-
neth Clark. In my formative years I had watched entranced the
monumental television series *Civilisation* in which Clark imperi-
ously guided the viewer on a tour of the high points of human
creativity in the course of twelve beautifully made episodes.

The author on the *Antiques Roadshow*, trying to break bad news gently

With his immaculate scholarship and patrician delivery, Clark was my role model. That would have been all very well had the general public of, say, Rochdale been bringing in Tiepolo oil sketches and drawings by Perino del Vaga for me to look at. Instead what I had were oleographs after Landseer, interspersed with photographic prints of Millais's *Bubbles*, and the occasional Russell Flint lithograph. It got a bit dispiriting.

Actually I wasn't alone in my inability to elicit an animated reaction from the British public. They were a source of frustration to the producer, too. They were so frightened to show emotion, so cowed by the cameras. Secretly the producer was hoping one of them would faint, shriek out loud or even sustain a mild coronary when told the value of their treasure: it would have made such good television. On one memorable occasion I encountered an owner prepared to express himself, and it was no coincidence that he was American. When I told him his

watercolour by Foujita was worth £50,000, he turned to a little old lady in the audience and said, 'Want to marry me now?' But I fear my own performances, like those of the British public, remained pedestrian. I just didn't have the knack, that natural-ness in front of the camera that some people are blessed with. It was charitable of the BBC to put up with me for so long, twenty-five years as it turned out.

I came rather to enjoy the territory where the *Antiques Road-show* intersected with the used-car trade, where wide-boy gara-gist met fastidious metropolitan gallerist. Once a motor-parts dealer from Oldham brought in a dubious L. S. Lowry that he'd accepted from a customer in lieu of payment for repairing his car. I had to tell him his painting 'wouldn't be accepted as genuine on the international art market'. 'What, a fake, then?' I frowned. 'Fake' felt like one of those words that should be discouraged on early-evening television. 'I am afraid it wouldn't be accepted as genuine.' He was downcast for a moment, then he brightened up. Apparently the repaired bumper had fallen off the next day anyway. Something else that gave me pleasure was meeting an ex-convict who told me that far and away the most popular TV programme in Wormwood Scrubs, where he'd just spent twelve months for handling stolen cars, was the *Antiques Roadshow*.

Appearing on the *Antiques Roadshow* brought you a certain fame, and you were liable to be recognized in the street, or at least accosted by strangers in bars who wanted to know where they'd met you before. This rather went to the heads of one or two experts, who started developing prima donna-ish tendencies such as bringing chocolates for the make-up lady to solicit her extra attentions. One, when presented by a taxi driver with a bill for signature so it could be charged to the BBC, couldn't help himself and added 'with best wishes'. Fan letters were received

and secretly totted up competitively. Once I got one from a man
in Barnet. He said he'd recorded my performance that week
and watched it again twelve times. After careful analysis of the
footage he personally had no doubt that as I held forth about a
Victorian watercolour attributed to Birket Foster I was clearly
masturbating. Thereafter I made sure that I was never again
filmed with my hand in my pocket.

As the programme became more and more popular and
successful, members of the public appearing on it got more
and more optimistic about their property. A change came over
proceedings: rather than giving people pleasant surprises, you
were having to let them down gently. 'Value? Not very much,
I'm afraid. But it's such an interesting thing. Take it home and
enjoy it.' Once I got help from an unlikely source. There were
so many people in the hall in one location that the police were
on duty to keep order. An officer positioned himself behind
the table at which I was dispensing expertise and eavesdropped
shamelessly. I was having some difficulty in explaining to the
nice lady owner of an indifferent Norwich School landscape that
the impressive-looking signature on it wasn't authentic. At this
point the policeman intervened. 'I, on the other hand, madam,'
he declared delightedly, 'am a genuine Constable.'

Buying Art

The process of deciding that you want to buy a particular paint-
ing or sculpture is a bit like falling in love. You may see it first
in reproduction, perhaps in an auction or exhibition catalogue,

or on the Internet. Your eye is caught by it; it stays with you. You go and see it. The promise it showed as a photograph is confirmed in the flesh. (Or occasionally not. Sometimes it simply doesn't measure up to the fantasy you have woven about it, and you reject it, shaking your head at your own gullibility.) If it's as good as you thought once you've actually seen it, then the obsession intensifies. You can't stop thinking about it. If it's coming up at auction, you return to the catalogue again and again, maybe revisit it in the auction house or dealer's exhibition where it is on view, not so much to recheck it as to wallow in it. You are like a lover with an image of the person you have fallen in love with: you keep taking it out to savour.

If it's with a dealer then you have the option to buy it before anyone else does, to secure it for yourself. Negotiations can start immediately. But if it's coming up at auction there is an agonizing wait until the painting actually comes under the hammer. If you turn up to the sale yourself, you suspect every other person in the room of having designs on your lot. You're thrown into the depths of despair at the unaffordable price it will end up selling at. You are confronting the probability of the loss of the thing you love. My heart always races when the lot I want appears on the podium. Bidding for yourself, I find, is far more gruelling than actually being the auctioneer who conducts the sale. And the awful truth is that, very often, you don't get it. Other bidders' spending power is greater. Just as very beautiful people tend to elude one's romantic advances, so very beautiful paintings go for more than one can afford.

And then, just occasionally, you're lucky. Everyone else stops bidding and you've got it. Elation turns to momentary doubt. What was wrong with it that everyone else knew but you didn't? That passes: you've got it. You've bought it. It moves in with you. The love affair enters a different phase.

Bruce Chatwin, who spent seven years working at Sotheby's, takes the view that works of art are actually better than lovers. He observes the process of the auction and 'the nervous anxiety of the bidder's face as he or she waits to see if she can afford to take some desirable thing home to play with. Like old men in nightclubs deciding whether they can really afford to pay that much for a whore. But things are so much better. You can sell them, touch 'em up at any time of the day, and they don't answer back.'

Cataloguing Pictures

In the 1970s, when I used to catalogue old master paintings in the artificially lit depths of the Christie's basement, I learned that their subject matter was endowed with its own unchanging language. You deviated from the traditional terminology at your peril. There were river landscapes, winter landscapes, harvest landscapes; they could be wooded, mountainous or coastal, Italianate, classical or capriccio, extensive or even occasionally panoramic. Their populations (staffages, rather) comprised countryfolk, rustics, cowherds, shepherds and ferrymen. But – and here was a trap – the staffage of British landscapes must not be described as 'peasants'. Peasants were a strictly continental phenomenon. 'Don't you know any history?' the senior expert would rail at some unfortunate cataloguer who had committed this *bêtise*. 'The Peasants' Revolt? Wat Tyler? In 1381? There were no peasants in Britain after that.'

So it was only in continental pictures that peasants caroused

English countryfolk (W. F. Witherington, *The Harvest Field*,
oil on canvas, *c.* 1840)

or made merry in taverns and inns, while outdoors disreputable
dogs relieved themselves against the vegetation (an operation to
be described as 'favouring' a tree trunk). Further up the social
scale, elegant companies held levees, banqueted or ranged the
countryside as hunting-parties. History melted into mythology:
there were beggars and bacchantes, alchemists and sportsmen,
clerics and quack doctors. Magdalenes were penitent, Scipios
were continent and Venuses recumbent. Nymphs were surprised
by Satyrs and putti disported in painted cartouches. Thus an
Arcadia was brought to life in the sunless, airless confines of
the basement of King Street, St James's.

Every Thursday the senior directors descended from the Par-
nassus of their light-filled offices upstairs to conduct what was
known as 'The Hill', a meeting in the warehouse at which the

Flemish peasants (David Teniers, *Village Scene*, oil on panel, *c.* 1650)

cataloguers' work would be assessed, corrected, final attributions decided upon, and prices agreed in front of the pictures themselves. The Hill was the proving ground and the killing field. That was where you made or broke your reputation by the intelligence, or otherwise, of your contributions. Ambitious young Turks were not above getting in particularly early on Thursdays to go through the stacks of paintings secretly in advance in order to prepare their off-the-cuff attributions. One unfortunate colleague boned up in this way on a French moonlit landscape. He found what he thought was an artist's name on the reverse, noted it down and blurted out the moment it was held up by the porter: 'Isn't that by Claire de Lune?' There were certain phrases you clutched at to buy time. 'Right, is this good enough to be by Joos de Momper, or is it just an old copy?' one of the

directors would demand aggressively. You would peer thought-
fully at the figures and suggest they were a bit wooden. Or you
would draw attention to the quality of the foliage. Or suggest
that the sky had been repainted by an overzealous restorer in the
past. What you didn't do, which someone once did, was assert
that the trees were a bit wooden.

Today auction-house catalogues – and indeed those of some
dealers – are massive and freighted with learning. If dropped
from a first-floor window on the head of a passer-by, the impact
would be fatal. They are gloriously illustrated productions pre-
senting the full details of each lot – its provenance, where it has
been exhibited, in what publications it is mentioned – and then
adding notes to describe and explain further the context and
significance of the work. These notes are salesmanship disguised
in the language of art history. They differ intriguingly from the
way a museum might describe the same picture. Here is the
museum catalogue version:

A fragmentary work of the artist's old age, painted on the theme of ill-
ness and mortality in dark, foreboding colours; the lower section of the
canvas is largely unfinished.

There are seven phrases in the above that would be suicidal to
the commercial interests of the auction house: 'fragmentary', 'old
age', 'illness', 'mortality', 'dark', 'foreboding' and 'unfinished'. So
the auction-house catalogue might read as follows:

A spontaneous and moving work in which the artist draws on a
lifetime's artistic experience to present a subtly lit image of profound
insight, the vision of his theme energized by the supreme economy of
the execution in the lower section of the composition.

Christie's and Sotheby's

The art-auction business is, I think, unique. I don't know another global industry that operates as such a dominant duopoly. Toe to toe, Christie's and Sotheby's confront each other across the world, selling art in London and Geneva, New York and Hong Kong. Sometimes one house claims to have edged ahead in sales, then the pendulum swings back in favour of the other. I know, because I have been a director of both. There are subtle differences between them, although from the outside they appear remarkably similar in what they do and how they choose to do it. Both have distinguished histories, Sotheby's having been founded in 1744 and Christie's in 1766. The success of the two London houses is born of long experience and follows a simple formula. 'In troubled waters we catch the most fish,' said the art dealer William Buchanan in 1824, and for three centuries Christie's and Sotheby's have been adeptly fielding the treasures that death, divorce, debt and the disasters of war propel on to the market.

Auction is an ideal means of selling art, a commodity whose value has little intrinsic or objective value but is vastly inflatable by fantasy, aspiration and human rivalry. The fall of the hammer has also a marvellous and ineluctable finality. Private sales – the modus operandi of the dealer – are less easy to close. With a private sale, the asking price is set by the dealer as high as he feels is possible, and then worked down from as people make offers. With an auction one starts low, and hopes that competition will drive the price up. It doesn't always work in favour of the auction, but it often does. The art market regularly produces prices

realized in the heat of the chase at auction that would not have
been achievable by private treaty.

From its founding in the eighteenth century through to the
Second World War, Christie's was the dominant auction house
for the sale of works of art. Sotheby's largely sold books, and
didn't have the experience or reputation to compete when the
great art collections came to market. Madame du Barry's jewels
at the end of the eighteenth century were followed through the
nineteenth century by sales at Christie's from the greatest houses
in the land, of the dukes of Buckingham and Hamilton, Buc-
cleuch and Somerset, of the Earl of Dudley and the Marquess
of Exeter. And Christie's had the great artists' studio sales, too:
Gainsborough, Reynolds, Landseer, Rossetti, Burne-Jones and
Sargent.

But not many concessions to luxury or modernity were made
at Christie's before the Second World War. As the French art
dealer René Gimpel wrote in 1919,

It has its character this famous London saleroom where nothing has
changed for more than a hundred years. It's wonderful! Here there's no
need to pander to the clients paying out twenty, forty, fifty thousand
pounds for pictures! Christie's in England, in the country of com-
fort and cleanliness, has the audacity to offer sheer discomfort and a
parquet floor thick with dust. Pictures worth a few pounds alternate
with hundred-thousand-pound works and are sold along with them,
everything 'just as it comes' on the walls. Three, four rows, the pictures
one above the other, the finest sometimes perched just below the roof.

When I first joined Christie's in 1973 a wonderfully British
atmosphere of amateurism still pervaded the company. It was
an institution somewhere between an exclusive gentlemen's club
and a museum, a bastion of the British Establishment, an odd
mixture of garrulousness and reticence, of arrogance and schol-

arship. It was different from Sotheby's, who had led the way since the 1950s and were felt to be dangerously commercial. A crusty old Christie's director explained to me what in his view distinguished Christie's from Sotheby's. 'The difference between us and those barrow boys up in Bond Street,' he said, 'is that we are all heterosexual.'

It was a measure of the extent to which Sotheby's success had unsettled the old guard at Christie's. True, in those days the chairman of Sotheby's, Peter Wilson, was fond of surrounding himself with rather beautiful (and clever) young men. The switchboard, if one ever had occasion to ring Sotheby's up, was manned by an extraordinarily camp-sounding operator. 'Could I have John Brown?' a caller for the head of an expert department once asked. 'I don't see why not,' he was told, 'everyone else has. Putting you through now.' But it was more than that: Sotheby's was imaginative and innovative and knew how to make money. Wilson, a brilliant and mercurial chairman, was in many ways the creator of the modern art market as we know it today.

Traditionally both London auction houses had been whole-salers, purveying art largely to the trade in fairly squalid conditions. In this respect the Parisians had been ahead of the game. In 1919 Gimpel contrasted Christie's in London with the auctioneer Georges Petit in Paris, who 'begins by attracting customers with comfort in his immense gallery, providing hundreds of velvet armchairs. He shows them his pictures the way a goldsmith shows a jewel. He furbishes and gilds the frames, and of course cleans and varnishes the canvases, which are then spaced out harmoniously on the walls. A sale is more consummately got up than a first night, with good carpets too on the floor.' Forty years on Sotheby's, too, put carpets on the saleroom floor. It was for the Goldschmidt sale in October 1958. Peter Wilson had secured for sale seven great Impressionist pictures from the

Jacob Goldschmidt Collection and decided to present them in a stand-alone auction as a glamorous evening occasion to which you came in a dinner jacket. Everyone responded to the glamour, and a whole range of record prices was set for Impressionist painters. Suddenly auctions weren't just commercial transactions with art-historical undertones: they were social events.

Christie's, by comparison, was characterized by a French dealer I met as '*un peu constipé*'. I was shocked at the time, but in retrospect I suppose he was right. Christie's was nothing if not traditional. In the 1970s paintings by artists from Australia, South Africa, Canada and other former British possessions were lumped together and included in what was still called the 'Colonial Sale'. Works by American artists were also included in that category: it was as if, in the Christie's boardroom at least, history had stood still since 1766. Christie's forte was its English connections, its familiarity with the great stately homes that for generations had provided it with its business. Christie's success was built on its understanding that in every traditional Englishman there lurked a streak which found art embarrassing. Art had an emotional content which was difficult; art raised uncomfortable questions of aesthetics; and works of art themselves were possessions. They belonged to chaps. It would have been an appalling error of taste and intrusion into another man's privacy to go commenting on his possessions: his pictures? His wine? What next, his wife? This was why the elderly noble owner of a long-established collection felt so affronted when his son brought home a friend from Oxford, the young Kenneth Clark. 'Don't let that fellow come here again,' he spluttered afterwards. 'He kept asking me about my things.'

There was something rather splendid about the Christie's Old Guard in the 1970s. It was the final flowering of a very British ideal of amateurism. You might have questioned whether their

agonized reluctance ever to pass judgement on other people's possessions was a desirable attribute in people earning their livings as fine-art auctioneers. But the truth was that the pained inarticulacy evinced by the Old Guard when something so compromising as an expression of aesthetic or commercial opinion was demanded of them struck a deep chord of sympathy in many of their older English clients. Golf, cricket or shooting were respectable areas of interest, or even expertise. Art was a little unhealthy. The Old Guard acknowledged that their business had some tangential connection with the subject, but it was more reassuring to clients to offer an attitude of happy-go-lucky amateurism to it, to admit certainly to the existence within Christie's of specialists with a necessary job to do, but not to dwell too knowledgeably on their activities.

'Want to sell those spoons, old boy? Of course, delighted to help. Got some chap down in the vaults who's a genius at identifying the damned things. Reads the marks or something, but don't ask me how!' Or then again: 'Want us to flog your Rubens? But of course we'll take it off your hands. I quite agree, all that flabby female flesh about the place – it's enough to put a fellow off his food. Send it down and our chap will have a look at it for you. Don't be put off if he writes a damned ten-page essay for the catalogue entry. The buyers these days seem to like that type of thing.' Thus a seller's nerves were soothed: he was dealing with one of his own.

James Christie, the founder of the auction house in 1766, had to confront the same social dilemma. Joseph Farington records in his diary on 10 September 1810: 'Lord Dunstanville spoke of Christie, the Auctioneer, & expressed His surprise that a man who had been educated at Eaton School, & had been there distinguished for His classical acquirements should have submitted, or rather by choice should have chosen to be in the line of

life in which He is now established.' An uneasy awareness of this ambiguity still permeated the board of Christie's a century and a half later. A certain eighteenth-century rakishness also endured. I remember a senior director telling me that the one principle which governed his life was that he never accepted a shooting invitation for a Wednesday, because he couldn't decide which weekend to tack it on to.

Modern art was a problem to such natural conservatives. The idea of staging a contemporary-art sale met with agonized and protracted resistance at Christie's in the 1970s. Even Picasso was cause for a certain amount of boardroom hilarity among the Old Guard. A favourite story as the port and brandy circulated after lunch involved the purchaser of a Picasso attempting to export it from Spain and being stopped by an apologetic customs officer unable to sanction the smuggling of what was clearly a map of the military fortifications of Madrid.

The first time I ever went abroad on business for Christie's I was taken aside by a member of the Old Guard and given some advice. 'Remember one thing,' I was told. 'Foreign women expect to have their cigarettes lit for them.' He shook his head at the sheer, flagrant un-Britishness of it all. The information lay like a time bomb in my consciousness. I bought a box of matches at Heathrow. I was still fingering it nervously in my pocket when I arrived at the client's house and looked at the pictures. Then we sat down to lunch, where I was placed next to my hostess. I noticed a box of Marlboro by her napkin. Oh, God: I must be ready at any moment. The honour of Christie's was at stake; no, even the honour of England.

It happened as the coffee was served. I saw out of the corner of my eye the hand of my hostess reaching for a cigarette. Smoothly I pulled the box of matches from my pocket, extracted one, and struck it. But in my enthusiasm I struck it

rather too hard. The head flared off from the stick and fell on my knee, setting light to my trousers. I managed to extinguish the flame with a napkin, but by this time my hostess had lit her own cigarette. I had failed shamefully. It was an early lesson in client management.

My acquisition of a cigarette lighter for the next visit I undertook abroad could be read as a metaphor for Christie's need to change to survive. Change they did, finally coming to terms with the fact that foreigners accounted for a large proportion of the art market, and expanding successfully into Europe and America. Indeed the pendulum swung, and at the beginning of the 1980s it was the turn of Sotheby's, post-Wilson, to founder. There was a vacuum at the top. A bid for the company was made by a couple of Americans, Messrs Swid and Cogan, who were carpet manufacturers. Their business was called General Felt. The remnants of the Old Guard at Christie's were bemused: they couldn't find this fellow General Felt on the Army List. In the end Sotheby's was bought by another American, Alfred Taubman.

In 1998 Christie's itself changed hands and was bought by, of all people, a Frenchman. I could imagine my old colleague who wouldn't shoot on Wednesdays turning in his grave. So now both auction houses, having been acquired by foreign owners, had to shed some of their Englishness in the transition to twenty-first-century globalization. It was not a painless evolution. The price-fixing scandal that emerged in 2000 was a symptom of the upheaval, of how the old ways had to be exorcized before the new could flourish. The secret agreement between the chief executives of Sotheby's and Christie's to stick to a rigid table of commission rates was uncovered and led to massive legal settlements. For those of us who watched the drama unfolding from the inside, it was not difficult to understand how

this happened. It was a throwback to the old days in England when informal business agreements were brokered over lunch in gentlemen's clubs. It would not have crossed the minds of the people concerned that they could be breaking the law. And even if it did, they would still have felt secure, because a gentleman didn't betray confidences. But of course in America they *were* breaking the law. And in America there were people involved who *were* prepared to betray confidences. It was a classic example of Anglo-American cultural misunderstanding.

The irony of it all was that even when it was in place the secret agreement didn't result in the auction houses raking in fabulous profits. The motive behind it wasn't so much to clean up as to keep going. Margins had become so eroded by duopolistic competition that profits were tiny. For an explanation of how this could have happened, you have to look at the sort of people who work in auction houses. Many of them are

Internationalized demand for art: telephone bidders from
across the globe competing at auction

specialists who feel passionately about the paintings or objects
that they are handling, in some cases more strongly than they
feel about making money. Thus people were putting together
wonderful sales with very slim revenues simply for the pleasure
of handling the masterpieces. I can't think of another business
– certainly not one quoted on the New York stock exchange –
where this sort of purism distorts the moneymaking process.
But it did. So the commission-fixing was in a way an internal
mechanism, as much a brake upon the auction house's own staff
as on its clients.

'It isn't so much the worms that get everything in the end as
the auctioneers,' wrote George Lyttelton to Rupert Hart-Davies
in 1958. 'Except for insurance, auctioneering is surely the saf-
est racket imaginable – no risk, a sure percentage, and endless
material (including often the same objects sold again and again).
And they're all immensely pleased with themselves, as though

they were creating the masterpieces they sell.' But there is a sense in which the auction houses, in the twenty-first century, do create if not the works of art that they sell then at least the reputations of the artists who make them, particularly in the contemporary market. The very inclusion of work by a rising contemporary artist in a top evening sale at Sotheby's or Christie's is an imprimatur of that artist's importance, a consolidation of their brand. Similarly, the devotion of an entire sale catalogue to a single modern art movement – for instance Surrealism – is a validation of that movement and a sure sign that its market is on the rise [see Part II, **S**urrealism].

The past half-century has seen extraordinary changes in the art market and in the role the auction houses play in that market. The most significant is the change in emphasis from being wholesale clearing houses for the art trade to becoming high-powered selling forces that deal directly with the final user in the chain. In the process not only have enormous resources been devoted to marketing but sophisticated financial instruments have also evolved to facilitate the buying and selling of art for ever-higher prices [see **M**oney, Guarantees below]. What has made this possible is that both Christie's and Sotheby's have remained centres of excellence in one continuing respect: their expertise. So long as that remains the case I predict that the duopoly will flourish.

Collectors

Not everyone who buys art is a collector. A collector is someone who buys primarily for the love of the object, and for appreciation of that object in the context of the other works he or she already has in their collection. The best collections are works of art in their own right, appreciably more than the sum of their parts. Where a collection is the product of an individual collecting intelligence it is often more satisfying to look at than the chance agglomeration of major works that is combined in a museum. That's not to say that collectors are pure-minded human beings whose motives are untainted by thoughts of financial value. Art is so expensive now that no one can afford to take that view. Nor is a collector unaware of the 'trophy' aspect of the acquisition of a great work of art, and he will certainly derive pleasure from showing it off to his friends. But you know a collector when you meet him. He is different from the person who buys art to acquire symbols of status, or simply to furnish a house [see **S***tatus Symbols*, below].

It was Paul Mellon who, after having bid a world-record price for Cézanne's *Boy in a Red Waistcoat* and being asked if he had paid too much, explained: 'You stand in front of a work like that, and what is money?' Auctioneers and dealers love that story. They feel empowered by it. But it illustrates what can happen when a genuine collector with vast resources gets swept away by the desire to possess a rare work of art. I was once on the telephone in an auction with a bidder who wanted to buy a magnificent Giacometti sculpture, *Walking Man*. This very rare bronze almost never comes up. The collector had wanted it all

their collecting life. The three or four minutes of bidding were a memorable experience. The amounts of money by which each bid was increased were almost irrelevant; all that mattered was the object, and keeping alive the opportunity to own it. The quickening pulse of the bidding created an almost unbearable intensity. When the hammer finally fell, my client had bought it for £65 million, then the highest price ever paid at auction. But that barely registered by comparison with the relief, pleasure and exultation of acquiring the work. It was the crowning moment of a lifetime's collecting.

Today, more than ever, collectors must be rich. But it was not always like that. In former generations the intelligent collector of modest means could also operate successfully. The original of this type is Balzac's Cousin Pons, who made it a point of principle never to pay more than 100 francs for a picture. Nonetheless he manages to assemble over the years 1810–40 a superb collection of old masters, by sifting through the 45,000 canvases that changed hands annually in Paris picture sales. Pons is one of Balzac's most endearing characters. He has a charm and an innocence at variance with the scheming reprobates about him. His life's work is his collection. Balzac speaks of 'the collector's passion, which is one of the most deeply seated of all passions, rivalling even the vanity of the author'.

Pons was a fictional collector; a real-life Parisian collector in the same mould but of a generation later was Victor Chocquet. He was an early patron of the Impressionists, being absolutely convinced of their merit when everyone else was mocking them. But he had very little money. He worked as a civil servant in the French Customs. His income in the 1870s never exceeded 6,000 francs, of which 960 francs went on the rent of his modest four-room residence in the Rue de Rivoli. Still, he managed to put together a superb collection of the Impressionists, often for

Victor Chocquet, the early collector of the Impressionists, as drawn
by Cézanne

individual prices of less than 300 francs. When Chocquet finally came into money through his wife's inheritance in the 1880s, some of his enthusiasm for buying modern art diminished. It seems that he was one of those rare collectors largely driven by the excitement of being a pioneer, an excitement intensified by the paucity of the resources at his disposal.

The really big beasts in the collecting jungle in modern times have hailed from the merchant class. That is where the requisitely vast fortunes have been made. Luckily many of these merchant collectors have also been philanthropists. In America, where a friendly tax regime made it advantageous to leave your collection to a public institution, a number of major museums have benefited from rich men's largesse. From the collector's point of view there is the compensatory attraction of achieving immortality by keeping your collection together in a place where it can be admired by generations to come. So the Metropolitan Museum is the repository of the Havemeyer Collection, the Art Institute of Chicago is the home of the Potter Palmer Collection, and the Paul Mellon Collection can be seen in the National Gallery, Washington, and at Yale. The only British equivalent on this scale is Samuel Courtauld. His legacy does not just comprise the treasures at the Courtauld Institute: the Tate Gallery's holding of modernist French art would be threadbare indeed without his discrimination and generosity in the 1920s and 1930s. In Russia the achievement of two great modern collectors is kept largely intact in the Hermitage Museum, St Petersburg, and the Pushkin Museum, Moscow. Sergei Shchukin and Ivan Morozov – both of whom bought masterpieces from the studios of Picasso and Matisse before the First World War – conformed to type in that they were rich merchants. But in their cases the handing over to the state of their superb collections of French modernist art was involuntary. After the Russian Revolu-

tion their pictures were appropriated by the Soviet regime.

Not all the great art collectors of modern times were industrialists, however. Some have been artists, building on the earlier tradition of the old master acquisitions of Joshua Reynolds and Thomas Lawrence. Degas was another who used his incomparable eye to buy with discrimination and passion. And in the present day, could it be that Damian Hirst (one of those rare artists with the financial power to compete at high levels) will achieve longer fame through his art collection than his art? There are great dealer-collectors too: Ernst Beyeler and Heinz Berggruen, for instance, managed to amass in their dealing lifetimes enough great pictures to endow fine museums. This takes determination: I know from experience how difficult it is for a dealer to demarcate between his stock and his private collection.

Sometimes a sympathy between collector and artist leads to unexpected acquisitions. It is true that a collector with no eye will occasionally acquire a work of surpassing quality, on the principle that a monkey with a machine gun will occasionally hit the target. But it is very unusual to find a palpable dud in the possession of a great collector. We once had a Picasso drawing for sale that was an unusually poor one. It was the master on a true off-day. I was amazed to find that the buyer had been Stanley Seeger, one of the most discerning collectors of modern times, whose eye for Picasso was particularly acute. He explained later: 'I had to do it, you know. The drawing was so bad it had to be taken out of circulation.'

Dealers

Art dealing as we know it in the modern age was invented in Paris by Paul Durand-Ruel. He was the man who launched the Impressionists. Up until the 1870s there had been many dealers; but their objective had been to make a living by buying and selling the work of established, often dead, masters. Some operated in Italy, purveying to the privileged visitors of the Grand Tour. Sometimes they were painters themselves. Their expertise lay in sourcing the material and offering informed, if sometimes optimistic, attributions. Certain Grand Tourists were quick learners and began buying and selling on their own account. In fact George III, in one of his more lucid moments, remarked that all his noblemen were now picture dealers. Walter Scott confessed to misgivings about this development in 1827: 'I fear picture-buying, like horse-jockeyship, is a profession a gentleman cannot make much of without laying aside some of his attributes.'

The change in the role of the dealer in the second half of the nineteenth century had something to do with the changing perception of the role of the artist. The Romantic Movement emphasized individual genius. Gradually a role opened up for the dealer in contemporary art as the provider of access to that genius. Up until the middle of the nineteenth century the French contemporary artist sold his pictures by exhibiting at the Salon (the annual exhibition for conventional artists and academicians) and building a reputation there. But since that avenue was closed to the Impressionists, Durand-Ruel stepped in as the promoter of the individual painters of the movement, as interpreter of the 'difficult' new art. He pioneered the single-artist

exhibition, becoming the purveyor of artistic temperaments. He orchestrated positive criticism of them in influential newspapers; and he took them to the glorious new market of America.

The active branding of artists as commodities, paying stipends to them, nursing them through various price levels by a carefully judged series of commercial gallery exhibitions, all are features of the sophisticated contemporary art market of the twenty-first century. But all have their origins in the way Impressionism was marketed by Paul Durand-Ruel in the last quarter of the nineteenth century.

In art dealing, Durand-Ruel claimed, it was the art not the dealing that mattered. He invented the self-serving image of the dealer as idealistic pioneer, altruistic hero, almost as artist himself in the discovery, appreciation and promotion of new talent. Even in 1896, when Impressionism was selling well, he was still maintaining, 'I am rather particular as to what I buy, and if I were less rigorous in my choice, I would certainly have a much larger clientele than is the case at present.' Up to a point. No one blames a dealer for making an honest profit. But Durand-Ruel cleverly deployed his high-mindedness as a marketing tool. It's a tactic much used in the trade since, and still current today: 'I'd rather sell this picture to you, who understands it, than to a speculator who doesn't. If I make less profit, then so be it.' Or, if you're really clever: 'I've shown you all my normal stock. But upstairs I have a couple of really exceptional things that I only show to really special clients, those who will truly appreciate them.' These are hard to resist as selling lines, flattering to the buyer's self-esteem but at the same time increasing the pressure on him to buy. Durand-Ruel's achievement is that he established the template of the modern art dealer who educates his clientele, the high priest who interprets the mysteries of contemporary art for them.

'Lice on the backs of the artists' was how Duchamp described dealers. Not entirely fair, and even Duchamp had to admit that dealers were necessary to artists, too. But it speaks of a new relationship between painters and the people who sold their work for them. As modern art became more and more elitist and obscure, the interpreter, in the guise of the dealer, became an increasingly crucial factor in the process of selling the art. Not only was it a question of aesthetics; it was also one of financial understanding. Marie Cassatt wrote in 1904: 'In these days of commercial supremacy artists need a "middle man", one who can explain the merits of a picture or etching, "work of art" in fact, to a possible buyer. One who can point to the fact that there is no better investment than a "work of art".' A number of supremely talented operators fulfilled this role in the early twentieth century: Ambroise Vollard, Paul Cassirer, Daniel Kahnweiler and Léonce Rosenberg (memorably described by René Gimpel as 'tall, blond, and elegant like a pink shrimp') were crucial to the acceptance of French modernism.

It wasn't always easy. The dealer in his role as the gatekeeper to the contemporary artist risked unpopularity. He was viewed as an obstruction by collectors wanting direct access to the painter. Little has changed today. 'Pompous, power-hungry and patronizing,' says the collector Charles Saatchi of certain dealers, 'these doyens of good taste would seem to be better suited to manning the door of a nightclub, approving who will be allowed through the velvet ropes.'

The power of the dealer increases throughout the twentieth century. 'Painting is the most beautiful of professions, second only to selling paintings,' the painter Jean-Louis Forain teases Gimpel in 1919. The same year, Gimpel goes to Christie's and observes how English picture dealers are becoming grander than their clients (a continuing occupational hazard): 'The

Lord Duveen: the art dealer who became grander than his clients
(today an occupational hazard)

dealers have carnations in their buttonholes. Their shops may
be revolting, but they remain gentlemen.' He notes a conversa-
tion 'between two individuals, one of whom is wearing a form-
fitting frock coat, while the other, red-faced and rustic, with his
stomach protruding, looks like one of those figures who sit in
taverns in sporting prints. The latter is a lord, the former an art
dealer.' Some dealers even became lords, such as Joseph Duveen.

Quite a few became knights. In fact the twentieth century is the golden age of the dealer, with his power to make the reputations of artists and to build collections of lasting importance. The history of modern art in Europe and America is written almost as much in terms of its influential dealers as its painters.

In the twenty-first century art dealing has moved up another gear: today major dealerships such as Pace, Gagosian or White Cube have the resources to dress up their galleries as museums of modern art. They mount exhibitions of museum quality that include major loans, giving context and ballast to the two or three works embedded in the shows that are actually for sale. They are also globalized in their structure and reach: they attract the brightest new artistic talents by offering them shows in their own gallery premises in New York or London or Rome, in Mumbai or São Paulo or Hong Kong. Their salesmen crouch over screens at desks arranged in lines like those on trading floors. Their operations are impressively commercial.

'For those we are about to deceive, may the Lord make us truly thankful.' The art dealers' grace is a light-hearted admission that historically those who trade in works of art come in varying degrees of honesty and charm. Some are scholars; others are salesmen. Each has their own personal strategy for selling. Both the advantage and disadvantage of art is that you are marketing something of no definable objective value. It becomes worth what you can persuade someone to pay for it. You can do that by playing on their greed, their megalomania or their social insecurity. An instance of the selling power of the major dealer is recorded by a jaundiced Marie Cassatt in September 1886. She recommends an American visitor to Paris called Thompson to buy a Monet not at Durand-Ruel but at the less well-known dealer Portier. Despite Portier producing two good ones at knock-down prices, Thompson, she reports, 'preferred buying

one from Durand at 3000 frcs. I feel rather snubbed! I advised him to buy cheap, but I suppose he is the kind to prefer buying dear. I have very little doubt Portier's were the best pictures.'

It is true that the branding of a work can take place almost as much through its handling by a particular big-name dealer as through its authorship: thus a Durand-Ruel Monet was intrinsically more valuable than a Portier Monet. And it is also true that to a novice in the challenging and unfamiliar arena of the art world, a high price can seem a guarantee of quality. When I first became a dealer, I couldn't understand why a particularly fine early-nineteenth-century landscape I had on the gallery wall was attracting so little interest. My friend Jasper put me straight: 'You're underselling it,' he told me. 'It's too cheap. Double the price.' It found a buyer within a week.

My own dealing experience was fairly inglorious. It occupied the period from 1987 to 1993, the first three years of which produced one of the greatest booms ever in the art market, and the second three years of which saw one of the biggest slumps. Up until 1990, it was almost impossible not to be successful. A seemingly endless supply of Japanese money was banked up ready to be spent on Impressionist and nineteenth-century painters, particularly the well-known names. We set up in a gallery in Jermyn Street, a generous space on the first floor that spread laterally across two buildings. It was just a question of supplying the material. Opulent retirement to the south of France seemed just round the corner.

And then everything changed, very quickly, in August 1990. The Japanese stock market collapsed and Saddam Hussein invaded Kuwait. Interest rates shot up. Suddenly you couldn't sell a thing. At first I thought it was because of the positioning of our gallery. At one end it was above a famous cheese shop, Paxton and Whitfield, at the other above Floris, which sold

delicious scents and soaps. Simple, I decided: we'll just put all our pictures up the Floris end. But even that made no difference. My colleague Henry Wyndham and I were reduced to going to the cinema in the afternoons: we saw every matinee in the West End.

My friend Jasper is a successful and intelligent dealer who likes to hide the excellence of his eye beneath an imitation of the manner of an unscrupulous used-car salesman. He has compiled a list of the sentences a dealer least likes to hear from his client. They generally start with the same five words:

1. 'I like the picture, but I just want to show it to my wife.' The classic get-out. You know this is a deal that's going nowhere.

2. 'I like the picture, but my accountant tells me that for tax reasons I shouldn't be buying any more art this financial year.' A double whammy: no deal; and he's rubbing in the fact that he's vastly wealthier than you are.

3. 'I like the picture, but I'd like to pay for it with an exchange.' The client then proceeds to offer you a complete dud that he bought from you five years ago.

4. 'I like the picture, but I've been looking on Artnet . . .' Artnet. It's changed the entire face of art dealing. It's the website that records every single price for every single painting sold at auction over the past twenty-five years. And it's readily accessible to clients. They know your cost price. And they know the prices of similar works. They think they know everything. It's a disaster.

5. 'I'm a painter and I wonder if you'd be interested in selling my art.' Get out of my gallery.

In dire moments, as in the recession of the early 1990s when

nobody was buying any art at all, Jasper outlined a Plan B: 'I'm going to get all my stock back to my own premises and then have the place torched. There's a Chinaman who can arrange it, no questions asked, for a couple of grand. I could offer a few selected mates a place in the storeroom for their choicer stock and offset the cost. And then the sweet spot, the insurance pay-out. Ah, one can dream.'

It never came to that, but I remember Jasper's attention being caught by the fire in the Fine Art Warehouse Momart in London in May 2004. Work by Tracey Emin and the Chapman brothers went up in smoke, plus other important items from the Charles Saatchi Collection. No, I told him, this was not some-one else's Plan B being put into action. This was a tragic acci-dent, an act of God. Jasper nodded musingly. 'That's the thing about God,' he said. 'He doesn't know much about art but he knows what he likes.'

La Ronde

Imagine a picture, a Miró, say, a late, colourful, decorative one. You are a dealer, trying to make an honest crust, and a client consigns it to you for discreet private sale. He tells you he wants $4.5 million for it. You have it very beautifully photographed, you catalogue it lovingly, then you email the photo and details off confidentially to your target buyer, a collector in New York who has told you to look out for a nice late Miró. You quote him a price of $4.9 million, to include a modest $400,000 for yourself in commission, pitching the figure just below the psy-chologically discouraging barrier of $5 million.

The client likes it, but decides to consult another dealer in New York for advice on how much to pay. The price is

$4.9 million, the client tells him, should I buy it? The New York dealer prevaricates, because he's tempted to buy it himself at that price: he has been asked by a girl he knows in interior decoration to source just such a Miró as this, because the client whose house she is doing up wants one. So he shows her the image and quotes a price of $5.3 million (to include his own $400,000). The girl decorator shows it to her client, saying it costs $5.8 million (including her commission).

The decorator's client's wife decides against it because it doesn't go with the curtains, but shows it to her personal trainer who occasionally deals in art as a sideline and remembers a Russian he met professionally in Lyford Cay who also likes Miró; why not show it to him with his own mark-up on it? He calls it $6.5 million and emails it to Moscow. The Russian frowns and shows it to his art adviser who's also his girlfriend who's two-timing him with a rich Chinese who she thinks is more likely to pay a top price for the Miró, so she surreptitiously sends it on to Hong Kong, indicating that it's buyable at $7.5 million.

The Chinese client shows it for a second opinion to a French dealer he knows, who in turn remembers a dealer in London who has told him he is looking for a nice late Miró for a client and decides to slip it on to him. You are that dealer in London. Thus it is that five weeks later, on the same day that you call your original collector in New York to check if he has yet made up his mind to buy the Miró you've offered him for $4.9 million, you find the same picture being offered back to you at $8.5 million.

Emerging Markets

The first exploiter of an emerging market was the ubiqui-
tous Parisian dealer Paul Durand-Ruel, when he took French
Impressionist paintings to New York for the first time in 1886.
The growth in the American economy since the Civil War had
been phenomenal, and the country was primed and ready to
consume avant-garde European art. A decade or so later Paris-
ian dealers turned their attention to the burgeoning German
economy, on the principle that wherever new money is made
you will find aspirant art collectors. The number of outstanding
works of French modernist art that found their way into Ger-
man collections either side of 1900 is testament to the success
of the operation.

Economic cycles move on and new opportunities emerge.
If you wanted to impress your colleagues as an art dealer in the
late 1980s, you boasted about the number of Japanese clients
you had, and your intimate understanding of their tastes and
foibles. Unfortunately there was nothing coherent about the
multitude of theories put forward by the western art trade as
infallible principles for conducting business in Tokyo. 'For
God's sake don't offer them paintings of cliffs,' I was told by one
dealer. 'The Japanese are frightened of them.' 'Stand up straight,'
another one advised. 'The Japanese revere tall men. They think
they're nearer to God.' 'Don't try to sell them pictures with
crows in them'; 'Never let them lose face'; 'Always let them beat
your price down'; 'Never allow them to haggle.'

The first time I visited the apartment of a Japanese collector
I was thus uncertain how to behave. As it turned out, Mr A,

who was known to be a major buyer of the Impressionists, was relaxed and charming. The only problem was that I could see no paintings at all on his walls. All that hung there was a dull cluster of small framed documents. Perhaps Mr A belonged to that older tradition of Japanese collecting which held it to be vulgar actually to display works. I assumed that shortly a treasure or two would be fetched out from storage for my temporary delectation. But after twenty minutes' polite conversation nothing had emerged. I finally asked where his paintings were.

'Paintings?'

'Yes. I'd love to see them.'

He looked dismayed, as if I had suggested something faintly improper. 'Paintings not here.'

'Oh. Where are they?'

'Paintings much too valuable to hang in apartment,' he explained patiently. 'Paintings all in bank vault.'

He gestured instead to the cluster of framed documents and encouraged me over to look at them. They proved to be the certificates of each painting's authenticity, each one lovingly presented in a velvet slip. Here was the final reduction of art collecting to stock ownership.

A feature of the international art market over the past twenty-five years has been the growing power of emerging economies to shape and increase demand for works of western art. The Japanese were the first conspicuous investors from outside Europe and America. The vogue for buying French Impressionist paintings that swept Japan in the last quarter of the twentieth century had its roots 100 years earlier. By the late 1870s the first Japanese art students had arrived in Paris to study western painting first hand. They found Impressionism immediately sympathetic, and brought an appreciation of it home. Over the next two generations Japanese collectors began to buy

the Impressionists, extending their range to works by Van Gogh
and the Post-Impressionists as well.

A combination of economic factors led to a particular cli-
max of Japanese buying in the late 1980s. Post-war reconstruc-
tion and political stability had brought Japan to a period of
prosperity. There was the revaluation of the yen, the inter-
national spending power of which effectively rose by 100 per
cent between 1985 and 1987. Monets, Renoirs, Cézannes and
Van Goghs poured into Japanese collections. Western art dealers
and auctioneers had never had it so good. The climax came one
week in May 1990 when the same Japanese buyer, Mr Saito of
the Daishowa Paper Manufacturing Company, bought at auc-
tion both Renoir's *Bal du Moulin de la Galette* for $78 million
and Van Gogh's *Portrait of Dr Gachet* for $82 million.

In the summer of 1990 the inevitable happened: the over-
valued Japanese stock market toppled and went into freefall.
Suddenly Japanese speculators were no longer interested in
the art market. Mr Saito remained unfazed. He announced he
hadn't bought his Renoir and Van Gogh in order to resell them
at a profit. He had bought them because he loved them. In fact
he loved them so much that he proposed to be buried with
them when he died. Western art commentators were horrified
when they heard the news.

The Japanese withdrawal from the market triggered an
inevitable slump in Impressionist prices. Once the dust had
settled, the truth emerged about what some of the Impression-
ist paintings bought by Japanese had been used for. For certain
people in Japan valuable western art had been a useful means
of moving money around, what the Japanese call '*zaiteku*', or
financial engineering. In unscrupulous hands, paintings became
tools for money-laundering or tax evasion. A painting bought in
New York for, say, $2 million was soon after changing hands in

The peak of the Japanese market: Renoir's *Bal du Moulin de la Galette*, oil on canvas, 1876, sold in 1990 for $78 million

Tokyo for $8 million, in order to create a hidden slush fund. A Renoir would be used as a makeweight in a real-estate deal, in order to circumvent limits on what banks were allowed to lend to finance real-estate purchases. And paintings were good bribes for politicians. An indifferent Monet would be donated to a politician and then bought back at ten times its original cost.

Today Japanese buyers still bid for Monets, but they are informed collectors rather than frantic speculators. And Mr Saito, though sadly he has now gone to his grave, thought better of being buried with his Impressionist trophies. Those two great pictures are, I am happy to say, still above ground.

The new emerging markets for western art are China and South East Asia, India, the Middle East, Russia and Brazil. True globalization has been achieved: today the buyer of a Monet or a Warhol is as likely to be a Russian or a Chinese or a Brazilian as a European or a North American. It seems inevitable that once a country's economy starts growing conspicuously, its rich inhabitants start buying western art. It doesn't matter where in the world the country is located: new wealth in these economies is drawn to works by the modernist masters of Europe and North America. As what? A status symbol? Yes, in many cases. It is an advertisement of their wealth. For some of the new rich in the emerging markets a Monet or a Warhol is another luxury brand, like a Gucci handbag or a dress by Lacoste or a Ferrari sports car. To own such trophies is an assertion of your member-ship of a supranational elite, an axis of personal wealth that links London to New York to Los Angeles to Paris to Mumbai to Moscow to Shanghai. Members of this select axis have much more in common with each other than with the inhabitants of their own countries.

But not all the acquisition of western art in the emerging economies is brand-driven. There are also discerning buyers,

forming considered collections and building museums. Sophis-
ticated Russians, for instance, take pleasure in reconnecting
with the great pre-Revolutionary tradition of Sergei Shchukin
and Ivan Morozov, the inspired Moscow collectors who came to
Paris and bought masterpieces direct from the studios of Matisse
and Picasso just before the Great War. And in the moneyed
Middle East – to the fevered excitement of art dealers and auc-
tioneers – museum collections of enormous scope and ambition
are being put together with the help of western advisers. Where
next? The required reading of the informed art trade is now the
Emerging Markets supplement of the *Financial Times*.

Exhibitions

Exhibitions are assemblies of works of art put on view to the
public for limited lengths of time. They can be museum shows
which juxtapose paintings of the past that would not normally
be seen together in order to make an art-historical point; or
they can be commercial gallery exhibitions showcasing the
latest developments in contemporary art, sometimes compris-
ing works by a single living artist. The history of modern art
could be written in terms of a few momentous and influential
exhibitions of the avant-garde: the first Impressionist Exhib-
ition in 1874, for instance; the Salon d'Automne in 1905, which
launched the Fauves; Roger Fry's shocking Post-Impressionist
Exhibitions in London in 1910 and 1912; and the Armory Show
in New York in 1913, which gave America its first experience of
up-to-the-minute European modernism.

To the artist, the exhibition is at once an occupational neces-
sity and a potential torture. The etymology of the word gives an
indication of the pressures and emotions involved. *Exhibition*:
place where one's work goes on public view; to make an exhib-
ition of oneself; exhibitionism; self-exposure (Cf. French: *Il
s'expose* = he exhibits his work); revealing of oneself; exposure
(to die of).

Blockbuster loan exhibitions are the high-profile temporary
shows, generally of work by dead major artists, mounted with
huge publicity by big museums. You see them advertised on the
metro, or on the sides of London buses. Queues form to get
into them, and they gather momentum like a successful film or
play to the point where you cannot expect to be taken seriously
in cultured circles if you admit to not yet having seen them.
They are not cheap to put on, but they look to recoup their
costs and even make a profit through the sheer number of
paying spectators attracted in, and the ancillary market created
for souvenirs: catalogues, postcards, calendars, furry toys. For
owners of major pictures, being asked to lend them to an exhib-
ition of serious stature in an important museum offers them a
distinct benefit. Inclusion will add kudos to the work and value
to its price in the future. I even know of one or two lenders –
owners of particularly desirable works, central to the theme of
the proposed show – who have demanded a cut of the exhib-
ition proceeds as their fee for agreeing to the loan.

The logistical traffic in major masterpieces across the world
that blockbuster loan exhibitions generate is occasionally the
source of anxiety. An extreme example was the famous Vermeer
show mounted at the National Gallery of Washington in 1996.
Twenty-three of the small number of known extant examples
of the artist's work were assembled – two-thirds of his entire
oeuvre. For once the hyperbole was justified: it was indeed a

A nineteenth-century blockbuster: *A Room at the Exposition Universelle of 1855, Paris*, by J.-B. Fortune de Fournier (watercolour, 1855)

once-in-a-lifetime opportunity to see so many pictures together by this achingly popular old master. After a hugely successful run in the US the exhibition was due to go on to the Mauritshuis in The Hague. Initially all twenty-three works were booked on the same flight to Amsterdam. Then prudence prevailed and they were split up and rebooked on five different transatlantic flights.

Timing is everything in the art market, and knowledge in advance of a major museum exhibition featuring a particular artist is useful in determining the right moment to offer for sale a work by that artist. If you are clever as a dealer or auction house, you will introduce it to the market at the moment that capitalizes to maximum effect on the publicity already generated for the artist by the museum. Other ways that auction houses attach themselves to the bandwagon of a successful blockbuster

exhibition include sponsorship, which offers the opportunity to entertain their clients in the museum at the time of the show.

In the quest to attract visitors and generate profits, there is a constant temptation for museums to put on exhibitions featuring artists of proven box-office appeal rather than to experiment too riskily. An amusing parlour game is to think up the most commercial titles you could imagine for museum exhibitions: you wouldn't go far wrong with 'Monet: Colour and Light', or 'Van Gogh: the Years of Agony', or 'Picasso's Women'. Less commercial might be: 'Sir Godfrey Kneller and his Circle'; 'Vlaminck: The Later Works' or 'The Genius of Adriaen Brouwer'.

Experts

Expertise in art has its nuances. You can be an art historian, an art dealer or a museum curator; a critic, a connoisseur or a specialist; or indeed you can even be an artist. But expertise in each of these cases means something slightly different.

The British painter Benjamin Haydon had no patience with outside expertise. 'No other professions are cursed with connoiseurs [*sic*] but Poetry & Painting,' he complained in 1815. By a connoisseur he meant a man who has no practical experience of or ability in the field of activity in which he claims to be an authority. 'There are no connoiseurs in War, in Physic, in Surgery. No man will trust his limb to a connoiseur in Surgery; no sweet girl in Consumption, with her lovely bosom wasting & her sparkling eye sinking, would believe in her recovery if a Connoiseur was her adviser.'

Haydon's objection to connoisseurs raises interesting questions. Are football correspondents the less effective critics for not having played the game professionally themselves? Or opera critics for not being trained singers? Haydon is in no doubt that expertise in a subject should be allowed only to those who practise it. He would certainly have been shocked by the importance assumed by 'non-playing' art critics in the subsequent two centuries. The Abstract Expressionist Barnett Newman writing in 1951 has similar objections to 'experts': 'The artist is approached not as an original thinker in his own medium, but, rather, as an instinctive, intuitive executant who, largely unaware of what he is doing, breaks through the mystery by the magic of his performance to "express" truths the professionals think they can read better than he can himself.' Rothko echoes him: 'I hate and distrust all art historians, experts and critics. They are a bunch of parasites, feeding on the body of art. Their work not only is useless, it is misleading.'

But it is the weakness of modern art, suggests the critic John Canaday (in a review of Rothko's MOMA retrospective), that it cedes some of its power to critics.

The painter today has become a man whose job it is to supply material in progressive stages for the critic's aesthetic exercises. This is a distressing cart-before-the-horse relationship, but it has its legitimacy in a day when other arts supply most of the needs that painting used to supply, and leave painting only its more esoteric functions. In such a situation it is quite natural that the critic may be tempted to find most in the painter who says least, since that painter leaves most room for aesthetic legerdemain.

The apparent necessity of connoisseurs, critics and, indeed, the twentieth-century phenomenon of the 'interpretive' dealer, is inevitably irksome to artists, who tend to feel they are the ones

best equipped to judge art in general, and certainly their own art. But this confidence in their own insight doesn't always extend to that of fellow artists: when Wyndham Lewis went blind, Augustus John sent him a telegram imploring him above all not to give up his art criticism.

Great experts, dealers, connoisseurs and critics have what is mysteriously referred to as an 'eye'. This is an ability to divine the status of a work of art by looking at it carefully. Is this painting by X, or is it from X's studio? Or is it merely a later copy or pastiche? If by X, is it an average one or a great one? And, if you work in the art trade: how well will it sell? (This represents an important subdivision of the 'eye', sometimes called a 'commercial eye'.) What constitutes an 'eye'? It certainly helps to have a highly tuned and capaciously retentive visual memory; but you also need a feeling for quality and a graphologist's ability to recognize the individual 'handwriting' of artists in the way they put paint to canvas. These talents are largely instinctive; but they can be polished by study and experience. In its most honed form, an eye can be breathtaking. I had a colleague in the Old Master Department at Christie's who was genuinely marvellous. He would look at a random picture in the storage basement and exclaim, 'That's by the same hand as that painting three along from the door in the passage outside the bedroom where I stayed at Chatsworth.' And he would be right.

There is a quasi-scientific element in the function of the expert that distinguishes him from the airy-fairyness of the connoisseur or the critic. In this respect the expert is less concerned with whether a painting is good than whether it is authentic. This is what makes him or her serviceable to the art trade (and to the law courts). He or she is increasingly specialized: each of the major artists in art history has its acknowledged current expert, the person you go to for the decisive

opinion, the person whose verdict is respected [see Part III, **A**uthenticity]. There was a tradition in France that this power of expertise, of decreeing what was and was not authentic, remained in the artist's family after his death. That is gradually dying out and now most authorities are independent, generally operating in the academic world. They are outside the art market, but they must walk a tightrope to preserve their integrity. On their word hangs whether a work is worth £5 million or nothing; and yet they see nothing of that money themselves. In no other area of the arts does academic expertise confer this financial power.

There are potential conflicts of interest here, not least when the ultimate authority on an artist is also a dealer. Wildenstein, for instance, determine the authenticity or otherwise of works attributed to a number of major artists, including Monet, Renoir and Gauguin. They aim to achieve the necessary independence of judgement by maintaining a Chinese wall between their dealing operation and their research Institute. It is a Chinese wall that has to be of particularly solid construction. Rivals in the art world now and then call for a team of independent building inspectors to check on its durability. It still appears to hold.

At the opposite end of the scale from the quasi-scientific expert who deals in objective questions of authenticity is the art critic, whose concerns are aesthetic and subjective. An expert who confirms that a painting is genuine will, as I say, have more impact on its commercial value than a critic who says that it is good. But the view of critics can still weigh in the commercial balance. This was a factor in the most famous artistic court case of the nineteenth century: when Ruskin wrote in 1877 of a Whistler *Nocturne* that he never expected 'to hear a coxcomb ask two hundred guineas for flinging a pot of paint in the public's

face', Whistler sued. Personal pique doubtless came into it, but Whistler was also aware of the financial damage that a negative criticism from the hugely influential Ruskin could do to an artist's prices.

There is no shortage of twenty-first-century art critics, but it is questionable whether any of them exercise Ruskin's commercial power. Perhaps too many suffer a failure of discriminatory nerve in the face of uniform adulation of the new [see Part II, **I***nnovation*]; and the sweeping away of the old rules and boundaries of what constitutes art encourages self-indulgent 'aesthetic legerdemain' in writing about contemporary art, but hinders cogent judgement [see **G***lossary* below].

F*airs*

Art fairs are the dealers' riposte to the fearsome power of the auction houses in the marketplace. At the big international fairs – Basel, Miami, Frieze in London for modern and contemporary art, Maastricht for older stuff – the world's leading commercial galleries assemble in one place and offer their wares to the globalized art-buying public. Their aim is to replicate the excitement, frenzy even, of a big international auction week in London or New York. And they succeed. Large numbers of rich collectors, curators, critics and museum people do indeed congregate. Local airports are suddenly costive with private planes. Fairs are places of enormous art-world activity: primarily commercial, of course, but there is also incessant gossiping, boasting and networking. There are even a few artists present, although

their attendance at such events can be traumatic, having been memorably likened to a child unwittingly seeing its parents making love.

Putting on an art fair is a considerable diplomatic achievement for the organizers. They have to manufacture a unified event out of a mêlée of rival commercial entities; and no group of people is more individualistic and less amenable to outside authority than art dealers. First of all there is the question of who to admit as exhibitors. This is often decided by a committee of senior dealers showing at the fair, and serious wounds to the egos of the excluded are sustained in the process. Similar injuries are then inflicted in the fraught business of allocating who gets the best stands in the exhibition hall. And finally there is a vetting committee with the power to throw out artworks from individual stands if they are deemed not to be of sufficient quality, or of dubious authenticity. It is a miracle that anyone is speaking to anyone else by the time of the opening night.

Two sorts of business are done at big fairs. The first is the fevered initial buying of exceptional material being revealed for the first time by the galleries concerned, which as a buyer involves exerting maximum leverage on your reputation and spending power to be the first allowed into the exhibition hall. And then there are the wily old hands who wait until the last day before making insultingly low offers on works that have not yet sold. In my brief experience as an exhibitor at Maastricht, one falls with pathetic gratitude even on this second category of deal.

The fair involves a different approach to selling art from the auction [see **C**hristie's and Sotheby's above]. With an auction you start temptingly low and hope to end up high; there is in theory no upper limit to the price level that competition between two bidders may achieve. As a dealer selling at a fair, you start high

and will probably end lower. Negotiation almost always results in a price being agreed some way short of the original asking figure. People who stumble out of Basel or Maastricht impressed by the quality of art on display but shocked at the prices have failed to factor in this imaginative elasticity.

Football

I have this recurring dream. I am on the pitch in a big Chelsea game at Stamford Bridge. Not as a player: I used to have those fantasies, but no longer. No, I am a late-middle-aged man with grey hair wearing a suit, but somehow I am in the playing area, an incongruous figure standing on the goal line as an opposition cross is swung into what the Italians call the 'corridor of uncertainty', that area of maximum discomfort to the Chelsea defence. The ball reaches one of their strikers, who propels it towards the goal. The grasping fingers of our goalkeeper Petr Cech take the power out of it, but it is rolling ineluctably over the line. And then I – still clutching a briefcase – somehow manage to hack it away with my tasselled loafers. I am conscious of relief, and then anxiety. Will my intervention count, or will it be overruled and a goal awarded to Chelsea's opponents? Surely not, if the ball didn't actually cross the line? The incident will certainly be seen on *Match of the Day*, and analysed by the expert panel. What will they say? What will they say at Sotheby's, who after all pay my salary? Will it be the sort of positive visibility for the brand name that the Press Office is constantly trying to encourage?

Leaving aside the question of why the acutest anxiety in the otherwise serene and privileged existence of an ageing art expert is the possibility that Chelsea might concede a goal, I am intrigued by the lateral seepage of football into unexpected areas of modern life. The art world is one of them. For instance there is an interesting financial parallel over the past forty years between the world-record price paid at auction for a painting and the highest-ever transfer fee paid for a footballer. Here is how the story develops:

Date	Footballer (£)	Artist (£)
1968	500,000 (Anastasi: Varese to Juventus)	
1970		2,310,000 (Velázquez)
1973	922,000 (Cruyff: Ajax to Barcelona)	
1976	1,750,000 (Rossi: Juventus to Vicenza)	
1980		2,700,000 (Turner)
1982	3,000,000 (Maradona: Boca Juniors to Barcelona)	
1984	5,000,000 (Maradona: Barcelona to Napoli)	7,370,000 (Turner)
1985		8,140,000 (Mantegna)
1987	6,000,000 (Gullit: PSV Eindhoven to AC Milan)	30,111,000 (Van Gogh)

Date	Footballer (£)	Artist (£)
1990	£8,000,000 (Baggio: Fiorentina to Juventus)	43,107,000 (Van Gogh)
1992	13,000,000 (Lentini: Torino to AC Milan)	
1996	15,000,000 (Shearer: Blackburn to Newcastle)	
1997	19,500,000 (Ronaldo: Barcelona to Inter Milan)	
1998	21,500,000 (Denilson: São Paolo to Real Betis)	
1999	32,000,000 (Vieri: Lazio to Inter Milan)	
2000	37,000,000 (Figo: Barcelona to Real Madrid)	
2001	53,000,000 (Zidane: Juventus to Real Madrid)	
2004		60,000,000 (Picasso)
2009	80,000,000 (C. Ronaldo: Man Utd to Real Madrid)	
2010		66,000,000 (Picasso)
2012		74,000,000 (Munch)
2013	86,000,000 (G. Bale, Tottenham to Real Madrid)	89,000,000 (Bacon)

Cristiano Ronaldo:
more expensive than
any work of art

The biggest disparity was in 1990, when Japanese Impressionist fever drove a Van Gogh (*Portrait of Dr Gachet*) to £43 million [see **E**merging Markets above], but the world-record price for a footballer stood at only £8 million, the price Juventus paid Fiorentina for Roberto Baggio. After the collapse of the Japanese art market the Van Gogh record stood for fourteen years. During that time the record football transfer fee gradually

caught up, boosted by the game's increasing television revenues, and finally in 2001 overtook the Van Gogh when Real Madrid bought Zinedine Zidane from Juventus for £53 million. The Whitney Picasso (*Boy with a Pipe*) clawed the highest peak back for art in 2004 when it sold for £60 million but then Cristiano Ronaldo was bought by Real Madrid from Manchester United for £80 million in 2009 and Real Madrid paid £86,000,000 for Gareth Bale in 2013. Later the same year art triumphed again when a Bacon triptych sold for £89,000,000.

What is interesting about the current situation is that the people paying large transfer fees in football are also in several cases major buyers of art, which certainly wasn't true a generation ago. The same Russian and Middle Eastern money that is so influential in deciding the destiny of the Champions League or the Premiership is also finding a home in art. Obviously this is exciting for a Chelsea-supporting art expert. But given the resale value of paintings after ten years, and the resale value of footballers after the same period, my constant fear (from my anxious vantage point on the Stamford Bridge goal line) is that Roman Abramovich may ultimately reach the conclusion that his money is safer in art.

Glossary

This is a dictionary within a dictionary, a glossary of words that recur in contemporary writing about art. They are words the meaning of which has become twisted by the desire to energize banality, to elevate mediocrity, or simply to make a sale. Some

of the terms assembled here can be applied to works of art of any period; but many of them are particularly the province of contemporary art. Their prevalence is testament to the difficulty of evolving a serviceable vocabulary for contemporary art, of evaluating verbally something the looseness and lack of boundaries of which has put it almost beyond the realm of words. The best art world professionals very occasionally find language that pins down the elusive quality of a work of avant-garde art and brings enlightenment to the spectator; most just go on using the words listed below.

accessible: euphemism for obvious or superficial (see **decorative**)

angst: anger, pain, despair, but with a Teutonic imprimatur of authenticity

anticipate: prefigure, as in 'Turner's colour effects anticipate those of the Impressionists.' A misleading word, in so far as it implies some sort of intention on Turner's part; as if he realized that there was some sort of better movement coming and was doing his best to get close to it

appropriationism: borrowing someone else's image; best understood as an equation:

Appropriationism + Irony = Pop Art;

Appropriationism − Irony = Plagiarism

canon: the critically agreed order of things; the span of an artist's achievement. E.g., 'the canon of art history', 'an artist's canon'. Another of those solemn words that draw subliminal parallels between art and religion. Cf. the canon of saints, icons. The verb is 'to canonize', as in 'This iconic work canonizes the Pop Art of Murikami.'

challenging: obscure, incomprehensible or unpleasant, as in 'X's challenging Abbatoir Series'

charming: overused adjective, describing a painting in which

the only positive feature one senses is the desire to please, not necessarily achieved (see **interesting**)

chromatism: grand word for 'colouring', e.g., 'the artist's bold chromatic response to his subject' (translation: jarring colours)

coda: a term of musical imagery, meaning a passage added after the natural completion of a movement; so a useful word to cover any work of art that is late, weak or a pale imitation of an earlier peak

contextualize: Modern artists are constantly described as contextualizing, decontextualizing and recontextualizing. Take the example of Marcel Duchamp's Dadaist masterpiece, *Fountain* – his urinal. It was first contextualized as an object in which to pee. Then it was decontextualized and became simply an object. Finally it was recontextualized as a work of art in which to pee

corpus: (also **oeuvre** or **opus**) grand words to denote an artist's body of work. E.g., 'This study of a poodle is unique in the artist's corpus/oeuvre/opus.'

critique: anything that you can connect with an earlier work by another artist (as in Picasso's 'critique' of Delacroix's *Femmes d'Alger*); also – distressingly – used as verb

cutting edge: a work of art with sufficient sharpness to break new ground (see **groundbreaking** and **seminal**)

deconstruct: (as in 'deconstructing stereotypes') part of the favoured modernist process already encountered with contextualizing (see above): first you construct, then you deconstruct, and finally you reconstruct. This leads to a transmutation or a transformation

decorative: devoid of intellectual substance

dichotomous: fashionable word to indicate a contrast or contradiction, e.g., 'dichotomous tension between distance

and proximity' (translation: 'there's a foreground and a background in this painting')

difficult: one step beyond 'challenging'; applied to a work that is so obscure, incomprehensible or obscene that there's nothing to do but admit it

emblematic: (as a verb, to emblematize) grand word meaning illustrative of, or typical of. E.g., 'Hockney's vivid chromatism (see above) is emblematic of his engagement with Californian light.'

evidence: often used as a verb, I am afraid

gallerist: fashionable term for an art dealer with a gallery; except that, somewhat confusingly, a gallerist does not generally have a gallery, but a 'space'

gem, jewel: small, undersized. 'An absolute little jewel'

gestural: a brushstroke that shows evidence of the effort of making it

gnosis: pretentious word for 'knowledge of something', often with a mysterious connotation; theory, as against 'praxis', meaning practice. 'The long periods of time X spends contemplating his own navel goes to the heart of the artist's gnosis.'

groundbreaking: new, innovative, therefore above criticism. An agricultural metaphor: previously uncultivated land has to be broken up and prepared before seed can be sown in it (see **seminal** and **cutting edge**)

honest: inept

hybridization: interbreeding, the production of hybrids; useful word to describe a painting in which the artist combines more than one idea or theme or 'methodology' (see below); extension of agricultural imagery into the botanical: earth is tilled ('groundbreaking'); seed is planted ('seminal'); plant interbreeds with another ('hybridization')

iconic: supremely typical, therefore recognizable; adhering to its brand (icon = image, emblem, so an image emblematic of its brand). But at the same time an icon has a religious significance; thus it is a ritual object, something to be worshipped. Iconic is almost the highest word of praise that modern art criticism can find for a work; an indication of the way the market prizes typicality as highly as originality

image-making: fashionably minimalist term for the function of the artist; variants are 'picture-making' and the even more minimalist 'mark-making': a mark is something even more basic and less bourgeois than a picture or an image

important: art-historically significant but difficult to sell. 'X's important painting of a massacre in a leper colony.'

inimitable: distinctive, familiar, and therefore often actually highly imitable

interesting: all-purpose word to disguise the observer's inability to fathom the point of a painting

interrogation: emphasizing of contrast. E.g., 'The rough surface of the stone and its highly polished finish create an interrogation of textures.'

italicization: the process by which irony is added to a familiar idea or image and thus transforms it from the banal into a work of art (see **appropriationism**, **contextualize**, etc., above). E.g., 'Man Ray's italicized baguette'

Man Ray's baguette, painted baguette in plexi case, 1964: the italicization of an everyday object

journey: artists don't have careers any more, they go on journeys

landmark: once you have broken new ground ('ground-breaking') with something sharp enough ('cutting edge') and inseminated it ('seminal') what emerges creates a new mark on the art landscape ('landmark'). 'A landmark work in the artist's oeuvre'

less is more: small, undersized. Murmur it with feeling in front of a little 'gem' (see above) to indicate that you have risen above the philistine pursuit of size and quantity. But to avoid confusion, do not use on Henry Moore maquettes

market, ahead of: overpriced. 'The gallery's brave pricing initiatives sometimes put it ahead of the market' (translation: We haven't sold anything for six months)

masterpiece, masterwork: overworked term that has lost its impact; hence necessity for additional ballast, e.g., 'unique masterpiece'; when that too palls for the same reason, recourse is sometimes had to 'highly unique masterpiece'

mature: debilitated by old age. 'A work of the artist's maturity' (translation: Oh dear, he's lost it)

messiness: sometimes a positive attribute, as in this description of the style of Cy Twombly: 'the aggressive release of explicitly defiling messiness'

methodology: method

modality: fashionable synonym for 'style'

monumental: oversized; 'the impressive monumentality of the composition' (translation: careful, it won't fit through your front door)

passionately deployed capital: euphemism for art investment

place (verb): sell to a collection, the word high-mindedly emphasizing the aesthetic rather than commercial aspect of the transaction

praxis: pretentious synonym for 'practice'. Sometimes paired with its contrast 'gnosis' to mean 'theory and practice'; e.g., 'emblematic of the artist's painterly praxis' (translation: a typical work)

primitive: if used prior to 1890, inept; post-1890, powerful

radical: another adjective favoured by art critics derived from agricultural imagery. When you've tilled the earth ('ground-breaking') and planted the seed ('seminal'), you can pull the plant up by its roots ('radical')

schema: word with satisfying if impenetrable Kantian over-tones, generally used as a pretentious synonym for 'scheme', of which it is the Greek form (what a difference a vowel makes)

seminal: word used to describe a work that with the hind-sight of art-history looks like it influenced a lot of later artists; agricultural imagery again: the seed, once planted, spreads and proliferates

signature work: easily recognized, as in 'I'm looking for a signature work by Monet.' (translation: One that all my friends will identify the moment they walk into my drawing room)

signifier: the use of the word itself signifies that the writer is fashionably familiar with semiotics, the science of signs, whose basic tenet is 'a sign is something signified by a signi-fier'. If at all possible a signifier should be deconstructed at the first opportunity, and then reconstructed in order to effect a transformation or transmutation

similacrum: Latin again, a grand word for an 'imitation' or 'replica'

source (verb): acquire a work of art; 'sourcing', then 'placing' is the activity of the modern dealer; sorry, gallerist, curator or art professional. One of the most exciting things in art deal-ing is the difference in price between the thing sourced and the thing placed

space: gallery

spontaneous: undisciplined, messy

subtle: dark, e.g., 'The subtle tones of Théodore Rousseau's foliage.'

subvert: useful word to cover illogicality or inconsistency. Ah! It must be an intentional subversion, probably of an out-moded function. 'Basquiat's misspelling of the word X on his canvas is a witty subversion of bourgeois convention.'

synthesis: essentially it's more than one thing being combined. Useful word to use when you've exhausted 'hybridization' (see above)

tenebrist: literally shadowy; pretentious word for 'dark' (see **subtle**)

thematization: grand term for choice of subject matter. 'Lancashire street scenes are at the heart of Lowry's thematization.'

trajectory: career; sorry, journey

unique: so overused that now frequently enhanced by redundant or illogical adverbs, e.g. 'highly' or 'singularly'

unmediated: direct, simple. A pretentious word for 'immediate'; as in a work of installation art which 'forges an unmediated relationship between floor and ceiling' (translation: it's an empty room)

viewing experience: nauseating term to denote looking at a picture ('offers a highly engrossing viewing experience')

visceral: useful word to describe a strong emotional reaction, in particular an instinctive response to a work of art, as opposed to an intellectual one. Alternative form: 'There's no science here – it's all stomach'

watershed: the point at which flowing water diverges and goes in different streams; an artist at a watershed takes a decision to reject one line of development in favour of another.

Were the water flowing in the other direction, you would of
course achieve a 'synthesis' or 'hybridization' (see above)
zeitgeist: term much employed to indicate that an artist is of
his time; artists who go in a different direction from prevail-
ing fashion are sometimes referred to as 'anaesthetizing the
zeitgeist'

H*eritage*

It is right and understandable that countries should have meas-
ures in place to protect their heritage. Certain major works of
art, in both public and private collections, become part of a
nation's cultural fabric. These need to be preserved from the
completely free play of the market in order to prevent their
export and loss. What is less easy to agree upon is what con-
stitutes 'national heritage', and at what point the state should
intervene.

Different countries have different ideas on the subject. At
one extreme there is the United States where there is almost
no state protection of the cultural heritage. In my experience
it is unheard of for a work of art from an American collection
to be banned from export on these grounds; the assumption
is that there will always be enough rich Americans to perform
the preservation function as a piece of private enterprise. It is a
system that seems to work. At the other extreme there are coun-
tries such as Italy and Spain that have long-standing resources
of great art and take steps to protect it from export. Every work
above a certain value and more than fifty years old needs an

export licence to leave the country. These are not granted easily. And once an export licence is refused, it drastically reduces the financial value of the work concerned, because thereafter it is saleable only on the national, internal art market. Big international buyers will not touch it.

In Germany there is a relatively short list of works of art (under 100) that are deemed to constitute the national heritage and will never be allowed to be exported. The problem is that this list can be added to surreptitiously by the authorities. Private owners of really important paintings live in fear that this could happen to them; hence a regrettable but understandable inclination to get the thing out of the country into Switzerland at the first opportunity. Works cannot be listed retrospectively if they have already left Germany.

The situation in the United Kingdom is a reasonably effective compromise. Every oil painting valued above approximately £100,000 needs an export licence before it can leave the country. There is a group of the great and good of the art world – the Export Licence Reviewing Committee – which meets to decide whether to grant these licences, and in most cases it agrees to do so. But for major pictures, while it doesn't have the power to ban their export outright, it can put a stop on their departure for a period of six or twelve months during which a public gallery or institution – if it can raise the money – has the opportunity to buy the item at the declared price.

When this happens with a painting just sold at auction, it creates anxieties. The British seller is anxious about when he will get his money, and the foreign buyer about whether he will get his picture. There is usually a sigh of relief when the export licence comes through, although is is sometimes tempered by a sadness at the loss to the national heritage. I particularly remember a very beautiful Van Gogh drawing, quite possibly the best

The Van Gogh drawing that was lost to Britain (pencil, ink and gouache, 1888)

of its kind in a UK private collection, being bought by a US collector in 1995 for £8 million. After due consideration the Reviewing Committee regretfully granted it an export licence, because the price was too high for any British public institution to match. The consolation is the small but significant number of major works consigned for sale by foreign owners that end up in moneyed British private collections each year. It is not a totally one-way street.

Investment

When was art first seen as an investment, a commodity in which sharp financial intelligences could make money, as distinct from a vehicle by which dealers using their sharp aesthetic eyes and silver tongues made money? An early example of buying for investment was the syndicate of British noblemen who got together to acquire the magnificent Orléans picture collection when the French Revolution forced the Royal House to sell up. For a class that professed to disdain 'trade' the British aristocracy could be surprisingly entrepreneurial when it suited them: some of the Orléans pictures were then disposed of at considerable profit in a series of selling exhibitions in London. The rest were kept by the original investors at what ended up as no cost to themselves.

Later in the nineteenth century the emerging mercantile middle class became increasingly focused on art as a means of making money. Maupassant's Monsieur Walter, the business mogul in *Bel-Ami* (1881), shows off his art collection and con-

fides, 'I have other pictures in the adjoining rooms, but they
are by less known and less distinguished artists . . . At present
I am buying the works of young men, quite young men, and I
shall hold them up in the private rooms until the artists have
become famous . . . Now's the time to buy pictures. The artists
are starving, they haven't a sou, not a sou.' 'Prices go up and up,'
observed Zola in 1886, 'and painting becomes doubtful territory,
a sort of goldfield on the top of Montmartre launched by bank-
ers and fought over with banknotes.'

On the face of it, art is a problematic commodity in which
to invest. Each work is unique, and it's that lack of homogen-
eity that is a nightmare to orderly markets and the despair of
analysts. As this dictionary illustrates, the value of a painting
is determined by a confusing variety of factors: market trends,
fluctuations of aesthetic and art-historical fashion, the place
of the work within the artist's oeuvre, typicality, provenance,
condition. In their determination to impose order, analysts have
invented art sales indices which show that Impressionist and
modern art has gone up by X per cent while old masters have
increased by Y per cent over the same ten-year period. Such
concoctions are pretty meaningless. A better measure is the
performance of the same work of art coming up at auction over
successive decades.

Modigliani's *La Belle Romaine*, a sumptuously accessible,
stylistically typical nude [see illustration, Part II, **N***udes*] first
came up for auction in modern times in 1986 when it sold for
$4.1 million. It was offered again at Sotheby's in November 1999
and reached $17 million. It appeared a third time in 2010 and
made $69 million. I remember standing in front of it then and
reflecting on the pleasing symmetry of each increase. By 2021 it
should be worth around $210 million. It was a picture that had
a lot going for it. She was an attractive girl. A telling detail was

the pinkness of her buttocks. 'Know what that is?' suggested one admiring connoisseur. 'Carpet burn.'

Contemporary art dealers have made heroic attempts to construct a market that mimics other markets by increasing in measurable steps. Young artist A comes under a dealer's aegis as an unknown. In his first exhibition his price for a standard work is £5,000. He does well, and sells out. In his second exhibition, his works are priced at £8,000. 'Look,' cries the dealer, 'we have a market, and it's going up.' Measurably. It may be a self-fulfilling prophecy, but it's reassuring to people who want to read the art market like stock markets. At the right psychological moment one or two examples of the artist's work are judiciously fed into the contemporary-art auctions of Sotheby's and Christie's, where they are seen to make sums which validate the dealers' prices.

Today there are a number of art-investment funds, of varying degrees of success. They have to struggle with certain facts of life that limit their appeal. The first is that art investment very rarely works unless the art is kept for a reasonable length of time before being traded in again: a minimum of five years, but ideally more like ten. The second limitation is that during the period of investment, the art generates only costs rather than returns: insurance, storage, conservation, etc. And finally investors are cut off from one of the compensations which art ownership bestows upon collectors: the pleasure of day-to-day enjoyment of the work, the aesthetic dividend. The carpet burn.

The classic example – the template studied by economic historians across the world – is the British Rail Pension Fund. In the late 1970s, when inflation was running high and equity markets were underperforming, they took the daring decision to invest a portion of their resources in the art market. It was a radical move, tinged with desperation. They probably felt they

Claude Monet, *Santa Maria della Salute, Venise*, oil on canvas, 1908: from £220,000 to £6.1 million in ten years

had nothing to lose. And they invested no more than 2.9 per cent of the assets of the fund in works of art, spread across the full gamut of collecting areas from Old Master Paintings to Antiquities. Primly, but perhaps advisedly, they excluded only Contemporary Art. In the late 1980s they began to sell, capitalizing on the boom in art at the end of that decade. By the end of the exercise they had turned an original investment of £40 million into a return of £168 million. It had proved a satisfactory exercise. But within the collecting categories there were big differences in performance. Easily the most successful was the £3.1 million invested in Impressionist paintings, which realized in one gloriously successful sale in 1989 a staggering £33 million. It was a triumph for Sotheby's, who had advised the Fund on what

to buy. I can say that unbiased because at the time I was working for Christie's.

Just two examples of Impressionist pictures in the British Rail Pension Fund: a rather romantic Renoir, bought for £680,000 in 1976, sold in 1989 for £9.4 million and now hangs in the Getty Museum. Even more dramatically a Monet of Venice, which was bought for only £220,000 in 1979, then realized £6.1 million in 1989. Here I have to pause for a moment, mentally salivating. There's a quasi-pornographic appeal to the recitation of art prices that show spectacular increases in a short space of time; it becomes almost addictive. What might have been! What still could be! If only the Fund had stuck its entire resources into blue-chip Impressionists: there would now be a lot of retired British Rail porters with villas in the south of France.

Luck

Not many years ago a Japanese collector decided to consign his collection of Impressionist and Modern art to international auction. He consulted both Christie's and Sotheby's, and the inevitable beauty contest ensued. Each auction house produced for the collector a glorious proposal document, proclaiming their unique qualifications to sell the collection, providing estimates of what the works would realize, and outlining the far-reaching marketing plans they would put into action, their unique experience, expertise and enthusiasm, and the exceptionally generous business terms under which they would perform the sale. The documents abounded with graphs and pie charts, and lyr-

ical appreciations of the pictures themselves. The trouble was that the two proposals were almost identical. Even after having met representatives of each house, the seller found it impossible to decide between them.

The owner's way out of the impasse was inscrutably oriental. He determined to let fate decide. He invited the head of Christie's Japan and the head of Sotheby's Japan to call at his office and settle the matter once and for all in a game of Scissors, Paper and Stone. The momentous contest was over very quickly. Christie's emerged the winners and got the consignment, which was worth a considerable amount of money in commission.

There was a great deal of soul-searching and hand-wringing back at Sotheby's headquarters. What lessons were to be learned? Rigorous coaching in games of chance obviously needed to be added to every senior executive's training. But beyond that it was difficult to draw any definitive conclusion. There is an element of luck in all human transactions, even in painting pictures [see Part II, **A**bstract Art].

Sometimes this element of luck manifests itself in the whim of the impulsive buyer. It can happen that two people decide they absolutely have to have a lot in an auction and just keep bidding on it. (It helps if both are fabulously rich.) I remember a Monet of the Japanese bridge in his garden at Giverny that fetched £19 million because two people wouldn't stop bidding against each other. It became a very expensive rich men's argument. But if one of those two competitors had woken up that morning with a hangover and decided not, after all, to participate, then the perfectly acceptable price realized would have been £8 million, which was the point at which their bidding contest began.

Money

Money's various intersections with art create many points of interest (and influence on market weather); for example:

Financial Markets (Art and)

Art does not necessarily behave in the same way as other financial markets. Stocks can go down, while art goes up. In the dire financial climate of 2009, the demand for great art actually strengthened as people saw the virtue of having money in unique and valuable objects rather than in banks. The only thing that counts for the art market is the interest rate. So long as it is low, art as a home for money becomes highly attractive. But once it climbs, then art prices founder. No one wants to spend money on it. The most recent example is the doldrums of the early 1990s, when interest rates rose to double figures. It still brings tears to the eyes of art traders old enough to remember the hopeless inertia that ensued.

Guarantees

The expanding art market creates increasingly sophisticated financial instruments to help it function more effectively. At auction, one of the most interesting is the guarantee. From the seller's point of view, the disadvantage of auction is the possibility that the picture they are selling will fail to meet its reserve;

the more important the picture, the more damaging this is to its prospects of being offered successfully on the market for a number of years to come. It is blighted. As a business-winning incentive the auction houses therefore came up with guarantees, fixed sums of money that the vendor would receive for their painting regardless of whether the bidding reached that figure or not. If it made more than the guarantee, the surplus would be split between the vendor and the auction house.

The problem from the auction houses' point of view was that with the guarantee, while there was the prospect of add-itional reward if the painting sold well, they were also taking on a significant risk. This was fine in a rising market and exciting money was made in the surpluses; but when prices wobbled in 2008–9 both Sotheby's and Christie's found themselves owners of several expensive pictures which they had guaranteed but which had failed to reach their reserves. It was a bit like toxic debt in the banking world. Guarantees must stop, it was decided. They simply couldn't be afforded any more.

But the problem was that vendors still demanded them. Some of the plums could not be plucked without providing them. So the ingenious auction houses came up with the irrev-ocable bid. In effect this meant transferring the risk of the guar-antee to a third party. Discreetly, prospective purchasers would be canvased in advance: would you like to own this painting? If so, give us a guaranteed bid on it and you can buy it at that figure; but if it makes more in the auction, you can have some of the surplus above your guaranteed bid. When guarantees backed by irrevocable bids are in place, the auctions houses can breathe easily. They may make less money. But their risk has been passed on elsewhere. And the guarantees they offer are as attractive as ever to the vendor.

Real Estate (Art and)

There is an interesting graph to be drawn plotting the point
at which the value of an art collection exceeds the value of the
property in which it is housed. Super-rich collectors determined
to compete for the best examples will often own art that is more
valuable than their real estate, even though they live palatially.
Houses worth £20 million plus are probably the most likely to
contain art worth more than that. But what is the lowest-value
house whose value is exceeded by that of its art contents? It is
hard to imagine a collection worth more than £1 million housed
in a property worth less than £1 million. But it could happen. If
it did it would probably be in Switzerland, where major collect-
ors often live simply, with a minimum of show.

Relative Values

I was once interviewed by a charming girl from Austrian Televi-
sion about a painting by Klimt that Sotheby's were shortly to
sell. I answered her questions about where the painting stood
in the artist's oeuvre, why Klimt had become so prized interna-
tionally, and what we expected this one to make. Then, without
warning, she smiled sweetly and asked: 'And how can you justify
someone paying $20 million for this painting when that money
could build a children's hospital?' Unprepared for the chal-
lenge, I gave an inept and evasive answer about Sotheby's merely
reflecting the market and not creating it. But I thought about it
afterwards. The only possible justification for the high value of
art and the money spent on it not being devoted to the building
of a hospital to save people's lives is that there must be some-

A major landscape by Gustav Klimt, oil on canvas, 1913: worth a children's hospital?

thing to save people's lives for. Art has claims to be that thing, or one of them. So the provision of great art – as healthcare to the spirit rather than the body – also represents a legitimate expenditure of financial resources in a civilised society.

If only I had come out with it on camera.

Spending Power

My years in the art market have also brought me to various
tentative conclusions, none of them provable, about the amount
of money people are prepared to spend on an individual paint-
ing expressed as a proportion of their total wealth. I think it is
round about 1 per cent. This means you have to be worth £100
million before you will spend £1 million on an individual work.
Or if you spend £10,000 on something, you are probably worth
at least £1 million. There will be impassioned exceptions, but
as a general rule for private collectors, I think this holds good,
even for what happens at the highest, most rarefied levels of
the market. A man worth $1 billion will pay a maximum of
$10 million; and those few heroic bidders who compete for a
$100 million picture are likely to be worth individually at
least $10 billion.

Valuations

Something that as an expert one is occasionally asked to do is
to put a financial value on truly stupendous collections, the sort
of museum contents that – because they would never be offered
for sale – take one into the realm of fantasy. This is tremen-
dously uplifting and stimulating. For a moment one feels an
illusory power over the object one is assessing, even a brief sense
of possession. I was once asked to value the Shchuckin Collec-
tion, held partly in the Hermitage and partly in the Pushkin
museums in Russia. It contains some of the greatest works of
twentieth-century art ever painted. When I was confronted with
Matisse's *The Dance*, I had to pause. Where does one start? The

first point of reference is the highest price ever paid at auction; then the highest price ever paid in a sale by private treaty. Then one has to make a jump of imagination: how much greater and more desirable a picture is *The Dance* than either of these? Then one has to bear in mind the most powerful buying entities in the world and imagine how much they might be prepared to part with in order to own it. If a man is prepared to pay hundreds of millions for a yacht, what would he pay for *The Dance*? As I mentioned above, I don't think the very rich are willing to pay more than 1 per cent of their total wealth on an individual work of art. But for something as momentous as this particular Matisse, they might have to break through that constriction: and doubtless one or two would.

Museums

I once jestingly proposed a way for museums to increase the number of people passing through their doors (which presumably is one of the measures of success of a public gallery). On the labels next to the paintings on view should be displayed not just the artist's name and the title, but also the amount of money for which it is insured. It was a flippant proposal, but I was surprised by the outrage it prompted in certain academic circles. I had thoughtlessly touched a very raw nerve.

The art market and the museum stand in an uneasy relationship to each other, compounded of mutual suspicion, admiration and jealousy. Art-market professionals look at museum curators and admire their scholarship and envy them the calm

of their surroundings and the quality of the art with which they work. They disdain in them the perceived academic tendency to prevaricate on a decision as to the status of a painting, to be forever either not committing themselves or changing their minds. Money concentrates the mind wonderfully. It sharpens you, the awareness that on your expert decision rides a lot of money, particularly if it's your own money, or at least your company's. Thus the attributions made by auction houses and dealers have to be right and have to be quick and clear-cut. Museum personnel, on the other hand, look at people in the art market and scorn their subjection to the commercial imperative, but envy them the money they are making. Occasionally a museum man scrambles over the barbed wire and makes a run for the other side to join the art trade. It's not an easy transition, and many have fallen in the no-man's-land in between. Even rarer is the passage of an art trader to a museum.

If trying to impress a potential buyer with the desirability of a painting, the dealer may well refer to it as being 'of museum quality'. We all know that many of the greatest works of art in the world are in museums, so this is a significant tribute. And if a painting is actually bought by a museum, this is something to boast about. That a museum went out of its way to acquire it is testament not just to the painting but to you as the dealer or auction house that sold it. On the other hand, if one dealer describes to another a painting as 'a museum picture', the nuance is rather different; it generally means a work of such surpassing uncommerciality that its appeal is limited to a few crazed museum curators driven by exclusively academic concerns. It might show a corpse, or a scene of torture, or a hag-like peasant woman with no teeth, or a personification of Death the Reaper. In this sense 'museum pictures' are at the opposite extreme from the 'decorative'; by definition they are those that

A cemetery of art? The Uffizi Museum, Florence, 1834, painted by
John Scarlett Davis, oil on canvas

no rich bourgeois householder would want to display on his
own wall.

The modern image of museums as cathedrals of culture, their
quasi-religious status, has an overawing effect. People visit them
in veneration, and in Britain the directors of the National Gal-
lery and of the Tate occupy positions commanding the degree
of national reverence formerly reserved for the archbishops of
Canterbury and York. But for some purists, the heterogeneity
of their contents undermines the proper appreciation of art.
Théophile Thoré-Bürger identified this problem as early as 1861:
'Museums are no more than cemeteries of art,' he wrote, 'cata-
combs in which the remains of what were once living things are
arranged in sepulchral promiscuity – a voluptuous Venus next to
a mystical Madonna, a satyr next to a saint.'

Human nature being what it is, museums are sometimes competitive with each other. The elite, such as the Getty Museum in Malibu with its hefty spending power, or the well-connected Met or MOMA in New York with their eminent and generous boards of benefactors, have the power to assert themselves financially. In the same way that artists and art movements become brand names, so too do the more famous museums; at first this merely took the form of ever-bigger museum shops, but now some have successfully franchised themselves in other places, even other countries. So the Louvre isn't just the venerable establishment in Paris: it will also shortly exist to show its art in the Middle East as the Louvre Abu Dhabi, and in provincial France as the Louvre in Lens. In Britain the Tate has versions of itself in Liverpool and St Ives. The implication is that art is enhanced by its ownership by a major museum, that the museum's brand gives it a higher profile and makes more people want to see it. At the opposite extreme stands an alternative operating model, under which all works in public ownership would belong not to individual museums but to a central pool, from which public galleries would have equal rights to borrow to mount ever-changing shows. Perhaps that is impractically idealistic, but it is not unknown today for two different museums to club together to buy the same work of art, to acquire it in part ownership. It is a start.

It is the smaller museums, the ones off the beaten track, that sometimes have the most charm. Once I found myself in a little museum in the American Midwest, being shown round the collection by a very eager elderly lady docent. She knew everything, and was proving a wonderfully informative guide. Then she paused in front of a cabinet of antiquities and pointed out an ancient Greek head. 'That head,' she told me, 'is 2,507

years old.' 'That's amazing,' I said. 'But how do you know so precisely?' 'Oh, that's easy,' she explained. 'I've been here seven years and when I came it was 2,500 years old.'

Nature *(Imitating Art)*

'Something very characteristic of our make-up is that we see nothing in nature that does not remind us of art,' wrote the Goncourt brothers in their diary in 1859. 'Here is a horse in a stable, and instantly a drawing by Géricault takes shape in our minds; and the cooper hammering a barrel in the neighbouring courtyard makes us think of a wash drawing done in China ink by Boissieu.' The Goncourts are not alone: Goethe speaks wonderingly of his 'gift of seeing the world with the eyes of that artist whose pictures have most recently made an impression on me'.

Where, if not from the Impressionists,' asked Oscar Wilde in 1891, 'do we get those wonderful brown fogs that come creeping down our streets? The lovely silver mists that brood over our river, and turn to faint forms of fading grace curved bridge and swaying barge? The extraordinary change that has taken place in the climate of London during the last ten years is entirely due to a particular school of Art. Things are because we see them, and what we see, and how we see it, depends on the arts that have influenced us.

Daily familiarity with art does indeed do strange things to you. If you look at too many paintings, it's true that reality starts being mediated by art rather than the other way round. My God! That cat slinks along just like a Giacometti sculpture.

Look at that man – he's got the face of a Daumier. That woman's got a figure like the Rokeby Venus (or, less excitingly, like a Rubens). And, if you're really sad: wow! Those sheep in that field look just like a Thomas Sidney Cooper (an indifferent Victorian painter of farm animals). One can go on: winter landscapes that appeal because they evoke Brueghel, real-life sunsets that have clearly been created by Caspar David Friedrich, football crowds on the way to the stadium that can only have been choreographed by L. S. Lowry.

Working in the art trade can colour one's perception of life in other ways, too. Waiting to catch my flight home one evening in the executive lounge of Geneva Airport, after an unproductive visit to a collector, I overheard a conversation being conducted behind some potted plants. 'First thing in the morning,' a disembodied voice was saying, 'we must get the Picasso photographed.' Oh my God. A Picasso being photographed urgently? It could only mean one thing. Christie's had won a piece of business that we didn't know about. I crept up closer so I could hear better through the potted plants. Even at this late stage perhaps we could get in a counter-offer to the owner to persuade him to consign it to Sotheby's. Then peering through the foliage I saw the truth. Two exhibitors at the Geneva motor show were bent over images of a car. The Picasso in question was a Citroën.

Status Symbols (Art as)

The model of the European oil painting in John Berger's words 'is not so much a framed window open on to the world as a safe let into the wall, a safe in which the visible has been deposited'. And he adds, 'oil painting, before it was anything else, was a celebration of private property. As an art form it derived from the principle that *you are what you have.*' From the Renaissance onwards, when huge fortunes began to be amassed in commercial centres such as Florence, money was spent in order to buy art the acquisition and display of which was perceived to be an assertion of wealth and power. It is simultaneously an assertion of something else as well, of course, something highly desirable: cultural sophistication.

As time went by, art became the symbol of a third aspect of status. If the art you owned was of a certain age, it could be manipulated to imply that your money was old money, that your art had been in your family for a very long time. It hadn't, of course, because you had just bought it. But if you bought the right sort of things – English eighteenth-century portraits (who was to say the distinguished Gainsborough on your wall wasn't of your own ancestor?), Georgian silver, Regency furniture, it gave you the veneer of aristocracy. It was a lesson that the new merchant class in the later nineteenth and early twentieth centuries cottoned on to quickly. Here was a primitive form of money-laundering: your new money, by being expended on old art, was washed into old money.

Andy Warhol understood about art as status symbol, about art as an assertion of wealth. He recognized that if you could

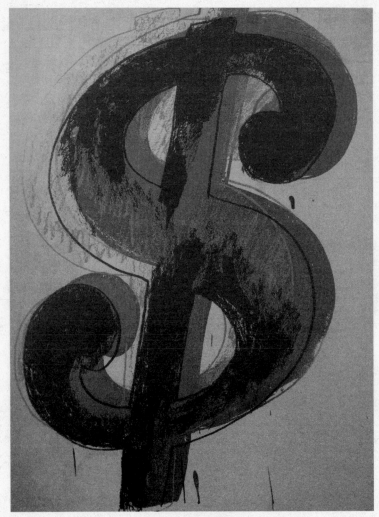

Art as a statement of financial power: the Warhol dollar (Andy
Warhol, *Dollar Sign*, acrylic and silkscreen ink on canvas, 1981)

make art that was at the same time literally an image of money
you could underline a very desirable message about art as money
and a person's ownership of that art. In fact you were on to a
winner. Hence his enormously popular variations on the theme
of the dollar: the series featuring the sign itself; and the mesmer-
izing canvases reproducing an apparent infinity of dollar bills.

In modern times a certain sort of acquirer of art has emerged
who is not really an art collector, but is hugely, immeasurably
rich. He will compete for the ultimate trophies in art because
they are precisely that: trophies, objects to which tremendous,
sometimes unique, status is attached. Zola's fictional art dealer,
Naudet (in *L'Oeuvre*) is an early exploiter of this sort of buyer
when he invents the 'American' trick: 'a single canvas hanging
in sacred isolation in a gallery and for which he would not even
take the trouble to name a price, he was so sure he could never
find the man rich enough to pay it, but which he sold in the
end for 2 or 300,000 francs to a New York pig breeder who was
only too proud to have been able to treat himself to the most
expensive picture of the year'.

The truth is that human beings buy art for a variety of
motives, as shown in the following pie chart:

Intellectual / aesthetic pleasure — 4.
Investment — 1.
Spiritual benefit — 3.
Status — 2.

In some people segments (1) and (2) occupy most of the pie;
in others (3) and (4) massively outweigh (1) and (2). While in
no two art-buyers are the proportions exactly the same, there
is something of all four components in everyone's motivational
make-up.

Taxation

Governments have an ambivalent fiscal attitude to art: sometimes they try to make money out of it by increasing taxes on it; at other times they try to gain kudos out of it by reducing those taxes.

There was a tax on artists' canvases in early-nineteenth-century Britain. You can see the printed stamps on the reverse of paintings of that period, to indicate that the duty has been paid. It seems rather brutal to make artists' lives – never easy at the best of times – even more difficult in this way. Was it conceived as a kind of Darwinian quality control, a measure to force bad or unsuccessful artists to give up entirely?

In the twentieth century, Britain introduced a system whereby important works of art could be exempted from estate duty, which seemed a good idea because it facilitated their passage from generation to generation in the same family. The problem came when the painting had to be sold. Then tax was payable at the rate in force when the exemption was made. In 1975, for example, X inherits from his father a great Sargent worth £2 million and it is exempted from the then inheritance tax rate of 83 per cent. He saves £1.66 million and gets to keep the painting. But thirty years later he comes to sell it. It makes £20 million, which is exciting; less exciting is that the 83 per cent estate duty rate then catches up with him so that he pays £16.6 million in tax. In this situation, if the Sargent is interesting to a national museum or institution, the government can step in and offer a 'douceur' to benefit both the seller and the acquiring British institution. The tax is waived, and by a com-

plicated formula a special museum price is established – for this imaginary Sargent probably in the region of £5 million. After that, the museum has to scrounge around for the funds. But if they are raised, the museum ends up acquiring the painting for 25 per cent of its auction value, and the seller receives appreciably more than the £3.4 million he would have ended up with in the auction room.

In the US, taxation has often been more favourably ordered for the owner of art. Early in the twentieth century the US introduced tax legislation which allowed those who donated works of art to museums to deduct from their taxes 30 per cent of their declared value, while maintaining possession of their works for the rest of their lives. As the museum that was to benefit from the donation had sole responsibility for making the valuation, all sorts of possibilities opened up. The trick was to set the value for tax purposes far enough above the original purchase price for the benefactor in effect to make a profit. It is no wonder that American museums of that time grew so rich in holdings.

The European Union introduced import VAT – in effect an import tax – on all art brought into the European Union. For art of a certain age it is set at around 5–6 per cent, a reduced rate from full VAT, which is very decent of them. But on some contemporary art, full VAT of around 20 per cent is levied. The question of sculpture that exists in multiple casts presents a problem that has caused the tax authorities great soul-searching. They decided that if it existed in an edition of twelve or less it would attract VAT at the lower 'work of art' rate; but if more than twelve existed then full VAT would be payable on the grounds that it entered the category of a 'mass-produced object'. The classification of what is and isn't art has always been vexatious to the taxman. In 1927 a case was fought out in the New York courts to decide whether Brâncuşi's *Bird*, an abstract

sculpture, was indeed a work of art, in which case it could be imported free of duty, or a piece of machinery, in which case duty of 40 per cent was payable. Counsel for the tax authorities took the view that because it was not recognizably a bird it could not be defined as a work of art. A number of artists, including Jacob Epstein, testified in defence of the sculpture. After two years' litigation the 40 per cent tax was rescinded.

Then there is *droit de suite*: this is a tax of French origin born of a sentimental desire to right the wrongs of history, to benefit artists-who-never-made-a-penny-in-their-lifetime-but-look-at-their-prices-now; a measure to assuage Van Gogh Guilt Syndrome. So a tax of 4 per cent (capped at 12,500 euros) is levied on the sale of every work created by an artist who died less than seventy years ago, and paid to the heirs of that artist. In practice what this means is a significant financial boost to the already-rich Picasso and Matisse families. It is not payable in the US, which has sensibly opted out of the scheme.

One of the consequences of taxing art is that increasing numbers of good paintings and sculptures find their way into Freeports. These are high-security warehouses that, although sited in neutral territories such as Switzerland, are effectively in no country at all and sit beyond the reach of fiscal jurisdiction. Here you can stow your great art and it attracts no tax or duty. You can even sell your art in the Freeport, and as long as it stays there and you keep moving, the transaction will not be subject to any tax. This means that some of the great treasures of world art are held in Freeports, never to be seen by anyone. It is a depressing illustration of how art, which was once rated by its attractiveness, is now assessed by its attractiveness to tax; and how works of art have become financial vehicles so powerful they must be hidden away from view lest they expose their anxious owners to the attention of the fiscal authorities.

Could there be a more dispiriting way to close a dictionary of the art world? The problem is that T for Taxation comes so near the end of the alphabet. Let me do it another way, by repeating the verdict of Gulley Jimson [see Part I, **F**ictional Artists] on the relationship between money and art. As an artist, he says, 'I make art for fun and need money to keep alive'; whereas the occasional rich patrons he has dealings with 'make money for fun and need art to keep alive'. It's important not to lose sight of this distinction. In the end, the rich can always make more money; but art hidden away in Freeports loses its power to keep them alive.

ALLEN LANE
an imprint of
PENGUIN BOOKS

Recently Published

Robert Tombs, *The English and their History: The First Thirteen Centuries*

Neil MacGregor, *Germany: The Memories of a Nation*

Uwe Tellkamp, *The Tower: A Novel*

Roberto Calasso, *Ardor*

Slavoj Žižek, *Trouble in Paradise: Communism After the End of History*

Francis Pryor, *Home: A Time Traveller's Tales from Britain's Prehistory*

R. F. Foster, *Vivid Faces: The Revolutionary Generation in Ireland, 1890-1923*

Andrew Roberts, *Napoleon the Great*

Shami Chakrabarti, *On Liberty*

Bessel van der Kolk, *The Body Keeps the Score: Mind, Brain and Body in the Transformation of Trauma*

Brendan Simms, *The Longest Afternoon: The 400 Men Who Decided the Battle of Waterloo*

Naomi Klein, *This Changes Everything: Capitalism vs the Climate*

Owen Jones, *The Establishment: And How They Get Away with It*

Caleb Scharf, *The Copernicus Complex: Our Cosmic Significance in a Universe of Planets and Probabilities*

Martin Wolf, *The Shifts and the Shocks: What We've Learned - and Have Still to Learn - from the Financial Crisis*

Steven Pinker, *The Sense of Style: The Thinking Person's Guide to Writing in the 21st Century*

Vincent Deary, *How We Are: Book One of the How to Live Trilogy*

Henry Kissinger, *World Order*

Alexander Watson, *Ring of Steel: Germany and Austria-Hungary at War, 1914-1918*

Richard Vinen, *National Service: Conscription in Britain, 1945-1963*

Paul Dolan, *Happiness by Design: Finding Pleasure and Purpose in Everyday Life*

Mark Greengrass, *Christendom Destroyed: Europe 1517-1650*

Hugh Thomas, *World Without End: The Global Empire of Philip II*

Richard Layard and David M. Clark, *Thrive: The Power of Evidence-Based Psychological Therapies*

Uwe Tellkamp, *The Tower: A Novel*

Zelda la Grange, *Good Morning, Mr Mandela*

Ahron Bregman, *Cursed Victory: A History of Israel and the Occupied Territories*

Tristram Hunt, *Ten Cities that Made an Empire*

Jordan Ellenberg, *How Not to Be Wrong: The Power of Mathematical Thinking*

David Marquand, *Mammon's Kingdom: An Essay on Britain, Now*

Justin Marozzi, *Baghdad: City of Peace, City of Blood*

Adam Tooze, *The Deluge: The Great War and the Remaking of Global Order 1916-1931*

John Micklethwait and Adrian Wooldridge, *The Fourth Revolution: The Global Race to Reinvent the State*

Steven D. Levitt and Stephen J. Dubner, *Think Like a Freak: How to Solve Problems, Win Fights and Be a Slightly Better Person*

Alexander Monro, *The Paper Trail: An Unexpected History of the World's Greatest Invention*

Jacob Soll, *The Reckoning: Financial Accountability and the Making and Breaking of Nations*

Gerd Gigerenzer, *Risk Savvy: How to Make Good Decisions*

James Lovelock, *A Rough Ride to the Future*

Michael Lewis, *Flash Boys*

Hans Ulrich Obrist, *Ways of Curating*

Mai Jia, *Decoded: A Novel*

Richard Mabey, *Dreams of the Good Life: The Life of Flora Thompson and the Creation of* Lark Rise to Candleford

Danny Dorling, *All That Is Solid: The Great Housing Disaster*

Leonard Susskind and Art Friedman, *Quantum Mechanics: The Theoretical Minimum*

Michio Kaku, *The Future of the Mind: The Scientific Quest to Understand, Enhance and Empower the Mind*

Nicholas Epley, *Mindwise: How we Understand what others Think, Believe, Feel and Want*

Geoff Dyer, *Contest of the Century: The New Era of Competition with China*

Yaron Matras, *I Met Lucky People: The Story of the Romani Gypsies*

Larry Siedentop, *Inventing the Individual: The Origins of Western Liberalism*

Dick Swaab, *We Are Our Brains: A Neurobiography of the Brain, from the Womb to Alzheimer's*

Max Tegmark, *Our Mathematical Universe: My Quest for the Ultimate Nature of Reality*

David Pilling, *Bending Adversity: Japan and the Art of Survival*

Hooman Majd, *The Ministry of Guidance Invites You to Not Stay: An American Family in Iran*

Roger Knight, *Britain Against Napoleon: The Organisation of Victory, 1793-1815*

Alan Greenspan, *The Map and the Territory: Risk, Human Nature and the Future of Forecasting*

Daniel Lieberman, *Story of the Human Body: Evolution, Health and Disease*

Malcolm Gladwell, *David and Goliath: Underdogs, Misfits and the Art of Battling Giants*

Paul Collier, *Exodus: Immigration and Multiculturalism in the 21st Century*

John Eliot Gardiner, *Music in the Castle of Heaven: Immigration and Multiculturalism in the 21st Century*

Catherine Merridale, *Red Fortress: The Secret Heart of Russia's History*

Ramachandra Guha, *Gandhi Before India*

Vic Gatrell, *The First Bohemians: Life and Art in London's Golden Age*

Richard Overy, *The Bombing War: Europe 1939-1945*

Charles Townshend, *The Republic: The Fight for Irish Independence, 1918-1923*

Eric Schlosser, *Command and Control*

Sudhir Venkatesh, *Floating City: Hustlers, Strivers, Dealers, Call Girls and Other Lives in Illicit New York*

Sendhil Mullainathan and Eldar Shafir, *Scarcity: Why Having Too Little Means So Much*

John Drury, *Music at Midnight: The Life and Poetry of George Herbert*

Philip Coggan, *The Last Vote: The Threats to Western Democracy*

Richard Barber, *Edward III and the Triumph of England*

Daniel M Davis, *The Compatibility Gene*

John Bradshaw, *Cat Sense: The Feline Enigma Revealed*

Roger Knight, *Britain Against Napoleon: The Organisation of Victory, 1793-1815*

Thurston Clarke, *JFK's Last Hundred Days: An Intimate Portrait of a Great President*

Jean Drèze and Amartya Sen, *An Uncertain Glory: India and its Contradictions*

Rana Mitter, *China's War with Japan, 1937-1945: The Struggle for Survival*

Tom Burns, *Our Necessary Shadow: The Nature and Meaning of Psychiatry*

Sylvain Tesson, *Consolations of the Forest: Alone in a Cabin in the Middle Taiga*

George Monbiot, *Feral: Searching for Enchantment on the Frontiers of Rewilding*

Ken Robinson and Lou Aronica, *Finding Your Element: How to Discover Your Talents and Passions and Transform Your Life*

David Stuckler and Sanjay Basu, *The Body Economic: Why Austerity Kills*

Suzanne Corkin, *Permanent Present Tense: The Man with No Memory, and What He Taught the World*

Daniel C. Dennett, *Intuition Pumps and Other Tools for Thinking*

Adrian Raine, *The Anatomy of Violence: The Biological Roots of Crime*

Eduardo Galeano, *Children of the Days: A Calendar of Human History*

Lee Smolin, *Time Reborn: From the Crisis of Physics to the Future of the Universe*

Michael Pollan, *Cooked: A Natural History of Transformation*

David Graeber, *The Democracy Project: A History, a Crisis, a Movement*

Brendan Simms, *Europe: The Struggle for Supremacy, 1453 to the Present*

Oliver Bullough, *The Last Man in Russia and the Struggle to Save a Dying Nation*

Diarmaid MacCulloch, *Silence: A Christian History*

Evgeny Morozov, *To Save Everything, Click Here: Technology, Solutionism, and the Urge to Fix Problems that Don't Exist*

David Cannadine, *The Undivided Past: History Beyond Our Differences*

Michael Axworthy, *Revolutionary Iran: A History of the Islamic Republic*

Jaron Lanier, *Who Owns the Future?*

John Gray, *The Silence of Animals: On Progress and Other Modern Myths*

Paul Kildea, *Benjamin Britten: A Life in the Twentieth Century*

Jared Diamond, *The World Until Yesterday: What Can We Learn from Traditional Societies?*

Nassim Nicholas Taleb, *Antifragile: How to Live in a World We Don't Understand*

Alan Ryan, *On Politics: A History of Political Thought from Herodotus to the Present*

Roberto Calasso, *La Folie Baudelaire*

Carolyn Abbate and Roger Parker, *A History of Opera: The Last Four Hundred Years*

Yang Jisheng, *Tombstone: The Untold Story of Mao's Great Famine*

Caleb Scharf, *Gravity's Engines: The Other Side of Black Holes*

Jancis Robinson, Julia Harding and José Vouillamoz, *Wine Grapes: A Complete Guide to 1,368 Vine Varieties, including their Origins and Flavours*

David Bownes, Oliver Green and Sam Mullins, *Underground: How the Tube Shaped London*

Niall Ferguson, *The Great Degeneration: How Institutions Decay and Economies Die*

Chrystia Freeland, *Plutocrats: The Rise of the New Global Super-Rich*

David Thomson, *The Big Screen: The Story of the Movies and What They Did to Us*

Halik Kochanski, *The Eagle Unbowed: Poland and the Poles in the Second World War*

Kofi Annan with Nader Mousavizadeh, *Interventions: A Life in War and Peace*

Mark Mazower, *Governing the World: The History of an Idea*

Anne Applebaum, *Iron Curtain: The Crushing of Eastern Europe 1944-56*

Steven Johnson, *Future Perfect: The Case for Progress in a Networked Age*

Christopher Clark, *The Sleepwalkers: How Europe Went to War in 1914*

Neil MacGregor, *Shakespeare's Restless World*

Nate Silver, *The Signal and the Noise: The Art and Science of Prediction*

Chinua Achebe, *There Was a Country: A Personal History of Biafra*

John Darwin, *Unfinished Empire: The Global Expansion of Britain*

Jerry Brotton, *A History of the World in Twelve Maps*

Patrick Hennessey, *KANDAK: Fighting with Afghans*

Katherine Angel, *Unmastered: A Book on Desire, Most Difficult to Tell*

David Priestland, *Merchant, Soldier, Sage: A New History of Power*

Stephen Alford, *The Watchers: A Secret History of the Reign of Elizabeth I*

Tom Feiling, *Short Walks from Bogotá: Journeys in the New Colombia*

Pankaj Mishra, *From the Ruins of Empire: The Revolt Against the West and the Remaking of Asia*

Geza Vermes, *Christian Beginnings: From Nazareth to Nicaea, AD 30-325*

Steve Coll, *Private Empire: ExxonMobil and American Power*

Joseph Stiglitz, *The Price of Inequality*

Dambisa Moyo, *Winner Take All: China's Race for Resources and What it Means for Us*

Robert Skidelsky and Edward Skidelsky, *How Much is Enough? The Love of Money, and the Case for the Good Life*

Frances Ashcroft, *The Spark of Life: Electricity in the Human Body*

Sebastian Seung, *Connectome: How the Brain's Wiring Makes Us Who We Are*

Callum Roberts, *Ocean of Life*

Orlando Figes, *Just Send Me Word: A True Story of Love and Survival in the Gulag*

Leonard Mlodinow, *Subliminal: The Revolution of the New Unconscious and What it Teaches Us about Ourselves*

John Romer, *A History of Ancient Egypt: From the First Farmers to the Great Pyramid*

Ruchir Sharma, *Breakout Nations: In Pursuit of the Next Economic Miracle*

Michael J. Sandel, *What Money Can't Buy: The Moral Limits of Markets*

Dominic Sandbrook, *Seasons in the Sun: The Battle for Britain, 1974-1979*

Tariq Ramadan, *The Arab Awakening: Islam and the New Middle East*

Jonathan Haidt, *The Righteous Mind: Why Good People are Divided by Politics and Religion*

Ahmed Rashid, *Pakistan on the Brink: The Future of Pakistan, Afghanistan and the West*

Tim Weiner, *Enemies: A History of the FBI*

Mark Pagel, *Wired for Culture: The Natural History of Human Cooperation*

George Dyson, *Turing's Cathedral: The Origins of the Digital Universe*

Cullen Murphy, *God's Jury: The Inquisition and the Making of the Modern World*

Richard Sennett, *Together: The Rituals, Pleasures and Politics of Co-operation*

Faramerz Dabhoiwala, *The Origins of Sex: A History of the First Sexual Revolution*

Roy F. Baumeister and John Tierney, *Willpower: Rediscovering Our Greatest Strength*

Jesse J. Prinz, *Beyond Human Nature: How Culture and Experience Shape Our Lives*

Robert Holland, *Blue-Water Empire: The British in the Mediterranean since 1800*

Jodi Kantor, *The Obamas: A Mission, A Marriage*

Philip Coggan, *Paper Promises: Money, Debt and the New World Order*

Charles Nicholl, *Traces Remain: Essays and Explorations*

Daniel Kahneman, *Thinking, Fast and Slow*

Hunter S. Thompson, *Fear and Loathing at* Rolling Stone*: The Essential Writing of Hunter S. Thompson*

Duncan Campbell-Smith, *Masters of the Post: The Authorized History of the Royal Mail*

Colin McEvedy, *Cities of the Classical World: An Atlas and Gazetteer of 120 Centres of Ancient Civilization*

Heike B. Görtemaker, *Eva Braun: Life with Hitler*

Brian Cox and Jeff Forshaw, *The Quantum Universe: Everything that Can Happen Does Happen*

Nathan D. Wolfe, *The Viral Storm: The Dawn of a New Pandemic Age*

Norman Davies, *Vanished Kingdoms: The History of Half-Forgotten Europe*

Michael Lewis, *Boomerang: The Meltdown Tour*

Steven Pinker, *The Better Angels of Our Nature: The Decline of Violence in History and Its Causes*

Robert Trivers, *Deceit and Self-Deception: Fooling Yourself the Better to Fool Others*

Thomas Penn, *Winter King: The Dawn of Tudor England*

Daniel Yergin, *The Quest: Energy, Security and the Remaking of the Modern World*

Michael Moore, *Here Comes Trouble: Stories from My Life*

Ali Soufan, *The Black Banners: Inside the Hunt for Al Qaeda*

Jason Burke, *The 9/11 Wars*

Timothy D. Wilson, *Redirect: The Surprising New Science of Psychological Change*

Ian Kershaw, *The End: Hitler's Germany, 1944-45*

T M Devine, *To the Ends of the Earth: Scotland's Global Diaspora, 1750-2010*

Catherine Hakim, *Honey Money: The Power of Erotic Capital*

Douglas Edwards, *I'm Feeling Lucky: The Confessions of Google Employee Number 59*

John Bradshaw, *In Defence of Dogs*

Chris Stringer, *The Origin of Our Species*

Lila Azam Zanganeh, *The Enchanter: Nabokov and Happiness*

David Stevenson, *With Our Backs to the Wall: Victory and Defeat in 1918*

Evelyn Juers, *House of Exile: War, Love and Literature, from Berlin to Los Angeles*

Henry Kissinger, *On China*

Michio Kaku, *Physics of the Future: How Science Will Shape Human Destiny and Our Daily Lives by the Year 2100*